A GUIDE TO MEXICAN ART

A GUIDE TO

MEXICAN ART

From Its
Beginnings
to the
Present

Justino Fernández
Translated by Joshua C. Taylor

University of Chicago Press / Chicago and London

Translated from Arte mexicano de sus orígenes a
nuestros días, *2d ed. (Mexico City: Editorial Porrúa, 1961),
with additions by the author*

Library of Congress Catalog Card Number: 69-16773

The University of Chicago Press, Chicago 60637
The University of Chicago Press, Ltd., London W.C.1

Original work © 1961 by Justino Fernández
Translation © 1969 by The University of Chicago
All rights reserved. Published 1969

Printed in the United States of America

ACKNOWLEDGMENTS

I should like to thank the following institutions and individuals for their kind cooperation in authorizing the reproduction of works in their possession or under their care: Universidad Nacional Autónomo de Mexico; Instituto Nacional de Antropología e Historia; Instituto Nacional de Bellas Artes; Museo de Arte Moderno; Museo Nacional de Artes Plásticas, I.N.B.A.; Instituto Nacional de Cardiología; Mrs. Margarita Orozco and family; Dr. Eugene A. Solow and family; and Mrs. Inés Amor, director of the Gallería de Arte Mexicano. I especially wish to thank the artists whose works are here reproduced for their generous cooperation in the completion of the present work. I am grateful also to Professor Joshua C. Taylor, who is responsible for the excellent translation of my text.

CONTENTS

ILLUSTRATIONS

1. ANCIENT INDIGENOUS ART

(Unless otherwise indicated, the works illustrated in this chapter are in the National Museum of Anthropology, Mexico City.)

2. THE ART OF NEW SPAIN

Medieval-Renaissance Art

3. MODERN ART

Romantic Art

INTRODUCTION

This book does not pretend to be a history of Mexican art in any
strict sense, but rather a spiritual aesthetic guide that may help
in understanding and in winning affection for our arts. Mexico
is a fortunate country, blessed with a rich artistic heritage and
notable creative power. Every great period of its complex his-
tory has produced works of universal historical importance.

In schematic form we might divide the development of Mexi-
can art, which extends over some twenty centuries, under sev-
eral general headings: first, Ancient Indigenous Art, covering the
various aboriginal cultures before the impact of the West in the
sixteenth century; second, The Art of New Spain applying to
the art which flourished during the three centuries of the vice-
regal period when the country was known as New Spain, from
the first half of the sixteenth century to the first decades of the
nineteenth century; third, Modern Art, embracing Romanticism
and the nineteenth century, in which independent Mexico found
expression; and finally, Contemporary Art, which already spans
more than half a century if we consider it as extending from the
Revolution of 1910 until the present. There is another heading
that merits special attention: Popular Art, which we might call
"modern indigenous" art. Although it was to be found in the
other historical periods, we can study it most fully as it is still
being produced, its roots remaining deeply implanted in the re-
mote past.

Although the term Mexican Art, which we now readily ac-
cept, seems obvious and commonly understood, a moment's re-
flection should be given to the complexity for which this simple
denomination stands. In effect, all the art produced in Mexico
throughout the periods noted above is today recognized as
Mexican by virtue of its particular characteristics. Because of
the many qualities they have in common, it is always easy to
identify our ancient indigenous arts whether Mayan, Aztec, or
of some other culture—the works are unmistakable. In the art
of New Spain, although relationships with European art are very
evident, certain differences are just as striking. The best of our
nineteenth-century art can be compared to the best produced

in Europe during this period, but it also differs in many respects. And, as for the great Mexican art of our own day, not only is it original, it rivals in its greatness the major comparable works of Europe. Like every authentic art, Mexico's expresses its own life —a different life, with a marked personality at each stage of its history. For this reason, as well as for the artistic and aesthetic quality of the works themselves, it can justly be called as a whole Mexican art. This should not, however, be construed as a limitation, because, even though it is certainly original and has its own characteristics, it has a universal profundity and humanistic quality as well. In this lie its genius and its greatness. It is Mexican, but it is also universal—otherwise it would not be art.

The existence of this new great theme which is Mexican art poses serious problems, both general and particular, for the modern historian. First of all is the question of where Mexican art is to be inserted into our schemes of universal history. Just where is one to include ancient indigenous art, which is sometimes referred to as *Pre*-Colombian, *Pre*-Cortés, or *Pre*-hispanic? Is it to be linked with the ancient classical cultures of the Orient and the West, or is it to be included only at the point where those countries and cultures that were later called American were discovered in the sixteenth century, as part of the Renaissance? Since ancient indigenous art was not, at that time or during the succeeding centuries but only more recently, considered art, it would seem in a way almost a creation of contemporary criticism.

As for the art of New Spain, designated also by other names— Colonial, Viceregal, Spanish-Mexican—it has too distinct a personality to be included simply as another chapter of Spanish Renaissance, Plateresque, or Baroque art. It is an art that belongs to a particular historical time and place; it is the art of New Spain, the ancestor, along with indigenous art, of our innermost past—the past of present-day Mexico. It can take its place alongside the best works of contemporary European art at similar levels. Nineteenth- and twentieth-century Mexican art must certainly be regarded as a great expression of Western culture but with an American tone and, even more, with Mexican distinctiveness. But we can leave these questions. I wished only to raise

them as matters for reflection, so that Mexican art will not be considered in isolation as something exotic or as a curiosity; it will be accorded justice and fully understood and appreciated only if studied comparatively within the framework of a universal history of art.

I have been prompted to write this highly synthesized work out of a desire to foster a keener knowledge and appreciation of our Mexican arts. I hope that in viewing the total sweep of their history, even in so fragmentary a presentation, the extraordinary wealth of material will enhance the experience of any interested viewer. Mexican art has, in truth, notably enriched the human legacy. For those who already know much about Mexican art, there will be a few great novelties, few unknown works, to be encountered in the following pages; for the person approaching this material for the first time, all will be new. Rather than attempt to interest the reader in fascinating but minor details, I have concerned myself with the most typical and best-known works, hoping in this way to open up possibilities of understanding and to lay the groundwork for a fruitful encounter with a new world of vital interest and aesthetic enjoyment. It is important first to know, appreciate, and develop a taste for the best; then one may consider whatever one wishes. Only in this way can defensible and illuminating comparisons be made. I am convinced that education in art or in any other material of higher order need not, and certainly should not, disfigure culture by reducing it to the lowest possible level. On the contrary, true education consists in elevating the student to the plane on which great creations exist, even though it must proceed in gradual stages. Everyone has to arrive by his own means, and in these fields improvisations do not count. Only through his own efforts can a person attain the possibility of communicating with the great creative spirits through their works.

History offers us a variety of artistic forms; one must know at least the principal ones. Although we may like and appreciate certain of them more than others, we must not deny the value of some simply because we have other preferences. Every art belongs to a place and a time, and is the expression of people who also had their preferences. We should not fall into the vulgar

practice of decrying something simply because we do not understand it. Only by freely opening our minds to diverse possibilities can we enjoy the privilege of choosing and, in the last analysis, discover our own identity.

Perhaps this book will be taken simply as a selective catalogue with commentary on a few Mexican works of art. If so, I shall be quite satisfied. In any event, I do not recommend this book to anyone who knows everything and who has fixed ideas about all he knows. It is a book for the person who has seen nothing of Mexican art or who knows little about it, or for one who has encountered a few works that have awakened his aesthetic and thus his spiritual appetite. Perhaps also a person will find interest in the book who, although he knows much, is willing to listen to a voice different from his own. Art is for me the highest, the greatest artistic expression of a people, and we may come to know and to understand a society better through its creations. I speak of art, especially that of my country; I speak of spirit and of aesthetic taste as revealing the reality of existence of men in the past and of men today. I realize that to some this sounds archaic. So be it; but then we romantics must continue to speak about this, our world, even if it is already reduced to being a satellite of that other contemporary world burdened with practical enterprises. In any event, I offer this book to those who like poetic undertakings and adventures, and I think that I offer not a little in presenting some of the most important achievements of Mexican art. The liberties I have taken toward historical and archaeological knowledge should not suggest that I lack respect for the admirable contributions that our scientists have made in these fields. It is only that my interest in art and aesthetics obliges me occasionally to see things in a different way, from a different point of view.

Finally, I have taken special pains to consider many of the best-known works since I believe that they are precisely the ones which we actually know and appreciate the least. In our search for the new, the works which may be called classical are frequently discarded; yet these are the works of greatest importance. For this reason, in ancient indigenous art, for example, I have preferred to consider the first-class works to be seen in the

collections of the National Museum of Anthropology in Mexico City. In other periods, I have concentrated on those works that seem to me to merit the greatest esteem. I hope that my selection will always be revealing.

1

ANCIENT INDIGENOUS ART

When we think of ancient indigenous art, a whole series of different forms belonging to various times and places comes to mind. Its creators were men with ideas, ideals, and religious beliefs, with customs and techniques quite different from our own. In their cultures they expressed their manner of living, of humanizing the world; they created their works of art as an expression of their consciousness of life, their vision of the world—physical, human, and divine. In the following pages we shall consider a few works which indicate the forms of artistic expression and the general feeling of these cultures. The objects we shall look at will be treated, arbitrarily if you wish, as works of art. We shall not be concerned in any strict sense with archaeology, or linguistics, or ethnology, or history, even though all these are necessary in some degree for a thorough understanding of art. The idea that greater understanding diminishes aesthetic pleasure or makes it impossible is simply false.

To help create a coherent picture, we shall follow an order which is in part chronological and in part geographical or regional. In many instances, the exact chronology is insecure or uncertain, but it is necessary to build on some hypothesis even though its accuracy cannot be absolutely guaranteed. Archaeologists speak of Preclassic, Classis, and Postclassic periods. Let us put these divisions aside for a moment in order to form some ideas of our own directly from the objects themselves. In general terms, ancient indigenous art developed during some twelve centuries before Christ and for fifteen centuries after Christ, interrupted only by the Spanish Conquest in the sixteenth century.

One must adopt a new attitude if one is to understand ancient art—or modern art—since the academic "naturalist" tradition, which insisted that art was only the "reproduction of nature," is inadequate. To be sure, it was considered valid through much of the modern period, especially when the academies dominated and taught that the only beauty possible was the ideal beauty of classical Greece. But, art is expression, free to set its own limits. It may come close to the natural model or it may depart from it, according to its intentions and necessities. For each historical

moment, one must know what the creative man proposed to accomplish and the means he employed. By presuming to examine the whole historical range of art from a strictly naturalistic point of view or from that of classical beauty, we would eliminate all possibility of understanding many works that rightfully have a place. But since this tradition is very powerful, inherited as it is from our immediate past, many persons fall into the vulgar habit of passing opinions before great works of art without any justification, and just as likely will turn their backs remarking, "What ugly monkeys!'

Ancient Indigenous Art must be seen as an historical and artistic expression quite as valid as any other, and one must discover its particular aesthetic value, its characteristic beauty, so different from classical and traditional canons. It is a symbolic art *par excellence*.

The Art of Western Mexico. It is fitting to begin with one of the most attractive manifestations of the ancient indigenous world, that commonly known as "Tarascan," although this term is actually too narrow when applied to the mass of works produced in the vast region in western Mexico extending along the Pacific coast from Nayarit, Colima, Jalisco, and Michoacán to Guerrero. The creators of the works that we are about to consider seem to have been Náhuatl in origin, if one judges by language, but their origin is not actually known. Some earlier stages exist, but the art we know best belongs to a period extending from the tenth to the twelfth century. It arose in a remote time, made contacts with other cultures, and lingered on until the sixteenth century. It is a small-scale art; monumental works do not exist. Ceramic sculpture, sometimes skillfully polychromed, dominates. Executed with the utmost artistic expressiveness, the works are both attractive and forceful. In general, they depict the occupations and attitudes of daily life, both domestic and military, but also incorporate into art the figures of animals. In fact, especially well known are the fat little dogs, which possibly symbolize Xólotl, the God of the Dead, who in this disguise guided the deceased in the other life. This is, in other words, funerary sculpture.

One of the most extraordinary figures is that of a warrior in

a combative pose grasping a club with both hands (fig. 1). As protection he wears a kind of leather jacket and a cap, possibly of the same material, as well as full short pants. It is, of course, evident that the proportions of the figures do not correspond to nature, nor do the various parts of the body. Instead, the artist has created a figure that marvelously expresses what he wanted to say. The body is strong, the head is solidly planted, the gesture and the attitude are convincingly real. Without a doubt, this is a man who is defending himself or who is attacking in full vigor, his face serene and alert, his arms ready to deliver a blow. There is not a single illogical or unnecessary form, and one shape harmoniously unites with another to create the perfect sensation of aplomb and of imminent action. Further, the face evinces profundity and psychological sensitivity—it is a man who watches and waits. The proportion, the handling of material, the simplification and the sureness of artistic expression— all contribute to a perfect realization of the artist's intent. It is a fully achieved work of sculpture.

Possibly even more refined is the hunchback leaning on a cane, on a kind of pedestal or base made of two fish whose bodies unite to form a U (figs. 2 and 3). It is made of red clay burnished to an exquisite finish, smooth to the touch and attractive to the eye. Deformed creatures seem to have had special significance in relation to divinity. The fish can be explained by the closeness of lakes and the seacoast. Note that the head of the figure and the bodies of the fish are incised or scratched with a simple but effective design representing the tattooing or painting on the face and the scales of the fish; or possibly this is an old man, and the lines on the face indicate wrinkles. Other incised lines depict hair and the weaving in the cap. The hump is so close to nature in its rendering that the deformed spinal column is clearly visible. The pendants hanging from the collar serve, in a way, to balance the posterior protuberances. Is he a hiker? It would seem so; he looks contentedly toward far-off horizons. Everything about him is natural, and yet the work is in no way a naturalistic copy.

In some other figures, the face and sometimes the entire head are exaggeratedly large, and the nose and mouth are rendered with exceptional harshness. Sculptures exist of both men and

women, with clothes, wearing only loincloths, or completely
nude; some are shown squatting on their heels; others are in
various poses as they go about their domestic affairs, engage in
war, or simply sit meditating; others stretch out on the ground
on their backs or go through contortions. Some pieces are richly
polychromed, others are sober in color. The simplification is at
times extreme, but the figures always retain a natural appear-
ance; the artists well knew how to capture the essential qualities
of forms and their functions and to express these in a synthe-
sized fashion. The well-fed little dogs are exquisite and appeal-
ing, in spite of the fact that the expression on some the faces is
frightening (fig. 4). Who would not be won over by the well-
defined forms of these pot-bellied bodies with their little feet
and tails? Their ears are usually erect, and all have their eyes
wide open as if looking at something far away, a characteristic
frequently to be found also in the human figures. Some little
dogs wear a mask, the symbol of disguised personality. Figures
of other animals also exist, such as ducks, parrots, tarantulas,
chameleons, cranes, sharks, armadillos, tortoises, pigs, and
tlacuaches (opossums)—all imbued with life. There are also
decorated utensils, such as bowls, some of which are supported
by human figures while others follow plant forms which are ex-
tended to make perches for three parakeets.

Knowledge of other aspects of these peoples' lives is furnished
by the figures modeled in groups. There are houses, temples,
and people gathered together as if in ceremonial deliberation
or involved in ritual dances in which both men and women
participate according to a determined order. The sense of move-
ment and life that the artist impressed upon these ceramic
sculptures is extraordinary; the profundity of observation and
apparent ease of expression are surprising. As more and more
sculptures come to light—and their number is infinite—one's
admiration grows for this art which has an unmatched vitality
even though associated with a cult of the dead and a preoccupa-
tion with the afterlife.

Although it would seem that these people did not make sculp-
tures of their gods in clay or on a monumental scale, some
sculptures in stone exist. They take the form of a figure reclin-
ing on his back in the manner of the Toltec and Mayan Chac

Mools. The name "Chac Mool" is Mayan and seems to signify the God of Rain.

Preclassic Art of the Central Plateau. The term preclassic has come to be used in archaeology to refer to those most ancient remains whose origins are lost in mystery. A preclassic period is recognized in almost all cultures. From our point of view, however, "preclassic" does not mean "retarded,' nor does it imply a low artistic evaluation.

At Tlatilco, in the Valley of Mexico, a great many small ceramic figures have been found which, although most of them are only three or four inches tall, show surprising expression. They depict men and women dressed in loincloths or skirts or completely nude. Their principal characteristic is an exaggerated volume of the thighs, carried out in such a way as to make one think that this might have been the expession of an aesthetic ideal. These little sculptures from Tlatilco, related to the culture of Zacatenco and the Olmecs, have an unexpected grace (fig. 5). The women wear elaborate coiffures, even though nude, and have certainly plucked their hair to create an interesting effect. This, together with their slanting eyes, the painted adornment of their bodies, and their poses, produces a seductive attractiveness. As in the West, neither large sculptures nor images of deities have been found. Here too we are dealing with an art concerned above all with life, expressed with surprising refinement.

Some figures found in Gualupita, in the state of Morelos, are different from those of Tlatilco, even though they retain some relationship with them. The body is more rotund but not exaggerated in its proportions, and the head is modeled with great skill. An extraordinary example is a head (fig. 6) that seems to be that of a boy, although it may be that of a woman. The clay is modeled in an almost naturalistic manner, even though the parts have been simplified. The hair is indicated by means of scratched lines and hardly stands out from the head except for one lock that detaches itself. With grace and understanding the artist has joined the brows, modeled the cheeks in order to create deep sockets for the eyes and give relief to the nose, and formed the half-open mouth. It has the protruding

lips and down-turned mouth which characterize the so-called Jaguar type encountered in other sculptures of the Gulf coast. This form seems to have originated in the muzzle of the tiger, a sacred animal. The expression of the face is childlike but shows great character. The ears, also simplified, are perforated for earrings. This is a magnificent testimonial to the fact that archaic art can achieve the highest quality and that even in remote antiquity some cultures reached a superb level of development. This head is a little masterpiece, the product of a refined and accomplished art.

As for architecture, the so-called Pyramid of Cuicuilco in Tlalpan, on the outskirts of Mexico City, is the most ancient; it was discovered beneath the lava of the volcano Xitle, which erupted, it is calculated, before the Christian era. Actually, the mound is the base of a temple or place of invocation that was erected on a more or less circular plan and was some eighty-eight feet high with five stepped stories. The monument is interesting for its form and antiquity.

The Art of Eastern Mexico. Now we may turn our attention to the coastal regions along the Gulf of Mexico, from the Pánuco River to the south of Veracruz and Tabasco. This vast, rich zone was without a doubt the site of cultures which are not only interesting but important. Huastec, Totonacan, and Olmec cultures developed here, of which the latter especially had a far-reaching influence on other cultures of the central plateau and extended to the south, across the Isthmus of Tehuantepec, perhaps even to Chiapas and Guatemala.

The Huasteca, a region that includes parts of the states of San Luis Potosí, Hidalgo, and Veracruz, has attracted particular interest in art for the stone sculptures found there. These are sacred images, such as those representing *Pantécatl*, the God of Pleasure and Libations (fig. 7). His likeness is severe, sober, and rigid; he wears a great semi-circular headdress like a sunburst and a conical hat similar to that worn by Quetzalcóatl in some representations. There is an example also of the head of a female deity wearing a headdress in the form of a sunburst and a conical hat, but her face emerges from the open maw of a serpent.

Another of these extraordinary sculptures from San Luis Potosí, now in the British Museum, has characteristics similar to the preceding but is dressed in a short skirt which, together with various parts of the body, is richly decorated with glyphs. The back is even more extraordinary: a skull takes the place of the head, and the costume and the glyphs are even richer. Two large paws with eagle claws hang down the back. Is it a representation of the Sun, of the God of Death, or of Quetzal-cóatl? Perhaps it symbolizes various deities. A genuinely impressive work of sculpture, it possesses the hieraticism and artistic quality of Egyptian images from the time of the Pharaohs.

The Huastec sculpture of the British Museum may serve to represent the transition between the more sober, simplified works and the so-called Huastec Adolescent (1.45 meters high and 0.41 meters across the shoulders), one of the supreme jewels of ancient indigenous art (fig. 8). In fact, no other figure will be found of such high quality and which maintains such a pleasing balance between the natural human body and artistic expression. The youthful limbs, the attenuated figure, the expression on the face as if about to speak with half-opened mouth, the body decorated in part with glyphs associated with the corn cult (like the sculpture in the British Museum) and, finally, the proportion and elegance of the figure—all help to qualify it as a masterpiece of a very great and refined art. It would seem to represent Quetzolcóatl as a young god and as a priest; he carries on his back his son, who is said to have been "born without aid of woman" and whom he converted into the sun. The glyphs, it is interesting to note, are related to Mayan culture. But, above all, it is a first-rate work of art and might honorably, even advantageously, be placed along side the archaic Greek images of Apollo.

As time goes by, the Olmec culture continues to increase in interest; it is of capital importance as a source and point of origin for other cultures, perhaps the ancient Mayan. From the southern region of the Gulf coast, extending as far as the Isthmus of Tehuantepec, a vast quality of work has appeared, so excellent in quality that it must be considered the product of a well-established and developed culture.

In La Venta, Tabasco, in San Lorenzo and Tres Zapotes,

Veracruz, colossal heads have been discovered which have distinctive physiognomic characteristics: thick lips and deeply incised mouths, broad noses and large eyes (fig. 9). They wear caps, doubtless of leather; and their expression and scale are imposing. To cut monoliths of this size and quality demonstrates a mature technique and a notable power of expression. Not only is each element well constructed, well proportioned, and in its correct place, but the artists have accentuated the outlines of the lips to give greater firmness and character to the mouth, and have marked the pupils of the wide-open eyes in such a way as to accentuate the fixed gaze which is concentrated on the distance, on the infinite. These heads are overwhelming.

Other monoliths have been found in the same zone which are thought to be older. Each represents a human figure, bearing a child in its arms, emerging from the mouth of a great snake. In Veracruz there are steles with complete figures in delicate relief. From other sites in the same region come small sculptures in jade of bluish and other tones, representing figures with a jaguar type of mouth. Some of these jade sculptures are painted red, a color which must have had a magic-religious significance. But sculptures in other stones also exist, such as the seated figure from El Tejar, Veracruz, carved in black granite (fig. 10). The proportions are carefully worked out, although the artist wanted to give major importance to the head, which has thick heavy lips that recall those of the colossal heads from San Lorenzo and La Venta; the nose, however, is different, being aquiline in type. The figure's only apparel is a leather cap tightly fitted to the head; the body is nude and settled in a restful pose. The polished granite adds greatly to the attractiveness. The really exceptional sculpture is, however, another: it is a seated stone figure of a man with his arms raised to the level of his chest instead of falling in repose; the body leans toward the left in such a way as perfectly to express movement—perhaps this is why he has been called "The Wrestler." He wears only a belt that serves as a kind of loincloth. His head seems to be shaved, but he has a beard and a mustache. In type, he is quite different from the representations in other sculpture from the regions south of Veracruz, from which this comes (fig. 11). The structure of

the head is different, and the eyes are very deep-set; the back is treated with a sensuous simplicity that only a great artist could achieve. In the movement expressed by the nude body as well as in its soft fleshiness and distinct naturalism, this piece takes its place as a most extraordinary sculpture and reveals the fact that the Olmec artist was conscious of every means for achieving the most varied expressions, from the most abstract designs to forms that closely approximate a living model, from the absolutely static to the most natural movement.

Especially enchanting are the little sculptures of dwarfs or children with large heads and mouths and jaguar type of features; the deeply incised line of the downward-drawn lips is characteristic of Olmec sculpture, which seems obsessed by the features of the sacred animal: the jaguar. But in spite of the character and the force of the expression, the artist has suggested a kind of tenderness, evident especially in the proportions of the arms and the legs of the little naked bodies (fig. 12).

In the so-called axes, so designated because of their general shape although they are actually votive offerings, there is a great variety of expression. They are carved from different stones, and almost all are of first quality (fig. 13). Some more closely approximate the natural model, although the elements are treated in a synthesized fashion to achieve a striking expressiveness. In others, however, the abstract design itself is of an expressive force and an intellectual refinement worthy of the most sophisticated contemporary artist. One of the devices occasionally used in these sculptures is perforation, as in the superb head of a parrot that comes from Xochicalco, Morelos, and that Henry Moore might well sign (fig. 14). Its simplicity of design and perfectly realized form are of the first order. Into the block of stone the artist first cut an interesting and well-determined profile; on one half of the head he has shown the feathers and cut a perforation for the eye. The other half, on the right, contains the beak and the nostrils; between the two halves the opening of the parrot's maw is so precisely formed that it beautifully balances the solid areas and the perforations above; in the middle of the hollow is the tongue. It is another masterpiece. The sculpture of our own time does not go much beyond this; nor have many expressive means

been discovered that were not already used with supreme mastery in the indigenous sculpture of ancient Mexico.

Then too, we must consider the famous "yokes," U-shaped stone sculptures from Central Veracruz, usually finely decorated with heads and serpentine elements (fig. 15). Their function is not clear, but they would seem to have served for the magical protection of the deceased, whose head was possibly placed in the opening. Also performing a religious-magic function in relationship to the dead, so-called palms have been found which possibly served as votive offerings (fig. 16). They are elongated, finely decorated sculptures of very elegant form. There are a great many varieties of these; some of them represent a human being whose head protrudes from the open mouth of an eagle and whose body is depicted on the "palm"; a great plumed headdress rises in extraordinary fashion over the head. Finally, it should be noted that sculpture in the area of Central Veracruz, furnishes us the only clear manifestation of happiness; the famous little "smiling heads" and some other ceramic figure sculptures are almost the only ones in the entire severe panorama of indigenous art to be distinguished by a smile and are truly of seductive charm.

Although we have considered here only a few works of Olmec art, the richness is infinite both in number and in aesthetic quality. It is thought that the Olmec culture flourished centuries before the Christian Era. One fact is, however, clear: the forms it created persisted, even though the traces may appear somewhat sporadically, in all later indigenous art, thus indicating its great antiquity.

Nor is its certain whether this culture developed along the Gulf coast and then later invaded the central plateau, finally reaching the southern part of the Pacific coast, or whether its development began in this latter region and then extended to the Isthmus and the Gulf. The Olmecs were powerful and refined creators, the fathers and grandfathers, perhaps, of other cultures.

Mayan Art. Of all the ancient indigenous art of America, none is more famous or more admired than the Mayan. Certainly its fame is well justified, for its works of art in general as well

as for its great monuments. Its sculpture in particular is memorable, although, especially after the discovery of Bonampak, its mural painting also demands attention.

Mayan culture is divided into two great periods: the Classic, occupying the vast regions south of Yucatán from the Isthmus to Honduras and extending in its development from the second to the tenth century A.D.; and the Postclassic, on the Yucatán peninsula, which flourished from the ninth to the fifteenth century, more or less. At least, by the time the Spaniards arrived, the culture had already for some time nearly disappeared and its great works were in ruins and covered by underbrush. We can forget the pompous concept of "empire,' once commonly used, and speak simply of classic and postclassic art, following the same chronology.

Classic Mayan art reached its golden age in the next to the last century of its development. It was a noble culture that made great advances in knowledge, especially in astronomical observation and the calculation of the calendar. Its existence was perpetuated by its monuments. One need simply think of Palenque to evoke the greatness of this culture, without a doubt the most refined to have existed on the continent. Palenque has been an inexhaustible source of treasures, and the notable discovery of the tomb beneath the so-called Temple of the Inscriptions has done away with the idea that the pyramids were never used as funerary monuments. This is an important example that invalidates the earlier widely assumed generalizations. The room discovered beneath the temple, or rather in the base of the pyramid which supports the temple, is covered by a false arch or a Mayan arch consisting typically of two inclined walls sloping toward the center. In this room a huge stone with a splendid relief was found, and beneath the stone was a sarcophagus cut from a monolithic block. The sarcophagus contained the remains of a person together with various precious objects and a jade mask covering the face of the deceased. Also from this room came some magnificent male heads wearing great plumed headdresses. The facial features of one of them (fig. 17) are made distinctive by the long, prominent straight nose which extends between the eyebrows as a narrow form well into the forehead. The linear elegance

of these heads is very impressive, and the entire treatment, whether of the face or of the headdress, shows an artistic mastery of the highest order. There is a line that runs from below the mouth, up along the nose, finally to disappear beneath the headdress; harmonizing with it is another which runs from the neck up through the topmost plumes in a rhythmic motion. Then too, the contrast between a certain naturalism in the face and the simplified form of the mass of plumes and the flower over the forehead contribute to the singular beauty of the composition; it furnishes a superb example of the artistic creative capacity of the classic Maya. As for the form of the nose, it must have accorded with an aesthetic ideal, and the effect was created by artificial means.

Another recent discovery of great importance is the mural paintings in Bonampak, Chiapas. The walls of three rooms are covered with paintings of scenes showing crowds of persons engaged in various kinds of ceremonies and scenes of war. One painting shows in the upper part a great chief richly attired and in the lower part the unfortunate prisoners, some of whom have already been sacrificed (fig. 18). Basically, the composition is organized in horizontal bands at different levels, and within each band the figures are arranged as in a frieze. The sense of form is what we would call classical or, according to Wölfflin, "closed" form, in that the drawing defines and limits the areas with great precision and the forms thus take on an absolute clarity. But the Mayan artist knew how to make the most of his drawing from the line itself and, letting his brush flow freely, gave his strokes both ease and sureness. All the figures in this scene, as well as in the other, are excellently drawn and their adornments are richly colored; they stand out sharply against the smooth backgrounds that preserve the harmony. Among the various figures there is one of exceptional beauty: a dead prisoner whose nude body is stretched out on the steps at the feet of the great military chiefs. His body seems overcome by a kind of lassitude. The composition is dominated by a smooth and elegant line that flows from the right foot, through the leg, the torso, and the left arm. Then too, a suggested line relates the left knee to the right shoulder, creating a contrasting movement that counters that of the reclining

body. The torso has its own undulation terminating in the head, which is tipped back to rest upon the left arm. This figure would be enough in itself to establish the reputation of the ancient Maya as great painters, because these adroitly handled means and their effects belong only to artists of the very first order.

The ancient Maya are well known as sculptors and for their rich and refined reliefs. Mayan commemorative steles are works of great art. Among the most exquisite pieces is a circular stone carved with a border of numerals indicating a date which in our chronology corresponds to the year 590. It is a commemorative altar for a ball game and was discovered in Chinkultic, Chiapas (fig. 19). The composition is excellent, and the drawing and fine execution of the relief are consummately beautiful. In the center is a ball player dressed in a short skirt, probably of leather, and wearing a great headdress of flowing plumes. He bends his right leg and braces his knee on the ground to gain momentum for striking an enormous rubber ball with his hip. His thighs and lower legs form a rectangle, but the line of his right thigh continues up through the body to the head, were the forceful movement is dispersed in the plumes. The left arm, stretched out stiffly, braces itself on a glyph-marked stone to steady the blow. The right side of the player's body is protected by a sandal, a shin guard, and a short leather skirt. His chest is bound with several bands, and his right arm, from the wrist to the elbow, is covered with what seems to be a fitted sleeve decorated with tiny feathers. One could not ask for a more controlled composition, either as a whole or in detail, and one senses especially the structure of the player's body through the way in which the artist has given each member its proper place in the composition in order to create, without violence, the necessary force for striking the ball. This relief is a gem of classic Mayan art.

The Mayan were also expert in ceramics; some of their vases with figures and scenes on the outside are comparable to similar Greek works. Another delightful creation of Mayan art, and certainly no less impressive, is the clay figurines that come from the island of Jaina, off the coast of Campeche, found there in an ancient cemetery. The elegantly dressed women and

serene and haughty men give a good idea of what the people were like. One figure of a seated woman—we might say of a matron—covered with a tunic down to her feet, composed on a strong vertical axis, has a distinctly monumental character in spite of its small size (fig. 20). The tunic unifies the figure, simplifying the form and at the same time underlining some of the parts. The appealing simplicity with which the body is treated gives particular emphasis to the impressive head with its puffed face tattooed around the lips and the lower jaw. She smiles, her mouth half open, and her expression is frankly winning but tinged with an undefinable hint of maliciousness. As customary with the Maya, a great sweep of the forehead is exposed, but the hair makes an imposing effect, pulled back and drawn into a great headdress with puffs tied together with a decorative cord. Long cylindrical ear ornaments jut from the lobes of the ears. The whole coiffure is very elegant and has a Chinese air about it; from the artistic point of view, it is masterful. How very skillful were these sculptors from Jaina to be able to express reality without turning to a vulgar realism or naturalism! The expression is maintained in a truly poetic equilibrium—one that creates a more subtle and more human reality. Works of art like this justify our considering the Maya a refined people and allow us to penetrate into their aesthetic ideals. For that matter, the Dresden Codex should be considered from the point of view of art, for possibly it is the work that achieves the greatest aesthetic quality.

Classic Mayan art left great monuments, such as those of Zayil, Labná, Kabá, and, above all, Uxmal; among these the Palace at Uxmal, so-called "of the Governor,' has no rival in austerity and elegance. From Uxmal, Yucatán, also comes the sculpture called the Queen which originally was inlaid and formed a part of the ornamentation of one wall of the Pyramid of the Magician (fig. 21). It has the elegance of the traditional refinement but also something new; a cruel bestiality and aggressiveness in the face. The human head protrudes from the open mouth of a serpent as if it were a transformation of the reptile, thus creating an easily understandable symbol by which man could recognize its fierceness and power. But this is only one of the many interpretations it might be given. A fully satis-

factory explanation has never been found for this constant symbol of ancient indigenous art: these heads or faces of human beings that emerge from the mouths of reptiles or the beaks of eagles, erasing the boundaries between the species and thus, perhaps, expressing a concept quite different from our own about the nature of the universe. To be sure, it remains problematical whether this represents a woman—woman need not always be related to the serpent—although it is true that, in spite of its harshness, the face has a certain elegance. There is an effect of heavy breathing and the rigid down-turned mouth and protruding lower lip are, in truth, features that move one to a kind of terror when one looks at them fixedly with concentration, even though they attract by their formal perfection and artistic force. The brutish effect is much heightened by the tattooing on the face, picked out in relief on the right cheek and on part of the chin and jaw. It is a misleading sculpture; the white stone in which it is cut and the elegance of its lines make it seem at first glance the product of a rather precious art, but it is nothing of the sort: it represents an art that is vigorous, formidable, and dramatic, and the emotion it provokes is profound. It is the face of a sinister deity. It is a work of art that achieves tragic beauty.

To penetrate in greater detail into the rich artistic inheritance of the classic Maya, would be to go on without end. It is enough to study one head from Palenque and one from Uxmal to understand the basic character of that art we call Mayan.

Postclassic Mayan art was influenced in important ways, as early as the twelfth century, by the culture of the central plateau, especially by the Toltecs. Perhaps it was this that caused the Maya to change the forms of their art from what these had been in earlier times. Actually, their art lost its refinement, even though they were able to continue creating and inventing. Monuments such as those of Chichén Itzá take their place in history as great creations. But the reliefs in the buildings in Chichén Itzá do not attain the heights of those of classic Mayan art. On the other hand, how monumentally beautiful is the Temple of the Tiger in the Ball Court! And their success with other forms of designs, such as the rounded corners of the "Castillo" or Pyramid of Kukulkán is notable. But there is a

refinement that is in some indefinable sense too bland, not at all the vigorous refinement of Palenque. Yet this can be said only within the context of Mayan art as a whole, for the effect of Chichén Itzá, for example, seen in its own right, is overwhelming in its monumentality and definite beauty.

Few sculptures are so powerful and splendid as the famous red jaguar within the great "Castillo' at Chichén Itzá, which is on top of an earlier pyramid that was covered over by a new construction. It is a throne, a stone seat, in the form of a jaguar, painted red and inlaid with jade; on its back was a mosaic disc composed of precious materials. The simplicity of its structure, its formal relationships, color, and material mark it as exceptional. But above all, the head is tremendously moving in its expressive force. The great eyes are simple spheres of green jade, the open mouth reveals powerful fangs, and further jade inlays contribute to the formidable effect. If post-classical Mayan art had produced nothing else, this would have been enough to place it in its esteemed category.

Teotihuacán Art. The brilliant culture of Teotihuacán maintains an unmistakably original character in the panorama of the ancient indigenous world. Archaeologists have tried to clear up the enigma posed by the culture, and now, thanks to ceramic pieces found in different sites and at different levels, they have been able to establish four stages of development. But the chronology remains imprecise. It would seem that the culture originated before the Christian Era and perhaps reached its high point between the fourth and the ninth centuries; this would mean that it existed at the same time as the classic Mayan. It is thought that the extraordinary structure of the monumental Pyramid of the Sun belongs to Stage I and was built all at one time on the flat plain and not superimposed on other pyramids of various epochs. In Stage II, the fantastic pyramid of the Temple of Quetzalcóatl was constructed. Stage III is marked by the severe classical, architectonic, and geometric forms of Teotihuacán in its full maturity, also seen in the mural paintings and the great variety of elegantly designed ceramic pieces. In Stage IV, a decadence must have set in, coincident with the advent of Toltec culture.

Apart from these archaeological facts, however, two types of artistic expression are clearly distinguishable, very different in spirit: that of the Pyramid of Quetzalcóatl, with its rich symbolic ornamentation; and that of Teotihuacán, severe, simple, and geometric, which might be called the more intellectual and rational, showing great organizing capacity.

From the remains of the Pyramid of Quetzalcóatl, which also includes Tláloc, we may gain some idea of the overwhelming effect that the whole complex must have provoked, with the great vertical planes of the individual stories richly embellished with symbolic ornament, which must be imagined in its original polychrome. Today those parts which still remain in place are impressive, and can be seen beneath the pyramid of later date belonging to the group called La Ciudadela. To be seen there are the plumed serpents, with their great, terrifying heads jutting out from the wall, alternating with the no less formidable images of Tláloc, God of Rain (fig. 22). Shells and snails, originally polychromed, fill other spaces. The whole concept of the pyramid is of the first order; it is a masterpiece of architecture whose only parallel is perhaps the Pyramid of Tajín in Papantla, Veracruz, which probably dates from a later period. The panels of the vertical masses are composed with great skill as rhythmically accented friezes, the thrusting heads of Quetzalcóatl and of Tláloc breaking the plane harmoniously and enriching the design of the whole with well-calculated patches of light and shade. In spite of the fact that the rich decoration makes the pyramid appear highly embellished, the general concept is distinctly architectonic, based on geometric structure both in its totality and in its detail. This clearly demonstrates that the rational, intellectual spirit of the Teotihuacán people, which was to reach its maximum expression at a later time, was already manifest in the Pyramid of Quetzalcóatl.

Mural painting had an important development in Teotihuacán. A single but exceptional example, one of the frescoes of Tepantitla, might stand for many (fig. 23). The relatively small room which contains the principal paintings must have been in its own day one of exceptional luxury and charm. In general, the decoration follows an architectural scheme, but

the lower panels on either side of the main entrance are composed with great freedom, following artistic intuition rather than rigid structure, and herein lies much of their fascination.

One panel depicts Tlalocan, the Paradise of Tláloc, and is worthy of careful study. At the left, at the top of a hill, a spring arises which descends to form a river at the bottom of the painting, where it terminates in a kind of a canal. A host of small human figures, drawn with few but expressive lines, stand out in different colors against a dark red background. Around the figures are plants with blossoms and butterflies. The inhabitants of this paradisiac place are occupied in a great variety of activities: they dance, sing, chase butterflies, play, rest, and bathe. Two aspects of the work are exceptional. First is the freedom of composition—the artist has proceeded to cover the space with figures with no guide other than his artistic intuition: when there was a space, he put in a plant, a human figure, or a butterfly. Then there is the freedom of the execution itself in detail, for with the greatest simplicity the painter was able to give a naturalness to the attitudes and states of mind expressed in the different activities of the small human figures. Anyone knowing the work of Paul Klee will find a suggestive similarity in this great scene. Its candor, grace, and perfect artistic expressiveness make this mural painting an incomparable gem; it carries the viewer to mythical regions in which he can experience absolute freedom, joy, and happiness —and all this through the imagination that this truly great work of art reveals.

But now we must erase from our minds all trace of the paintings we have just seen in order to turn our attention to the most perfect and majestic religious and ceremonial architectural complex of the ancient indigenous world, for it is based on a radically different concept. This is evident in the plan itself of the sacred "city" of Teotihuacán (fig. 24). Its rational —or one might rather say, rationalist—ordered, strict, inflexible character justifies the people of Teotihuacán's reputation as great planners. Along a great central axis, the so-called "Avenue of the Dead," running imposingly from south to north, are various groups of structures, temples, courtyard, and pyramids. To the south, on the east side of the avenue is the com-

plex which has been called La Ciudadela. It is an immense rectangular courtyard surrounded on the sides by a continuous platform supporting a symmetrically arranged series of pyramidal forms which must at one time have held small temples or places of worship. At the end of the central axis is the greatest pyramid of the group, which covered the ancient Pyramid of Quetzalcóatl. Few architectural complexes are more imposing in their severity; the stairways as well as the pyramids are of an astonishing geometric simplicity, even though in their time the color with which they were covered must have produced an effect very different from that of today. It is naked, majestic, classical architecture. Further north, on the other side of the San Juan River, there is another group of mounds organized according to a strict system of architectural axes with nothing left to chance. Close by rises the colossal Pyramid of the Sun; the stairways ascend on the western side (fig. 25). It is a geometric architectonic mass which proves what man's creative ability can produce in confronting and competing with the monumentality of nature. The sloping sides of the successive stories give the pyramid a dynamic profile. From the top, which once supported the temple, one has a view over the whole of the Valley of Teotihuacán. On the western side of the avenue, next to the Pyramid of the Sun, is the Temple of Agriculture. Finally, facing on a courtyard surrounded by places of worship, the Pyramid of the Moon, with stairways to the south, brings the entire composition to a close. It is from the top of this monumental structure that one can see most clearly the course of the Avenue of the Dead as well as the whole architectural complex with its axially organized buildings. To be sure, the Pyramid of the Sun and the Pyramid of the Moon are the outstanding features, but equally admirable are their position within a system, the grandiose concept of the general plan, and the skillful arrangement of the building groups. On the western side of the courtyard, in front of the Pyramid of the Moon, stands the recently discovered Palace of the Quetzalpapálotl. It has a severe but beautiful courtyard, and many of its walls are covered with frescoes.

The Teotihuacán people's formal sense must be clearly undertood, beginning with their architectural planning, because

this same feeling for form rules their entire art, from the small onyx jaguar, now in the British Museum, to the colossal monolith known as Chalchiutlicue, the Goddess of Waters (although this identification is problematical) (fig. 26). This latter, which stands some ten and a half feet high, was found near the Pyramid of the Moon. The image was cut from a huge square block of stone, and retains, to an extent, the original form. Actually, it is very simply conceived, but in this very simplicity lies its force. The composition is based on a sequence of horizontal bands in different planes, interrupted only for indications of the feet, the hands, and the face with its ear ornaments. On the head, a block, like a huge headdress, weighs down upon the form that represents a stunted body. There is a hole in the chest that must have originally been inlaid with a precious stone, such as onyx or jade. The *huipil*, which scarcely covers the upper part of the body, follows an angular path at its border to permit the hands to be seen. The skirt is decorated with a Greek key design. Groups of small rectangles indicate the toes, and above them are feather ornaments. The costume, which is extremely severe, could hardly be more sober, for it is composed of only those elements that are indispensable. The stone is actually carved in a relief technique, and the figure as a whole suggests the idea of a great pillar. Few other sculptures approach its abstractness; it overwhelms by its impressive size, by its rigid geometry, and by its dehumanized expression. It has the ideal beauty of a geometrical form—that is to say, the abstract, intellectual beauty more interesting than attractive—an immobile rigidity that might perhaps have characterized the mentality and the life of the great builders of Teotihuacán.

The Teotihuacáns' hieratic use of form in artistic expression appears in other works: in masks, for example (fig. 27). In spite of the fact that these are sculptured to approximate the human face, they relinquish none of the abstract, impersonal quality that dominates all this art. They are, however, very impressive. In the quality of the stones from which they are carved, as well as in their simplified treatment and fine modeling, generally they are first-class works of art.

The lack of a precise chronology raises problems that are still unsolved. But even this brief consideration of a few

prime works of Teotihuacán art is enough for one to realize its originality, its greatness, and its extreme importance.

Toltec Art. The history of Toltec culture has been the subject of serious study and can be partly documented. In general terms, it was related to the Nahua culture, and its establishment in Tollán or Tula, in the state of Hidalgo, seems to have taken place at the beginning of the ninth century. Its principal site seems to have been abandoned and destroyed by the twelfth century. From this later date can be traced the Toltec emigration to different regions, to the central plateau itself, to Yucatán, and to Central America. All agree on the Toltec influence felt by other cultures, and the traces are, indeed, unmistakable, as, for example, in postclassic Mayan art beginning with the twelfth century. The dispersion of the Toltecs was brought about by the struggle between its great chief and priest Quetzalcóatl (an historical personage not to be confused with the legendary figure by the same name) and Tezcatlipoca, who succeeded in expelling Quetzalcóatl, who then emigrated to the Gulf coast, where he is said to have been transformed into a morning star. Although this last part is of course legendary, it remains a fact that some aspects of Toltec culture are to be found in the rebirth of Mayan art in Yucatán.

The Toltecs were famous in art for their architecture, sculpture, painting, mosaics, feather work; later, when the Aztecs wanted to indicate artists of quality they called them "toltecs." But the problem is that, at least until now, the remains of Tula, with all their size and interest, are not sufficient, it seems to me, to justify such extraordinary fame. Certainly the so-called atlantes are basically columns or colossal pillars, gigantic carytids in human form with their great clearly carved heads topped by plumed headdresses (fig. 28). Further, the sculptural execution is very rigid and dry, without the refinement that can be found in the works of other cultures. They are developed in rocky superimposed cubes, and the structural concept is close to the intellectual and dehumanized abstract expression of the Goddess of Waters of Teotihuacán. Other atlantes of smaller size, which later reappear in Chichén Itzá, come no closer to being great works of sculpture. The serpen-

tine columns, which were also adopted by the postclassic
Mayan culture, form an artistically and architectonicly inter-
esting solution worthy of admiration. On the other hand, a
fragment of symbolic ornament from the vertical panels on
the platform of a pyramid has the force but not the refinement
of a fully matured art. Particular interest is, however, fur-
nished by the "crenelations" that crown it, made up simply of
a series of rectangular, open volutes, arranged to produce an
excellent effect. Other reliefs on the rocky cubes, parts of
ancient columns, are only slightly worked out and primitive
in expression.

I hope that archaeologists and other enthusiasts of Toltec
culture will pardon the above observations, but they are based
objectively on the works that have until now been presented
for our consideration. Toltec art takes on more stature for us
when we look at the Chac Mool discovered in the last century
in the area of Tula (fig. 29). This, to be sure, is a magnificent
work of art of great quality. The entire reclining human figure
is developed out of, or cut from, a single block. The composi-
tion is beautifully suited to its purpose. The shoulder, arm, and
hand are united in a dynamic rhythm, which is continued by
the thigh and the leg, to form a kind of half frame, so to speak,
to set off the head with its striking face and plumed headdress.
The forms are relatively soft, without losing force, since all the
profiles have been rounded off. The receptacle resting on the
abdomen and between the legs is tightly integrated with the
rest of the sculpture, with the result that the total work is com-
pact, strong, clear, and refined. It is interesting to note that
the expressive feeling of this work, as well as such details as
the snail shells or bells which hang from the collar and adorn
the leg, is closely related to later Aztec works. Even though
today the face is badly damaged, there are still traces of semi-
rectangular rings around the eyes and of a kind of mustache
below which the tongue protrudes from the mouth. Is this
Tlaloc, the Rain God? Possibly, but in any event, it is a sculp-
ture of well-conceived and well-realized forms, softly and even
sensually modeled to lend a feeling of humanity.

Rather than great and numerous works of art, Tula simply
provides evidence that the Toltecs had inventive genius, for

their works are original in almost all aspects, whether one considers the atlantes, or gigantic roof supports, which, in their character and dimensions, recall such ancient works as those of Tiahuanaco or even of Egypt. Perhaps without the influence of Toltec art, the Postclassic Mayan culture would not have achieved its exceptional architectural creations, such as the Temple of the Warriors, the Court of the Thousand Columns, or the serpentine columns of the Ball Courts in Chichén Itzá. Toltec culture—its spirit and its forms—was without doubt powerful, but it was when it joined with other cultures that it was able to develop the ideas which the relatively short existence of its own culture in Tollán perhaps did not permit. Anything beyond this is only conjecture. The Aztecs did not enjoy a longer period of power, and yet reached the highest level in their art. But they took advantage of whatever cultural tradition they could—this was a part of their genius.

Even before the question To what culture does Xochicalco belong? other questions come to mind: Is it Toltec? Is it Aztec? Is it Mayan? Halfway between the south and the center of Mexico, Xochicalco, in the state of Morelos, was another great religious and ceremonial "city." The site is best known for the foundation or section of a pyramid which was discovered long ago, but this is only a small part of the whole if one takes into account the full development of the architectural complex. The relief on the sloping wall is one of the most beautiful of its kind in existence (fig. 30). The plumed serpent moves its body in rectangular undulations, as in a Greek key design; in the spaces left free by the undulations appear figures seated with their legs crossed, wearing great headdresses which are actually heads of plumed serpents. They seem to be priests, and bear the unmistakable stamp of Mayan reliefs. The execution is such as to articulate clearly the parts within the general composition so that each plume is distinct. The effect is striking, because in the sunlight the forms of the relief produce a series of lights and shadows that give great animation to the rich ornament. The heads of the plumed serpents themselves exhibit noteworthy expression, with their mouths open to show their forked tongues. This is one of the most attractive and singular archaeological complexes, uniting the fin-

ish and vivacity of Mayan Art and the severity and force of
Toltec art.

Zapotec and Mixtec Art. The Zapotec and Mixtec cultures
have come into particular prominence, especially because of
the work undertaken some time ago at the great architectural
complex of Monte Albán in Oaxaca, and because of the notable
discovery of a great number of objects in Tomb 7, including
some in gold, of Mixtec origin. The ruins of Mitla, on the
other hand, had long been known.

At Monte Albán, archaeologists have been able to establish
five distinct periods: the first reaching back to before the
Christian Era; the second extending from the first century to
the fourth century; the third, which is the Golden Age, span-
ning the period between the sixth and tenth centuries and in-
corporating Teotihuacán and Mayan influences; the fourth,
reaching to the twelfth century, is marked by decadence and
is perhaps the period in which the Zapotecs abandoned Monte
Albán to take refuge in Mitla and Zaachila; the fifth epoch,
which seems to have been predominantly Mixtec, was the
period in which Mitla flourished, at the beginning of the thir-
teenth century, and was terminated by the Spanish Conquest
in the early decades of the sixteenth century.

Monte Albán was a religious center with a great architec-
tural complex built upon the flat top of a mountain overlooking
the entire valley of Oaxaca, and served also as a vast necropolis.
Naturally, the tombs and funerary urns are among the most
interesting objects. Zapotec urns are unmistakable because of
their vigorous character and their ornamental richness. For the
most part, they are made of polychromed pottery. The bat,
which appears in various works of art, symbolizes an important
deity in their world. From the golden age comes a Zapotec urn
with a human figure represented as seated in front (fig. 31). He
wears an enormous headdress of the head of a vampire jaguar,
which in its turn wears a headdress of plumes, foliage, and
butterfly wings. The effect is striking in the fierceness that
radiates from the composition. In its way it is another instance
of a human figure protruding from the mouth of an animal.
Another such urn, equally complicated and aggressive, is im-

bedded in the paneling at the entrance of Tomb 104 (fig. 32).
This is framed by rigid rectangular forms like Greek key de-
signs, at different levels on the wall. The whole façade of the
tomb is severe; to close the entrance, there is a stele covered
with glyphs.

Earlier than the complicated forms of the Zapotec urns from
the golden age is an especially fine one that is monumental in
character, even though it also is of ceramic (fig. 33). For its
magnificent simplicity, its dynamic lines, and the human face
depicted between the jaws of a vampire jaguar, it deserves con-
sideration as a splendid work of art. The rather "naturalistic"
face makes a strong contrast with the bold, abstract expression
of the animal head, carved out in very simple planes, as is also
the enormous semi-circular collar which surrounds the lower
part of the face. About this urn there is something Mayan
which is difficult to define; possibly, it is in the features of the
face. But this should not be considered surprising, because dur-
ing the second epoch there were large-scale migrations and
strong influences from Central America. In any event, this is a
truly solemn funerary urn of authentic beauty.

This spirit of simplification and "naturalism" lasted into the
golden age, for it is to be found in a marvelous work of Zapotec
art—the seated figure that comes from Cuilapan, Oaxaca (fig.
34). It is of ceramic and, although relatively small, recalls in its
attitude and quality the famous seated Egyptian scribe in the
Louvre. The naturalness of the form does not consist in any
vulgar naturalism, but in the softness and pliableness of the
execution. The legs supply cross; the arms lead naturally to the
hands, which rest easily on the legs; the profiles of the body are
delicate and elegant; the head, with its simple cap, is youthful;
and the face expresses astonishment, the mouth recalling the
rhythm of the Jaguar type. Further, the color of the clay, its
glossiness, and the fine glyphs marking the chest and cap, com-
plete the feeling of attraction, the true emotion that one feels
before this small but great work of sculpture.

Another great masterpiece of Zapotec culture is the jade mask
of a bat belonging to the second epoch of Monte Albán (fig.
35). It is composed of fifteen pieces which fit together to create
this suggestive image. One could not ask for greater simplicity

or finer invention. It seems a demon from hell, with its eyes and teeth of white shell standing out against the green, polished jade. This work and the funerary urn we have looked at from the same epoch are enough to suggest the magnificence of Zapotec art at this time.

From the treasure taken from Tomb 7 at Monte Albán, we might select two pieces of Mixtec gold work that are unrivaled in quality: the head of Xipe, Our Lord the Flayed, whose skin symbolizes spring and who wears an exceedingly fine filigree headdress; and the great hollow cast pectoral, also of filigree gold, representing a deity, possibly Mictlantecutli (fig. 36). The latter work is superb not only because of its precious material but because of the emotional expression that the artist has achieved. The headdress is very rich and ingeniously composed, and the rectangular collar inscribed with dates and the symbol of Ehécatl serves wonderfully to set off the striking face with its skinless jaws and its tense half-opened mouth displaying two rows of sharp teeth. Here the angularity of the forms achieves an overwhelming and unequalled expression of tension, grief, and terror which, combining strangely with the luxuriousness of the adornment, makes this piece a work of art of the highest order and of singular tragic beauty.

It is to the last of the Zapotec epoch, the fifth, that the buildings of Mitla belong, The Place of the Dead, justly famous for its walls, which are almost totally covered with bands of ornament suggesting the Greek key pattern. Even from the outside, the proportion of the structures—palaces, temples, cloisters, or whatever they were—which emphasizes horizontality, manifests a sense of poise (fig. 37). The possible affect of heaviness in the buildings is relieved by superimposed panels filled with key patterns that provide richness and a certain unsettling dynamism.

The interior rooms are no less richly adorned than the exterior with bands of key patterns, and are rich in effect (fig. 38). One must admire the technique with which these designs are executed, for this is not mosaic but small cut stones shaped with great precision. The inner part of the stone is imbedded in the wall, and the individual shapes are combined to form the dynamic "Greek" patterns. Today these rooms are open to the

sky, having lost their roofs through time; perhaps these were of wooden beams. These dark rooms—they have openings only for communication—with their rich ornaments illuminated by fire, must have created an effect as rich as that of Oriental art. But the contrast is magnificent when one leaves one of these rooms to enter a patio, small but well proportioned, and contemplates the intense blue of the sky. What an extraordinary architectural concept! Its great merit resides not in the technique of symbolic decoration on the walls but in the combination of this effect with the contrast between the interior and the exterior. In Mitla, the monumentality is not what impresses so much as the artistic sagacity in handling proportion to create the composure and the intimacy of the interior spaces, the rooms, and the patios. If ancient indigenous architecture at some point reached a maximum of refinement, it was certainly in these buildings, with their expression of intellectual beauty; precise but luxurious though not sensual, they are, on the contrary, severe and exacting, suggesting the life of a religious order, of a cloister.

We should not be surprised by the variety of expression to be found in so much of the excellent Zapotec and Mixtec work. For one thing, the cultural development was very long, extending over some sixteen centuries at least; then too, the culture of this area was blended with others from the south, the center, and all directions.

Aztec Art. Although we have already considered many varieties of indigenous art, we still have before us as a kind of climax, Aztec or Mexican art—above all, its sculpture, which, to my way of thinking, has no parallel in quality in the entire ancient indigenous world of America. In fact, it is one of the great expressions of its kind in the universal panorama of the history of art.

The Aztecs, correctly called Mexica, belonging to the extensive Náhuatl family, migrated to the area that was later to be called the Valley of Mexico and settled on an island in Lake Texcoco. There they founded the city of Tenochtitlan at the beginning of the fourteenth century. Their rapid development and the extent of their conquests and alliances are astonishing,

extending their domain, called an empire, from the Gulf to the Pacific coast, and from the central plateau to the Isthmus. Their influence went even beyond, as far as Yucatán. It should be borne in mind that it was general practice among the indigenous cultures to absorb what was suitable to them from earlier cultures, especially from those they subjugated, and this practice was carried to the extreme by the Aztecs. With great intelligence, they incorporated into their own culture not only knowledge, such as the calendar, but even the gods themselves, who became a part of their pantheon. Thus in many ways the Aztecs represented almost a compendium of the cultural traditions that preceded their own development and marked the summit of the ancient indigenous world. All this was possible because of their inventive genius, their political, military, and creative talent, and their sense of religion. In effect, their God of War, Huitzilopochtli, was the motivating force that gave impulse to their basic activity: offering captives as sacrifices in order to maintain the gods, that is, to maintain the order of the universe as they thought of it. It is ridiculous to judge other people, ancient or modern, exclusively by our own principles instead of trying to understand their ideas, their ideals, and their beliefs. In Aztec culture, which was wholly pervaded by religion, the practice of human sacrifice is certainly repellent. But one must not forget that they were not the only people in the history of the world to indulge in this practice, and, above all, that their vision of the world and of life had a superior spiritual, religious aspect as well as a practical and material one; these various aspects together comprised the culture. From the standpoint of our interest, which is their art, we must realize that it was their concept of being that gave the particular and extraordinary character to their works, and these we must approach objectively.

Certainly not to be overlooked is their plan of Tenochtitlan, with its great ceremonial center, its plazas, the four principal avenues coordinated with the cardinal points of the compass: one, toward the north, linked the island with Tlatelolco and Tepeyac; another, toward the south, extended to Coyoacán and Ixtapalapa; another, toward the west, communicated with Tacuba; finally, toward the east, one reached only to the edge

of the island to lose itself in the waters of Lake Texcoco, where there was a wharf. A number of secondary avenues subdivided the area; others, combined with an organized system of canals, facilitated transportation by foot or canoe and bounded the plots with their houses and orchards. It is not surprising that such a well-organized city, with pyramids, temples, patios or atriums with clean, polished floors, palaces, and the houses of leading citizens, provoked the Spaniards' admiration. Actually, this plan, conceived in accordance with religious ideas, in its orientation to the four winds, was also practical and agreed with the ideas of city planning current during the Renaissance in Europe. For this reason, when the Spaniards built the capital of New Spain on the ruins of Tenochtitlan, they took advantage of the basic structure of the Aztec plan. Tenochtitlan is the best example of a true city, with all its utilities, its districts, and its great center for religious ceremonies.

But if it were not for the few remains that have come down to our time and some written testimonies, we should know little of just what the Mexican capital was like. Of course, from other pyramids, such as those of Tenayuca near Mexico City, we might form some idea, but none of the architecture of Tenochtitlan remained standing. So we must turn our attention to other works if we wish to look at something concrete. And the first and most important material is the sculpture.

We might begin with some pieces which are relatively minor in size in comparison with the great monoliths but which are no less expressive and moving. For example, let us look at a sculpture representing Coatlicue, Goddess of the Earth, although the figure has also been interpreted as that of a woman who died in childbirth, which would make it an image of Cihuateteo (fig. 39). The work is in basaltic stone, about thirty inches high. She is seated with her legs folded under and wears a skirt adorned with feathers and snail shells. Over her *huipil*, suspended on her breast like a collar, are a skull and a pair of hands. Her face, which bears an amiable expression in spite of the skinless mouth, juts out between the elaborate ear ornaments. A kind of mantle extends from head to foot, and she wears a crown of skulls as a headdress. With her arms close to her sides, she raises her hands to show her palms. The propor-

tion of the body and the head, the expression of the face with the eyes wide open (or, expressed in another way, with the cranial orbits completely filled), the crown and the mantle hanging from it—all give a positive enchantment to this sculpture. Once accustomed to the skulls and to the face itself—which is both alive and dead, a skull and yet it has flesh—the attraction grows to the point of kindling a tender feeling; she seems to be a pretty child, chubby and ingenuous, attired as if for a wedding, filled with contentment. The simplicity of the artistic means and the sensuous roundness of the forms contrast with the macabre headdress, which is the coronation of life. Women who died in childbirth had their abode in the Western Paradise and came to earth on certain nights to haunt the living; they were an evil omen for women and children.

One of the most impressive sculptures is the small, slightly less than four feet high, Coatlicue, which comes from Cozcatlán in the state of Puebla, (fig. 40). It is the figure of a standing woman with her arms raised showing the palms of her hands. She has paws instead of feet, and part of her body is covered by a skirt of interlaced serpents. Between her pendant breasts she wears a stone inlaid with precious material. Her head is almost a skull, and yet, even though her mouth is flayed and her eye sockets and nose are nothing but holes, she is covered with skin and her ears are adorned with circular pendants. Coatlicue is the Goddess of the Earth but has other complex meanings, such as life (the serpents) and death (the skull). Once again we encounter a sculpture that expresses a state halfway between life and death. The artistic expression is fearsome, and the strong emotion it provokes is sustained by the serene and mysterious attitude. The inlays of turquoise and white and red shell in the teeth, cheeks, and nostrils lend a special attractiveness in spite of the tragic face. To be sure, the sculpture must have once looked very different from what it does today, since the eye sockets were probably filled with an inlay of some precious material and the holes in the head were used to adorn the work with plumes. If art is an expression that moves one and reveals something profound, this sculpture is a work of the first order. It should be noted that the figure is created on a vertical axis crossed by a horizontal made up of

arms and hands, nearly to form a cross, symbolic of the four directions. This arrangement serves to intensify the expression since it allows each element to express its own force, and thus an order is formed which is solemn, tragic, and magnificent.

Of different character from the above pieces is the Stone of Tizoc, a circular commemorative monument, about eight feet in diameter, with reliefs depicting activities of war (fig. 41). A series of people are shown in dynamic postures depicted in such a way as to give them lively expression; their costumes with great plumed headdresses enrich the scenes which, repeated rhythmically, are inbued with movement and naturalness. The artistic stature of these reliefs and of others cut in this great monolith is great. Entirely free from mannerisms, they are executed with a clear and direct vigor without crudeness; the forms are rounded to give them a softness agreeable to the eye and inviting to the touch. A work of excellent composition and indisputable aesthetic value, it is one of the great achievements of Aztec sculpture. Another such is the Océlotl-Cuauhxicalli, a monumental sculpture in the form of a jaguar crouching over his paws (fig. 42). The huge bulk of the creature extends in a horizontal line, and in his back a depression is cut, the *cuauhxicalli* or receptacle in which possibly human hearts were placed as a part of the sacrificial ritual. He raises his head, with his eyes open, and shows his ferocious mouth with its great tusks. The lines of the mouth follow an interesting and free undulation, and the whole figure is softly modeled in such a way that, in spite of its proportions and ferocity, it remains attractive. The simplicity of the whole expression and the elegance of the lines create a positive and incomparable beauty; it has some of the charm we have already found in the Coatlicue or Cihuateteo.

There are two exceptional works which might be looked at together: the Head of a Dead Man and the Eagle Man. Both serve as proof that when indigenous artists wanted to come close to the natural model they were able to do so and to achieve works of first-rate quality. In art, one is not concerned with primitiveness or the technical impossibility of achieving forms that have been used in Western culture with great genius in various periods of history, but rather with the ability to achieve desired ends in the best possible way, whether it be abstract or

symbolic or direct imitation of a natural model. The Aztecs were able to employ any form that they wanted to within the limits of their own ideals, notions, and beliefs.

I am afraid that I may seem to have spoken of these works as if they were academic exercises whose creators wanted only to reproduce the models, but this is not true. The Head of a Dead Man is tragic poetry cut in stone (fig. 43). By poetry, I mean creation. The forms are simple, synthesized, softly modeled, and, without little naturalistic details, create a broad and profound expression. The closed eyelids are more suggested than seen, and yet the exact and moving expression emerges, accentuated by the half-opened mouth and the deep lines on either side of the nose which set the shape of the cheeks. The hair—or possibly it is a leather cap—is indicated only by a single shape in relief, and the ears are artistically presented in synthesized form. Thus a true and human expression of death is achieved through the power of art, a sculptural art of the highest category. The same might be said of the Head of the Eagle Man (fig. 44), whose unmistakable beauty makes the work seem almost the product of the post-conquest era. But the synthesized treatment of the forms and, above all, the down-turned lines of the mouth, the last expression of the traditional jaguar type, leave no doubt about its Aztec origin, possibly from the end of the fifteenth century. A lengthy tradition culminates in this head, thrusting itself from the open beak of an eagle. But probably here it is not meant as an abstract mythical symbol, but depicts a Warrior of the Sun, of the Eagle, of Huitzilopochtli. If there was an intention of naturalness in the face, the sculptor raises it to the level of art by softly but energetically imbedding the eyes and marking tension and character in the rigid form of the mouth to give it a definitive dramatic touch. The beauty of this sculpture does not come simply from the fact that the features of the face are refined and come closer to a European type, but from its artistic quality and originality of expression.

Aztec sculpture encompasses a wide variety of forms even though all are recognizable as a part of one culture, of one aesthetic ideal, as we would say today. One will not find in it the hard angularity of classical Teotihuacán art, the rigidity of some Toltec sculptures, or the complicated symbolic ornamenta-

tion of Zapotec urns. Nor, for that matter, does it show the exquisite naturalism of classic Mayan art. On the other hand, it is a vigorous, synthesized, and direct art, and, although it may be based on geometric structures, these are well disguised beneath full and generally soft forms. In its formal and symbolic function, it is a natural art, but it is not naturalistic.

Such a work as the marvelous Ayopechtli or Ixcuina, the Goddess of Childbirth, in the collection of Robert Wood Bliss (Washington, D.C.), has no rival in the perfection of its dramatic expression and its synthesized form. It is carved from grey jadite spotted with red and, in spite of its small size (not quite ten inches high), has all the character of a monumental sculpture, especially in the magnificent head with the expression of grief reflected in the tense mouth, half opened to show the teeth. It is of an extraordinary harmony and moving reality. Everything contributes to make it a little masterpiece.

Of delicate beauty, although not lacking in dramatic impact, is the seated stone figure symbolizing Xochipilli, the Young or Rising Sun, God of the Flowers (fig. 45). The base is richly carved with symbolic ornament, as are parts of his body and the headdress which hangs down his back. His legs are crossed, and his feet are splendidly carved. His arms are close to his body, but he raises his hands in an expression that finds echo in the upturned face. Originally, his eyes must have been covered with some kind of precious material which would emphasize the ecstatic attitude, but the empty eye sockets we see today and the grimace of the mouth contribute to the dramatic expression. This combination of delicacy and drama is typical of Aztec sculpture, seen in this Xochipilli in all its perfection, in a presentation at once vigorous and exquisite.

The first Aztec sculpture that, a century ago, was thought to have some quality of beauty is the colossal head symbolizing the moon, Coyolxauhqui (fig. 46), who, according to the myth describing the birth of Huitzilopochtli, was the daughter of Coatlicue and was beheaded by that Warrior and Sun God. This magnificent head is carved in hard stone, compact and polished. Perhaps it was conceived to hang by its ears, for it has a symbolic relief on the bottom which, like others on the cheeks and on the headdress, is finely executed. Hanging over

the mouth is a nose ornament carved in relief. There is nothing exaggerated or discordant; on the contrary, the smooth and vigorous modeling of the face with its sensual roundness, the half-opened eyes, and the delicate treatment of the ornamental symbolic reliefs create a full-bodied and moving sculpture without equal; and its monumental scale underscores its solemnity and majesty. It is of incontestable beauty, and it is not surprising that it has been considered so for a long time and has been highly praised also in our own day. Notwithstanding, many persons have insisted that Aztec sculpture was executed by Toltec artists, denying in their irrational enthusiasm any merit to the culture for which it was created. Possibly, Toltec sculptures did work for the Aztecs; certainly, the Aztecs showed particular genius in absolving and exploiting whatever was useful to them from earlier cultures and ancient traditions. But the truth remains that never before the Aztecs was indigenous sculpture raised to the high level they were able to attain in expressing their ideas and religious beliefs. We would call these beliefs myths, but to the Aztecs they constituted a way of life to be followed with devotion and absolute spirituality.

Throughout the world the best-known monolith from Mexico is the so-called Aztec Calendar or Stone of the Sun (fig. 47). It has been so often reproduced on objects and in places quite foreign and unsuitable, and often in the worst possible manner, that it has tended to lose much of its importance from the point of view of art and aesthetics. This is most unfortunate, for it is one of the great master works of ancient indigenous art and, most particularly, of Aztec art. Its monumentality is a matter not only of its colossal size (it is almost twelve feet in diameter) but of the organization and strength of the forms from which the splendid relief is composed. Organized in circular bands or concentric rings, it has at its center the image or symbol of the sun, Tonatiuh, with its tense half-opened mouth exposing the teeth and pendant tongue. Around the center, four rectangles arranged symmetrically contain symbols of the four earlier suns: wind, tiger, rain, and water, representing catastrophies that had destroyed humanity four times. According to Aztec beliefs, their own period was that of the Fifth Sun, which would be destroyed by an earthquake, the symbol for which appears

between the two lower rectangles. On either side of the disk with the representation of Tonatiuh are eagle heads in the shape of claws devouring hearts—an allusion to the necessity for human sacrifice in order to maintain the sun and the entire universe. Then there are the ring of days, with its twenty rectangles and corresponding glyphs, the ring of the stars, and that of the heavens. These rings are interrupted by beaks or triangular forms representing the constellations or, rather, solar rays; these give the composition a rather expansive and dynamic effect for they are placed radially and symmetrically in perfect order. The outermost band is formed of two fiery serpents which were thought to carry the sun in its course; their heads appear in the lower part, and from their jaws protrude the faces of certain deities. Between their tails in the top section appears the hieroglyph for "13 cane," the birth date of the solar god then active.

In general, this is a cosmic mythological concept perfectly expressed through a geometrical order, arranged radially and in rings in such a way that the idea of the activity and movement of the solar disk, in the sky and in time, is clearly and symbolically set forth. Naturally, this monolith must have contained many meanings beyond those we have noted in summary form. New studies now in progress promise to reveal a complicated and more precise astronomical significance. From our point of view, considering the Stone of the Sun as a work of art, we can admire the order and harmony of the symbolic elements, the knowingly balanced geometric structure, the force and elegance of the relief which here, as in other Aztec sculptures, unites vigorous carving with suavity of form. All the sharp edges have been nicely rounded, so that there are no sudden or rigid contrasts but, on the contrary, a refined softness which only great art can achieve. The first impression that one receives from this overwhelming relief is one of astonishment at its size. Next one realizes the order dominating its composition, its dynasism, its radially organized triangular forms. Finally, there are the grandeur and authentic beauty to be found in the distribution of the symbols, in the synthesized designs, and in the suavity and complexity of the relief, which seems to glow, to be in a state of restlessness. It is not by chance

that the work has been so often reproduced. Its popularity indicates that there is something suggestive about this work that is satisfying to whoever contemplates it. But no reproduction exists—or will exist—that can produce the great emotion that one feels when face to face with the original of this monumental achievement of Aztec art.

Until now we have considered a variety of Aztec works: the plan of Tenochtitlan; a few sculptures which, though small, are of first quality as works of art—the small Coatlicues, the head of the Dead Man and of the Eagle Man, Ayopechtli and Xochipilli; and a few monumental sculptures, such as the Océlotl-cuauhxicalli, the Stone of Tizoc, Coyolxauhqui, and the Stone of the Sun. Any one of these works could in itself represent the great culture and art of the Aztecs. As a group they astonish one by their vigor, their scale, the skill and imagination of their creators, by their originality and fundamental knowledge—in sum, by their evident artistic and aesthetic quality. Nonetheless, Aztec art went even further, giving form to complex ideas and religious beliefs in a colossal monolith. The ideas relate to the cosmic order, to humanity, a concept of the above and the beneath, the four cardinal directions, and the primary principle of the life and death of everything. All these they synthesized in a single name and in one great sculptural work: Coatlicue (fig. 48). Like the other great monoliths it is a work of the fifteenth century of the Christian era—in a relief hidden on the plane upon which the figure stands, there is a glyph with the date "One Rabbit." The originality of form has no rival or parellel in the works of the ancient indigenous world, with its variety of cultures, or outside Mexico in the classical cultures of the Orient or the West. It is a gem of world art.

Some obvious things have been said about the Coatlicue: that it wears a skirt of serpents, for example. Other assertions are more problematical: that instead of a head, it spouts two streams of blood; that there is in the concept the idea of a goddess of the earth, of life and death. All the interpretations tend to be fragmentary and limited, when they are not actually erroneous, and formulated, it seems to me, without sufficient basis. Although not all the symbols can be interpreted with the same certainty, enough can be drawn from them to form some-

thing of an idea of what their creators set out symbolically to express. Because I was not satisfied with what had been said about the work, some time ago I undertook an aesthetic investigation of this colossal sculpture, which had always attracted me by its mysterious and beautiful forms. I was irritated that it was disparaged as "horrible" or "monstrous" without understanding or without serious study. This often happens with works that are truly first-class. I shall only briefly sketch here the results of my investigation to stimulate once more an understanding of the work and suggest the aesthetic sensibility necessary for confronting it. But the interpretation is complicated, and I have written on it at length in another work. Here I shall mention only the principal points.

Two aspects of the work must be considered, although they are intimately and indivisibly united: the formal, and the symbolic. In the first place, the structure can be viewed in three different ways: seen from the front, it is composed of forms immediately associated with the idea of a human body; seen from the side, the forms clearly suggest the image of a triangle or perhaps half of a pyramid; finally, seen in its totality, either from the front or from the back, other forms create the general shape of a cross. Now then, the human aspect represents the relationship of the deity to man or, at least, in its symbolic vagueness, in some way suggests humanity. The pyramidal structure is created principally by a large appendage which hangs down the back, from the waist almost to the ground, composed of thirteen leather braids on two distinct levels. The Aztecs conceived of thirteen heavens, the highest being Omeyocan, where the dual masculine-feminine principle resided—Ometecuhtli and Ome-cacihuatl. Over the braids is the shield of Huitzilopochtli, divided into two sections, and the whole hangs from a skull at the level of the waist. Through these forms runs an inclined line from the ground to the upper part, where, at the highest point, two serpent heads appear; and from there the verticality indicates the central direction—the above and the below. The cross-shaped structure is closely related to the human form and to the snakes which join hands, then, with the human element, suggesting a relationship between humanity and the divinities Quetzalcóatl and Xólotl, which, in turn, are symbols of other

astral bodies, the morning star and the evening star. But the basic idea of this crosslike structure is a reference to the four cardinal directions.

The legs of Coatlicue are formed from eagle talons, symbolic of the Sun God, and are decorated with eagle plumes. They are covered by a short skirt hemmed with a row of bells, symbolic of the thunder which preceeds rain. In the lower part, at the back, is a tortoise, which alludes to childbirth. The simple interlaced serpents that form the skirt are man, humanity, clinging to or dependent on the mother—the earth; but the serpents of the belt whose heads hang down in front are divine, as are all the rest, for their bodies are covered with precious stones. In the middle of the stomach is a skull. Coatlicue is dressed in the skin of a flayed woman, a symbol of spring, and is adorned with a collar of hearts and hands, referring to the sacrifices necessary for the gods. Further, she is shown decapitated, to symbolize the moon. Coatlicue is a female goddess, and for this reason is shown with a skirt, the tortoise, and the skin with pendant breasts; but this divinity is also male, and for this reason a great serpent can be seen beneath the skirt, lodged between the legs. Finally, the dual principle which forms the head not only caps the work but permeates everything, whether exterior, to the front, or to the back. Thus the sculpture Coatlicue becomes much more than just the Goddess of Earth or the Goddess of the Serpent Skirt. In effect it symbolizes the earth, but also the sun, moon, spring, rain, light, life, death, the necessity of human sacrifice, humanity, the gods, the heavens, and the supreme creator: the dual principle. Further, it represents the stars, Venus; and beneath the claws there is a relief that symbolizes Mictlantecutli, the Lord of the Night and the World of the Dead. His is the realm to which the sun retires to die in the evening and wage its battle with the stars to rise again the following day. Coatlicue, then, is a complete view of the cosmos carved in stone. Many different gods participate, but all are rendered mythically to enter thus into one ordering religion. It is the most elevated concept of the universe that the ancient indigenous world was able to achieve, and carried with it the singular belief that in order to maintain the cosmic order it was necessary to offer to the gods the precious liquid chalchihuitl (blood), the hearts of victims, principally prisoners of war.

There is then, on the first level, a cosmic concept; on the second level, this concept is converted into a series of myths with their respective deities; the third plane is that of art, which gives all the preceding a symbolic form within a harmonious order; finally, the fourth level is the aesthetic—the artistic and symbolic order is beautiful, possibly strangely so, but sensibly. The strangeness arises from the admiration itself, since one recognizes an order in the forms and yet does not understand at first glance what they mean, except for the most obvious symbols. The whole cosmic concept of the Aztecs is based on the struggle between opposites, on war as necessary for the offering of victims to maintain the gods—that is to say, they maintained order and activity by means of the blood of their captives. From this fundamental religious principle was derived the entire ordering of the Aztecs' social and individual existence, the severity of their forms of life and of their art. Then one might conclude that existence, both human and cosmic, was considered in a theological sense, and for Coatlicue to become an expression of all this, her beauty must impress and move one, become a tragic beauty. To me this is the most genuine and profound of all the beauties created or imagined by man, because it makes one conscious of the mystery of life and of death.

In Coatlicue, Aztec art expressed itself with profound knowledge, for it succeeded in giving form to a complicated concept by means of structures which were logical, geometrical, functional, and symbolic. Equally significant was the excellent carving of full and vigorous forms without mannerism, crudeness, archaism, or petty ingenuity, but strong yet soft, striking and grand. Look closely at the skulls on the belts, both in front and in back; their filled eye sockets give the precise expression of life and of death—they are at once fierce and of extraordinary tenderness. All this is typical of Aztec art, and can be found as well in their religious songs, their poetry, and their literature. On one side, there are terrible shouts and gestures of death and desolation; on the other, there is immense tenderness. Two examples are sufficient to demonstrate these qualities.

> Let the captured men be struck down;
> let the entire nation perish!

This is a fragment of a song to Cihuacóatl, the Serpent Woman,

also called Coatlicue, the Woman of the Serpent Skirt.

> There where lies the house of the tortoise chair,
> she descends, brings the pearl to light,
> the most brilliant plume [the child].
> Come here, you, come here!
> Come here now, newborn child, come here you!

This is a fragment of a song to Ayopechtli, the Goddess of Childbirth.

Coatlicue is the masterpiece *par excellence*, the sculptural masterpiece of the ancient indigenous world.

Aside from the monoliths we have considered, there are other works, minor in size but not in artistic expression, such as the superb rock crystal skull in the British Museum which is an impressive piece of sculpture both for its perfection and because of the material in which it is carved. It is certainly of a refined beauty. This is true also of the skull and other objects covered with mosaics in the same institution. Another example of this technique of applying mosaic to stone is the mask from the state of Guerrero that probably belongs to the Nahua culture (fig. 49). The materials are turquoise and coral, and the eyes are inlaid with iridescent shells and obsidian. The simplicity of the features and the serenity of expression appeal to our aesthetic feelings, and the wide-open eyes with black pupils add a quality which is at once vital and mysterious. It is a work of great force and delicacy.

Another art which must not be overlooked is that of feather work, in which the ancient indigenous peoples were very expert. However, since the material was perishable, objects made by this technique before the Conquest have almost entirely disappeared except for a few precious pieces. We must judge what they were like on the basis of some later examples, such as the magnificent miter in the Escorial or the plumed headdress of Montezuma II, of which the original is in Vienna and a faithful copy is in the National Museum of Anthropology in Mexico City.

Aztec pottery is delicate and original in form, and some pieces are decorated with symbols and polychromed in a manner that reaches a high level of artistic quality. They are, how-

ever, not superior to the ancient Mayan vases. Finally, there are the Aztecs codices, only four of which have survived from pre-Spanish times. Of these, the Bourbon Codex, which belongs to the Bibliothèque de la Chambre des Députés in Paris, is the most important for its artistic quality, although it does not achieve the level of the Mixtec codices or those of the Borgia group. Its hieroglyphic paintings are executed with firmness and vivacity, although with little delicacy and the color is limited in tone. Nonetheless, some of its pages, made from maguey paper, are splendid in the richness of their drawings.

SUMMARY

Looking back over our discussion of ancient indigenous art, based, as it was, on a very limited selection of works, we see that this art consists of a rich variety of forms closely related as symbolic expressions to the religious myths, life, ideas, and beliefs of the people.

In Western art, we admire the mastery with which the artists modeled their figures to present a lively picture of contemporary life and customs. The same might be said of the archaic art of the central plateau, which shows a naturalness and force, even in small sculptures like those of Tlatilco which reveal a particular ideal of beauty, seen especially in the form given to the lower limbs of the female figures. As for the art of eastern Mexico, we have noted that, in the first place, the scale changes, for from that region come highly refined great stone sculptures of the Huastecs and the monolithic colossal heads of the Olmecs. The formidable art of the Olmecs also introduced a particular form of mouth, called the jaguar type, that persisted even in some Aztec works of the fifteenth century.

In classic Mayan art, we admired the richness, elegance, naturalness, and refinement. This art also expressed a specific ideal beauty for the human face, including an artificially emphasized straight nose and broad, high forehead. The Maya were outstandingly original in their architecture, sculpture, painting, and pottery, as well as in the art of personal adornment, which we can admire in the reliefs and mural paintings. Postclassic Mayan art created great architectural complexes,

and, although it lost some of the refinement of classic Mayan, it gained in exchange a new dramatic vigor.

The classical art of Teotihuacán—the great architectural plan of the Pyramids of the Sun and the Moon, the ciudadela, and the geometric, angular sculptures—revealed a severity and grandeur and an extraordinary rationality. On the other hand, the most ancient art of Teotihuacán was rich and luxurious, and tended toward intuitive expression.

The Toltec art of Tula showed two types of expression: the hard and dry, although colossal and functional character of the atlantes; and the suave and knowing quality of the Chac Mool and the serpentine columns. Then too, their structural innovations were notable.

Also great builders were the Zapotecs and the Mixtecs. The art of both of these peoples was manifest not only in architecture, which they created with great understanding, but also in pottery, in the painting of codices, in gold work, and in sculpture. These are arts of undeniable force in their simplicity as well as in their symbolic and ornamental richness.

Finally, Aztec art has no rival in the field of sculpture. It brought together all the possibilities of ideal geometric forms as well as the subtle refinements of more ancient traditions, yet gave everything a new direction and vigor, going beyond the simply dramatic to achieve a characteristic tragic beauty.

Actually, the expressive forms of one culture's art cannot be confused with another, because each has its own distinctive characteristics even though one culture influenced another, although, because of this latter fact, some hybrid works are indeed, difficult to identify. Each had its originality and expansive force, but four cultures dominated in their influence at one time or another: the Olmec, the Mayan, the Toltec, and the Náhuatl. This last was the great summarizing culture because of its chronological position and the great creative achievement reached by the force of its own genius.

Anyone approaching ancient indigenous art who fails to discover its beauties can be sure that he will find no aesthetic pleasure in twentieth-century art either—or in any other, for that matter.

Selected Bibliography

In English

Bliss, Robert Woods. *Pre-Colombian Art*. New York: Phaidon Publishers (distributed by Garden City Books), 1957.

Caso, Alfonso. *The Aztecs: People of the Sun*. Illustrations by M. Covarrubias. The Civilization of the American Indian, no. 50. Norman, Okla.: University of Oklahoma Press, n.d.

Coe, Michael D. *The Maya*. Ancient Peoples and Places. General Editor, Glyn Daniel. Mexico City: Ediciones Lara, 1967.

————. *Mexico*. Ancient Peoples and Places. General Editor, Glyn Daniel. Mexico City: Ediciones Lara, 1967.

Covarrubias, Miguel. *Indian Art of Mexico and Central America*. New York: Alfred A. Knopf, 1957.

Gillmor, Frances. *Flute of the Smoking Mirror*. Albuquerque, N.M.: University of New Mexico Press, 1949.

Keleman, Pál. *Medieval American Art: Masterpieces of the New World before Columbus*. New York: Macmillan Co., 1956.

Kubler, George. *The Art and Architecture of Ancient America: The Mexican, Maya, and Andean Peoples*. Baltimore: Penguin Books, 1962.

León-Portilla, Miguel. *Aztec Thought and Culture: A Study of the Ancient Nahuatl Mind*. Translated from the Spanish by Jack Emory Davis. The Civilization of the American Indian, no. 67. Norman, Okla.: University of Oklahoma Press, 1963.

Robertson, Donald. *Mexican Manuscript Painting of the Early Colonial Period: The Metropolitan Schools*. New Haven, Conn.: Yale University Press, 1959.

————. *Pre-Columbian Architecture*. New York: George Braziller, 1963.

Soustelle, Jacques. *Arts of Ancient Mexico*. London: Thames and Hudson, 1967.

Spinden, Herbert Joseph. *Maya Art and Civilization*. Indian Hills, Colo.: Falcon's Wing Press, 1957.

Thompson, John Eric. *The Rise and Fall of Maya Civilization*.

2d ed., enlarged. Civilization of the American Indian, no. 39. Norman, Okla.: University of Oklahoma Press, 1966.

Westheim, Paul. *The Sculpture of Ancient Mexico.* Garden City, N.Y.: Doubleday, 1963.

In Spanish

Arai, Alberto T. *La arquitectura de Bonampak.* Mexico City: Instituto Nacional de Antropología e Historia, 1960.

Bernal, Ignacio. *Museo Nacional de Antropología de México. Arqueología.* Mexico City: M. Aguilar Editor, S.A., 1967. (Librofilm Aguilar.)

Corona Núñez, José. *Mitología Tarasca.* Mexico City: Fondo de Cultura Económica, 1957.

Fernández, Justino. *Coatlicue: Estética del Arte Indígena Antiguo.* 2d ed. Mexico City: Instituto de Investigaciones Estéticas, Universidad Autónima de Mexico, 1959

Flores Guerrero, Raúl. *Epoca Prehispánica. Historia General del Arte Mexicano.* Mexico City: Editorial Hermes, S.A., 1962.

Fuente, Beatriz de la. *La Escultura de Palenque.* Mexico City: Instituto de Investigaciones Estéticas, U.N.A.M., 1965.

Krickeberg, Walter. *Las Antiguas Culturas Mexicanas.* Mexico City and Buenos Aires: Fondo de Cultura Económica, 1961.

Marquina, Ignacio. *Arquitectura Prehispánica.* Mexico City: Instituto Nacional de Antropología e Historia, 1951.

Molina, Marta Foncerrada de. *La Escultura Arquitectónica de Uxmal.* Mexico City: Instituto de Investigaciones Estéticas, U.N.A.M., 1965.

Piña Chan, Román. *Una Visión del México Prehispánico.* Mexico City: Instituto de Investigaciones Históricas, U.N.A.M., 1967.

Ruz Lhuiller, Alberto. *La Civilización de los Antiguos Mayas.* Mexico City: Instituto Nacional de Antropología e Historia, 1963.

Séjourné, Laurette. *Palenque, una cuidad maya.* Mexico City: Fondo de Cultura Económica, 1952.

―――. *Arquitectura y pintura en Teotihuacán.* Levantamientos y perspectivas por Graciela Salvicrup. Mexico City: Siglo Veintiuno, Editores, 1966.

————. *El lenguaje de las formas en Teotihuacán.* Mexico City, 1966.

Soustelle, Jacques. *Pensamiento cosmológico de los antiguos Mexicanos.* Puebla, Mexico, 1959.

2

THE ART OF NEW SPAIN

With the coming of Western culture to the continent that would be subsequently called America, and especially with the Spanish Conquest of Mexico in the sixteenth century—the conquest of the country that would be christened New Spain—European art flourished. The conquistadors and the members of the various religious orders were well imbued with the new ideas and cultural forms of the Renaissance. But naturally enough, they brought as well the remnants of their medieval traditions and whatever else made up Western culture at the time of the military and spiritual conquest—and, eventually, the colonization —of New Spain. During the three centuries of the viceregal period, the artistic forms of the various epochs underwent a splendid development, their variety and richness encouraging great originality and exuberance. To deny the impressive quality of the art of New Spain would be an error explainable only by ignorance or bad faith. Even though the indigenous cultures left superb monuments and fine works of art from their expansive development, of no less value is the inheritance which Mexico received from that other superb component of its history— its viceregal past.

The principal and most significant art of the period is religious, doubtless owing to the great part the Catholic Church played in its encouragement. One must admire the gigantic and evangelical enterprise that was developed from the earliest times with extraordinary success by the missionary monks— Franciscan, Augustinian, and Dominican, who later turned over the difficult administration of their vast dominions to the secular clergy. Every epoch left its mark, its works, which belong as much to the Spanish as to the Indians who built them with their own hands, to the mestizos and the Creoles who erected the churches, parochial chapels, and cathedrals, and to the modern Mexicans who have inherited this rich treasure which must be preserved.

Whether the panorama is regarded in chronological sequence or not, there were three great forms of art to be distinguished in the three centuries that New Spain existed: the Medieval—

Renaissance; the Baroque, which dominated and lorded over the rest; and, finally, the Neoclassical, which marked the last category of the Viceregal Period and at the same time the first of Independent Mexico. But purely Medieval art does not exist, nor, for that matter, except for some few exceptions, does Renaissance; nor is Baroque art the same throughout the period; and the Neoclassical is not so classical as it might be, for it would not entirely turn its back on the Baroque. Then too, there are echoes that go farther back than the Medieval: for example, there are elements of Romanesque art, and Eastern echoes and Moorish forms appear. In the earliest times, local forms and techniques remain perceptible, even though little by little they become merged with the others. Throughout the art of New Spain, different ways of handling forms provided continuous originality, and popular expressions too were characterized by vigor, suavity, and inventiveness. All these various elements make up the art of New Spain, which in its curious amalgam, exuberance, richness, and originality, constitutes one of the most interesting chapters of world art in the modern period.

Just as I have done in Ancient Indigenous Art, I shall concentrate objectively on the works themselves, or, rather, on a selection of works that, I hope, will be sufficient to justify this characterization of the period. Certainly, it would be impossible to consider a fragment of the history of art in isolation, apart from a general knowledge that would provide appropriate comparative works. Those who know the general trends of European art will here be able to discover what is distinctive; those who know little of art will find here a whole new artistic and aesthetic world.

MEDIEVAL-RENAISSANCE ART

The first works to make a deep impression on the person who approaches the art of New Spain in chronological order are the monasteries, or convents, as they are usually called in Mexico, of religious orders. The first monks who came to America, arriving in 1524, were Franciscans; the Dominicans followed

in 1526; the last were the Augustinians, who arrived in 1533. The Jesuits made their appearance in 1572. The country was divided into provinces for the religious orders and into dioceses for the secular clergy. It is not possible to treat here the expansion of the Catholic Church, but the rapidity with which it spread, in spite of difficulties, is notable. Monasteries were created; sometimes these were only modest cloisters without a church but with those chapels which are called "open chapels" by which religious services were brought directly to the public gathered out of doors. One can imagine the contrast that the ritual of the new religion must have made to the Indian when he compared it with his own. Now the sacrifice of the Mass was offered in front of everyone; in the pagan rite, access to the temple itself was limited to the priests, and in the most important rites the people participated only at a distance. Very soon huge monasteries were constructed with monumental churches fronted by great courtyards with chapels at the corners. These latter were called *posas* because in them the Host "reposed" during processions. Sometimes the original open chapel was preserved if it did not become the apse of the church itself. Orchards and sometimes aqueducts and other services completed the compound. There is always a difference in size between the convent proper and the church, even in those instances in which the convents are two stories high and monumental. For the church—the house of God—had to tower above and dominate the complex—the house of men. Generally, a monastery comprised an entry portal which led into a low cloister housing the kitchens, refectory, dispensary, the "de profundis," and other dependencies. By a stairway, which was almost always monumental in scale, one reached the upper floor where the cells were distributed along the hallways enclosing the cloister; there were corridors on the outside toward the patio and also other corridors parallel to them on the inside which gave access to the cells.

Each of the religious orders had its distinctive emblem. The Franciscans' is composed of five bleeding wounds or two arms in a pinwheel form with hands displaying wounds and in the center a cross. The emblem of the Dominicans is a foliated

cross with sections alternating the colors of the order, black and white. The Augustinians' symbol is a heart, above which is placed a bishop's hat.

Construction of the monasteries differed in accordance with the rules of the order. The Franciscan cloisters were generally roofed with beams and a flat ceiling, and the scale and decorations were modest. The Dominicans built austere constructions, since their area extended far south into a warm climate, and the fear of earthquakes obliged them to take certain precautions. The most sumptuous convents were those of the Augustinians, who liked monumental size in everything—in their great fresco decorations as well as in other architectural and ornamental matters.

As for the open chapels and the *posas*, there were so many different types that they cannot all be treated here. In their actual form, they were creations original to America, but their function coincided with similar necessities in other countries and epochs.

With these general characteristics in mind—and we have not mentioned the crosses in the atriums, the rich façades of the churches, the porticoes, the cloisters with pointed arches and continuous barrel vaults or beaming, the cross vaults of the churches, and an endless number of architectural and decorative elements, now Romanesque, now Gothic, now Renaissance —let us turn our attention to a few fine monuments which will serve as objective examples. One thing remains to be said, however, and that is that the sixteenth-century monasteries of New Spain, in their amalgamation of forms and the extraordinary solutions realized in their structures, were the most original monuments in the architectural panorama of Viceregal America and were different from similar works built contemporaneously in Europe.

Franciscan Monasteries. One could make a list of Franciscan monasteries that would be overwhelming in number and in the quality of building and ornamentation. Some, such as in Mexico City, are now hardly recognizable at first glance, but in the smaller towns and cities where barbarousness and urban convenience have not completely disfigured or destroyed them,

their grandeur is still impressive. Only a few of these would be enough to demonstrate the extent of Franciscan activity in the sixteenth century: Xochimilco, Cuernavaca, Tlalmanalco, Tlaxcala, Calpan, Huejotzingo, Tepeaca, Tecali (for some of which only the church remains), and others in the center and in the north and east of the country or those of Yucatán, such as the immense complex of Izamal.

Let us consider one of these in particular: that of Huejotzingo in the state of Puebla. Even from the arches at the entrance to the forecourt, one gains an impression of majesty; on entering the great expanse of the courtyard, one's attention is caught by the posas in the corners, and one feels himself to be in an environment suitable for contemplation, confronted with a work of genuine architectural art. These chapels, with open arches on the sides, are composed of a cubical mass roofed with a vault that forms a high pyramid, topped at its summit with a cross (fig. 50). The silhouette this creates is novel and interesting, and the effect is complemented by the semicircular arches rising from clusters of colonnettes with Gothic bases and capitals, although these are reminiscent also of Romanesque. The archivolt is decorated with a chain design. Of particular interest are the fronts of the chapels, ornamented with the Franciscan cord arranged in a form known as an "Alfiz," with angels of an extraordinarily strong Romanesque-Gothic character carved in relief. In the center is a shield with the monogram of Mary over which is a crown that intrudes into the upper zone, decorated with four reliefs of Franciscan insignias showing the five bleeding wounds and three nails. There are even the remains of floral pinnacles or crests that decorated the upper part of the façades, behind which rose the pyramidal vault. These posa chapels of Huejotzingo, together with similar ones in Calpan, are the most beautiful in existence in their originality of form and harmony of composition. In the center of the courtyard is a cross, delicately carved in stone to imitate rough wood, with the crown of thorns at its base.

The effect of the exterior of the monastery, with its towering church dedicated to Saint Michael Archangel, is splendid. The walls of the temple, punctuated by buttresses, are adorned with what might be called open triangular crenelations that recall

the East in their Moorish design. The principal portal is a sober and interesting composition encompassing the doorway and the choir window (fig. 51). The frame around the door is extremely interesting; it is made up of two half-round pilasters whose shafts rise above the capitals to join the undulation of the lintel, a movement repeated at the outer face of the door frame to create a distinctive effect. Tall pilasters bound the portal on either side, and between these runs a heavy molding to complete the lower composition. Between the top of the door and this upper molding, six medallions with monograms are arranged symmetrically, and above them a kind of panel is formed by Franciscan cords. Immediately over the large pilasters, rising like torches, are two Franciscan shields edged with the Franciscan cord, adding to the richness of the upper part of the façade which contains the arched choir window enclosed in a rectangle formed by cords. The originality of this doorway is striking, with its freely treated Renaissance elements combined gracefully and elegantly with others of Romanesque and Gothic character to produce a result that has an indefinably "medieval" quality.

The real gem in the exterior of this church is the Door of Porciúncula in which the fantasy knows no bounds (fig. 52). The round arch supports a rich floral decoration that joins with the pilasters on either side of the door; these are composed of curious elements, and their shafts are interrupted by escutcheons. Their flowering capitals terminate in a kind of pineapple form. A molding with flower forms begins at the impost of the arch, and creates a frame that encloses two Franciscan shields as well as the ornamentation elaborating the arch of the doorway. Like the reliefs on the posa chapels and the principal façade, these around the Door of Porciúncula are carved in a robust manner with marked character.

It is not necessary to call attention to the entrance portico of the monastery; its two round arches express such strength that they attract as soon as one looks at the whole exterior complex (fig. 53). The pilasters on the sides are of Romanesque origin, but the central column seems to have been inspired by elements from some Hindu temple. The principal novelty is, however, in the archivolts, which are differently ornamented:

the left one is decorated with a chain design (recalling the form used by the Indians to symbolize water in their hieroglyphs); in the right one, each individual voussoir is emphasized with an abstract geometric flower.

When one finally enters the convent and allows one's gaze to wander among the arches that surround the cloister with its orange trees in the corners and its central fountain, the peaceful environment provokes a mystical feeling in anyone at all sensible to beauty. It is not the grandeur but the sense of seclusion that affects one. Finally, one's attention turns to the black and white fresco paintings which decorate the walls (fig. 54), especially to the panel with the image of the Immaculate Virgin with her symbols, flanked by representations of St. Thomas and Scotus. This mural, as well as others in the inner rooms of the convent, is exquisitely drawn, superior to many in the other convents.

Since it is impossible to consider all the cloister's beauties, let us go on to visit the interior of the church. Already the soaring height of the church has made its impression, but our admiration increases when we contemplate the Gothic rib vaults that cover the entire ceiling, creating an elegant design which interlaces in the vault of the apse. From the choir we can view the full beauty of these vaults and the complex design of their ribs.

Finally, artistic culmination in the church of Huejotzingo is reached in the splendid golden retable in the apse (fig. 55). It is one of the few remaining to us from the sixteenth century and one of the best. Of Renaissance—or rather, plateresque— structure and form, its various sections alternate panels with sculpture-filled niches and paintings. The paintings are of great quality, although today they have become so dark that they have lost their original effect. The compositions are excellent, and at least some of them are from the hand of Simón Pereyns, the first really great painter to work in New Spain. The relief of Saint Francis is truly beautiful and striking. Like the sculpture, the carvings on the retable are strong and rich. The columns which frame the niches are beautifully classical in proportion, and their variety enhances the composition. Those on the first level are Doric, much elaborated and decorated, as

are those on the second, although these last are Ionic. Those on the third level, also Ionic, are baluster-shaped and profusely ornamented. All the friezes are decorated with relief carvings. On the uppermost story is a painting between two niches, the whole flanked by two large medallions. Above, the image of the Eternal Father hovers in an arch, bringing the retable to its culmination. The total effect of this composition is superb; the moderate Baroque movement of its plan combines with the classical order of its composition to avoid monotony and yet conserve architectural integrity. The combination of the paintings, sculptures, ornamental carvings and gold entrances the eye, and the spirit remains absorbed in the majesty of the work. This retable provides a magnificent example in its kind of a growing freedom in Renaissance forms that will eventually develop what we know as Baroque art.

The builder of San Miguel de Huejotzingo was Brother Juan de Alameda, who also constructed other monasteries; it must have been built in the fourth decade of the sixteenth century.

In this brief consideration of a few aspects of the monastery of Huejotzingo can be seen the amalgam of architectural and ornamental forms from which it is composed and from which its originality and *sui generis* beauty derive. It is enough to contemplate the interior of the temple, with its Gothic vaults and Renaissance retable, to understand the traditional remains and the new forms that, in strange but harmonious combination, flourished in New Spain in the middle of the sixteenth century.

One other consideration must be noted. The monasteries of New Spain have generally been regarded as fortresses, especially the churches because of their austere form and crenelations or for their *pasos de ronda*, as in Tepeaca. But even if they do indeed produce this impression, in actuality their military character is only relative; the crenelations that crown the walls are there to serve a decorative, not a defensive, purpose. Spiritual fortresses they were, but not belligerent symbols.

Dominican Monasteries. Outstanding among the great monasteries erected by the order of Saint Dominic are those of Tepoztlán in Morelos, and Yanhuitlán and Santo Domingo in Oaxaca. Their construction is severe, appropriate to the warm

climate and an area subject to earthquakes. Yanhuitlán is one of the most notable examples of sixteenth-century monastic architecture. The monumental church is striking in its size, especially when the exterior is seen from the direction of the apse, for it recalls the great Spanish castles; its majesty and beauty have no rival. The main altar, of baroque composition, is magnificent. There are also others which are very fine. Santo Domingo is particularly famous for the rich ornamentation of the church, which is, however, of a later period. Its main altar was executed only recently, completed in 1959. Its severe cloister, with its thick walls and round arches, is very grand in its simplicity (fig. 56). The stairway, decorated in a Renaissance manner, is monumental (fig. 57). The cloister is roofed in an unusual and surprisingly modern way: it allows what modern architects call an open plan. It is spanned by a single barrel vault that covers both cells and hallways, the space being then divided by partitions wherever necessary without concern about the support of the roof, intercepting the vault wherever it was useful. On the other hand, the huge size of the cloister detracts from the sense of enclosure, although it does indeed have a kind of majesty.

The Dominican Monastery of Tepoztlán has characteristics similar to those of the others, although it is smaller in scale. Its setting among the hills is unforgettable, and from its roof, looking toward the east, one recognizes its strategic position between two imposing mountain ranges. The atrium or forecourt and the posa chapels are interesting, but even more so is the portal of the church, which is an exceptional example of sixteenth-century architecture (fig. 58). It has a poise, variety, and character that recall Romanesque art. The doorway is a round arch framed by Doric and Ionic pilasters, but these classical elements are used in so arbitrary a way that the result is distinctive. The Dominican emblem is repeated in the corners, monograms decorate the friezes, and pinnacles push beyond the upper cornice. Above this, a kind of pediment or "frontón" is formed from steeply raked moldings. In the triangular panel thus formed are three full-length figures, the central one representing Mary holding the child Jesus in her arms, both shown with large crowns; there is also space for two flower vases

placed like candelabras. In the upper part, above the pedimental shape, two large figures of angels support a panel, and above this is the window of the choir. To consider the elements which make up this façade so summarily gives no indication of the total effect, which is not only striking but moving. In the first place, the entire composition is treated like a huge relief; there are no great contrasts of light and dark, but each element looks as if it had been beaten into the stone in *repoussé* in so precise and neat a way that one admires the technical perfection of the execution. But this is not all—the execution of the figures is persuasive and interesting; drawn with exactness, the silhouettes stand out clearly; the drapery folds and other such details are indicated very delicately in such a way as to resemble fine drawings. Even stronger is the relief in the upper part, of two angels of colossal size. Their extended wings move in capricious undulations, and their expressive gestures are pathetic without being theatrical. Here also the drapery is simply indicated by fine lines within the plane of the relief. Its very original composition, its Romanesque reminiscences, the elegance and character of its reliefs, and its technical perfection—all make the façade of Tepoztlán one of the most beautiful and refined works of art created in this epoch. And once again, it is the combination of medieval concepts and forms with others from the Renaissance that produced a new art, thanks to the aesthetic judgment of its creators.

Augustinian Monasteries. The monasteries erected by monks of the Order of St. Augustine are the largest and the most richly ornamented of all. Here it will be possible to call attention only to the most notable aspects of a few of them.

Extraordinary for more than one reason is the Monastery of Saint Augustine of Acolman, just north of Mexico City on the road to Teotihuacán. Here the visitor has an unusual advantage because the monastery is not surrounded by a town, as is often true, but stands isolated in the fields, so that its majesty increases as one approaches it and the solitude of the site heightens the aesthetic and mystical spell. From the entrance to the atrium one can contemplate the harmony of the complex structure, but one's attention is attracted to a stone cross which

stands close by (fig. 59). One of the most interesting aspects of the sculpture is the Divine Face carved directly into the cross itself. Considered apart from the whole, the face recalls Gothic works, but when seen in conjunction with the rest of the cross with its reliefs, it relates to a kind of sculpture that Moreno Villa dubbed "tequitqui," associated with aboriginal tributary art. But whatever it should properly be called, the important thing is that it constitutes a true work of art, evocative in its dramatic expression.

The first thing to be seen at Acolman is the original monastery with its open chapel on the upper floor, in which there is a fresco painting with a monumental image of Saint Catherine (fig. 60). To the north, the large church was later built, its façade ornamented with the finest plateresque entryway ever created in New Spain. The immense wall is crowned with crenelations and in the center has a pedimented bell tower with three arches for the bells. The main portal occupies almost the entire façade, and includes in its design not only the door but also the choir window, extending upward to terminate in a cornice. The classicistic composition of the portal, its perfect execution and its outstanding artistic quality make the work admirable, recalling such exceptional examples as the doorway of the Hospital de la Santa Cruz in Toledo, Spain. The damage in the lower part, caused by floods, does not detract from the superb quality of the total effect. A round arch marks the frame of the door itself, and this form is repeated by another to create a double archivolt which is ornamented with fruit and other foods. Within the intrados at the base are figures of saints on pedestals with small canopies over their heads. Pairs of Corinthian pilasters, decorated in a plateresque manner, flank the door on either side and enclose niches with statues of Saint Peter and Saint Paul standing on consoles under elaborate canopies. In the spandrels, medallions tell the story of the Annunciation to Mary. Above the arch runs an entablature that includes a delightful frieze decorated with reliefs of medallions and of fantastic horses with floriated tails. The vertical direction of the pilasters is carried up beyond the cornice: in the center, by two figures of children carrying baskets of fruit on their heads; and on the sides, by flaming candelabras. In the center

are three niches arranged to be seen as a single composition, with the child Jesus in the center and two children playing musical instruments at the sides. The round arched window of the choir is placed immediately above and is decorated with a splendid plateresque frame with Ionic pilasters, baluster-shaped and decorated. Large shields on either side of the window break the simplicity of the smooth wall; the one on the right bears a symbol relating to the place. Both as a whole and in detail the portal is admirable, as much for its fine proportion as for the quality and character of its workmanship. In fact, if one wanted to know in just what that Renaissance orna-mental-architectural style called plateresque—because of its del-icacy and its resembling works in silver—consisted, there would be no better example than this doorway of Acolman to illustrate it, as perfect as those of the first quality in Europe.

After the portal, the most important part of Acolman is the great two-storied cloister with its round arches and elegantly proportioned, somewhat Romanesque, columns. The parapet on the upper story runs between the column bases, giving a somewhat archaic and medieval touch to the whole. On the lower story, reliefs with symbols of the Passion placed directly above the columns enrich the space between the arches. This cloister is interesting and strange, with its walls decorated with fresco paintings of scenes from the Passion in black and white, creating an effect that recalls the Italian Renaissance palaces without relinquishing a lingering flavor of the medieval (fig. 61). The paintings are interesting and were doubtless inspired by woodcuts from books of the period—the middle of the six-teenth century. Then one should explore other areas—the cells and dependencies of the monastery, which add particular charm (fig. 62).

The influence of Acolman can be seen in other Augustinian monasteries, such as those of Yuririapúndaro and Cuitzeo in Michoacán. The composition of the first of these is similar to that of Acolman, but it lacks the refinement of proportion and finish. The entire wall is covered with floral ornamentation based on a geometric scheme, and the effect of the whole is too rich to be classical and too crude in detail to be considered refined. On the other hand, it has a freely creative character

in which exuberance reigns, giving it originality. To see Acol-
man then Yuririapúndaro is like going from Renaissance
Europe to budding New Spain with its art just developing in
an original way full of character and freedom. The Monastery
of Yuririapúndaro is completed with a cloister roofed by a
Gothic vault of complicated ribbed structure (fig. 63); the
arches along the side are, however, round, and spring from
Corinthian pilasters imbedded in rectangular pillars. Once
again, the Medieval and the Renaissance are brought together
to form a new synthesis. The portal of Cuitzeo is simpler in its
composition (fig. 64) than those of Acolman and Yuririapún-
daro, but the carving is so bold that when seen in the bright
sunlight it creates an effect of extraordinary richness in its
contrasts, proving a notable example of tropical plateresque—
if I can be forgiven the term—and becoming no less beautiful
for the effect but, on the contrary, all the more attractive and
vigorous.

Perhaps the outstanding Augustinian monastery—vast in
size, with an elegant portal, a great Moorish tower, a low cloister
with vaults and Gothic arches, and a monumental stairway
with walls totally covered with fresco paintings—is the Monas-
tery of Actopan in the state of Hidalgo (fig. 65). There is
nothing comparable to the effect of the tower, either seen from
a distance or from close by. Its upper part is opened by large
arches, which in turn are surmounted by a series of small
arches, and the whole is crowned by pinnacles and crenelations.
It is an architectural form of vigorous beauty. The portal of the
church is original and refined in its severe classicism or, per-
haps, mannerism. The entrance portico of the convent is also
impressive, and the cloister is a perfect combination of Gothic
forms on the ground floor and Renaissance forms above, the
latter with round arches and severe Doric columns (fig. 66).
But Actopan would not be the magnificent monument it is
without the fresco paintings that cover the walls of the very
grand stairway (fig. 67). The composition of the paintings is
classical; the walls are divided into bands by friezes of Renais-
sance ornament of a type called Roman. Plateresque colonnettes
and flattened arches complete the structure, setting forth panels
with seated figures of saints or bishops, in general composed

with grace and yet with dignity. The total effect of the decoration is splendid and sumptuous in spite of the fact that, as in most sixteenth-century mural paintings, principal colors are white and black with some details in sepia, ocher, and red. In the vault, the voussoirs are outlined with black lines on a white ground, an effect deriving from Arabic art that was much to the taste of that time.

A visit to such monuments as Acolman and Actopan gives a good idea of the grandeur of Augustinian constructions in mid-sixtenth-century New Spain.

Open Chapels. I have already mentioned this type of religious structure as solving the problem in early days of officiating before a great number of the faithful when churches had not yet been built or were in the process of construction. There are a great many different kinds. Some are raised above the level of the surrounding area and have open arches toward the atrium, like the one at Acolman or the delightful one at Tlahuililpa in Hidalgo that looks for all the world like a festooned box at a bullfight or a theatrical presentation (fig. 68). Others are also richly carved, such as the chapel at Tlalmanalco (fig. 69) in the state of Puebla, which was never finished but whose highly decorative elements are the admiration of all who see it. Finally, there is a positively monumental example—the one at Teposcolula in the state of Oaxaca, which is unrivaled in its size and structure. Its thick but well-proportioned columns support round arches, and the vault of the apse has Gothic ribs. Only by looking at the work in actuality can one feel the effect of its grandeur expressed through every form; it is imbued with a genuinely imperial dignity. The chapel at Teposcolula surpasses in its refinement the no less grandiose chapel at Cuernavaca in the state of Morelos, with its three majestic arches and its ribbed vaults.

An entirely different effect, evocative of a distinctive feeling, is that produced by the interior of the so-called Royal Chapel in Cholula, Puebla (fig. 70). Rectangular in plan with several aisles and roofed by numerous hemispherical domes, in its simplicity and general layout it suggests a mosque. The Royal Chapel cannot properly be called open, like those built out of

doors generally to house only the altar and its pertinences; yet it is an immense covered space that permits the congregation to see the high altar and participate in the service from almost any corner. As regards visibility, it is open but under cover.

Open chapels belong particularly to New Spain in their form; in no other part of the world are they found in such great number and in such a variety of richness and structure. In their function, however, they possibly have their counterparts in other countries.

Civil Architecture. The governmental palaces, noble houses, and other types of civil architecture of the sixteenth century have almost wholly disappeared over the centuries. To be sure, some doorway or fragment of structure may remain, but this is of more interest to the historian than to the lover of art. In San Cristóbal las Casas, Chiapas, the somewhat plateresque doorway of the House of Mazariegos has been preserved (fig. 72). In Puebla, there is the interesting façade of the house called "of the man who killed the animal," with handsome jambs and lintel decorated with fine reliefs that seem almost like embossed leather or silver. In Cuernavaca, Morelos, the Palace of Cortés still preserves remnants of the original construction, especially the round arches of the entrance and those on the second floor, as well as the arcade of the loggia or terrace at the back of the building which is decorated with frescoes painted by Diego Rivera. As in other instances, the architectural elements are reminiscent of Romanesque forms; yet in their general placement, they draw their inspiration from Italian Renaissance palaces.

The only work of major importance that has been completely preserved is the monumental façade of the House of Montejo in Mérida, Yucatán (fig. 73). There one encounters a splendid architectural work that combines certain Renaissance refinements in its lower story with medievalisms—or free forms that appear such—in the upper floor, where the balcony juts out in such a way as to make the first floor cornice pursue a kind of a Baroque movement. The balcony door is flanked by two enormous military figures, and in the center, above the lintel, the great Montejo family crest is set forth in a spacious panel

rampant with floral decoration. Still higher on the façade are a frieze with Renaissance reliefs and the cornice which extends the full width of the building. The full façade is crowned with a kind of pediment with acroteria that displays at its center another shield supported by rampant lions. The general effect of the portal is indeed splendid because of the grand size and a peculiar character, at once refined and crude, that provides a particular attractiveness.

Sculpture and Painting. Two aspects of sixteenth-century sculpture are of special interest. One is an expression that recalls medieval forms—sometimes Romanesque, sometimes Gothic—in which the traditional indigenous sense of sculpture is occasionally lost, although at times it shows through. The second is a Renaissance expression that produced many works of superior quality. An idea of the first can be gained from some holy-water or baptismal fonts. An important example is the font in the Church of Acatzingo, Puebla, with a border formed of the Franciscan cord and enormous reliefs of angels of an extraordinary indigenous character (fig. 74). There are many with more or less complicated ornamentation that recall without a doubt great indigenous sculpture, especially the *cuauhxicallis* or recipients for blood and hearts. There are also some pulpits which are convincing works of sculpture, such as the one in the Church of Huaquechula, Puebla, which is pentagonal in plan. In its various panels framed by ornament to suggest niches are low reliefs of angels carved in curiously archaic forms. The pulpit is crowned by an elegant canopy with cord moldings and acanthus leaves.

The Renaissance style of sculpture must be sought in the retables of the period (fig. 75). We have already considered the one at Huejotzingo; now we might look at an exceptional image in stucco and gilded wood from the retable of the church at Xochimilco, Federal District. It is an extremely beautiful representation of the Virgin, of which the face and proportion of the figure recall classical sculpture (fig. 76). The folds of her mantle and dress are a bit rigid, and thus create only a slight movement without approaching the grand effects of later baroque sculpture. But the image that marked the beginning

of Western Renaissance art is the Virgen de la Salud (Virgin of Good Health) venerated in Pátzcuaro, Michoacán, except that in this instance the face is dominated less by a classical feeling than by Spanish character. Its beauty is austere and magnificent.

Mural painting in New Spain during the mid-sixteenth century follows the same two traits that the sculpture does. In the fresco paintings of monasteries, both medieval and Renaissance forms are combined, although the latter tend to predominate. As I have remarked, the color was generally limited to black and white with touches of ocher, red, and sepia, producing a pleasant decorative effect and evoking a kind of mysticism, for without a wide range of colors the passions take little part and spirituality reigns. There is, however, an exception: the paintings in the cloister of Epazoyucan in Hidalgo are completely colored panels, emotionally moving and beautiful. Almost certainly the scenes were inspired by prints of the period. Two of them are magnificent: a Descent from the Cross which expresses true pathos, and a violently drawn Way of the Cross that has been related to a print by Schongauer. Another exception is the painting of the choir vault in the Church of Tecamachalco, Puebla, whose scenes, some of which are delightfully ingenuous, recall miniatures from manuscripts. Sixteenth-century mural painting in no sense reached the high levels that this art maintained in Italy, even though it well fulfilled an ornamental and symbolic function in churches and convents.

As for panel paintings in oil, a few rather ingenuous separate works must be distinguished from the large paintings created to be incorporated into retables. An exceptional painting of the first type is a panel showing Saint Francis with a Christ figure in his hands (Behrens Collection, Mexico City). The freedom of expression, the coloring, and the attitude of the saint give it a naïve beauty that is very moving in its grace and candor.

An early group of painters who migrated to New Spain initiated what can be seriously regarded as Renaissance painting. Some Italianate, some under Flemish influence, they left works of quality. Many of their works have survived, although many are lost, such as the excellent Saint Sebastian in the upper part of the Altar of Pardon in the Cathedral of Mexico City,

a splendidly drawn figure, destroyed by fire in 1967. And then there are the works attributed to Simón Pereyns, some of which are certainly by his own hand, such as the paintings in the retable of Huejotzingo and the Virgin of the Altar of Pardon in the Cathedral of Mexico, also destroyed by fire in 1967, a beautifully composed painting whose central image had a delicate Italianate beauty. Saint Christopher, in the Cathedral of Mexico, is signed and dated 1588 (fig. 77). It is an elegant work, with floating baroque drapery. Other paintings attributed to Pereyns, such as the Saint Cecilia and the Saint Lawrence in the Pinacoteca Virreinal of San Diego, Mexico City, are treated in large planes and simplified drawing, as if to be seen from a distance; possibly they belong to a retable. They are attractive and masterfully composed and drawn. At least in these paintings there is no medievalism; the figures are executed with fullness, draperies are rich in movement and color, and finery begins to show itself wherever possible.

Certainly the impact of the Renaissance is to be seen in some few works of architecture and in some masterly retables and their paintings. But curiously enough, it is the hybrid works with their Medieval, Renaissance, Mudéjar forms or their suggestions of indigenous taste which exhibit the most original and interesting concepts and at times provide the most moving experiences—provided, of course, that one is capable of breaking away from the established canons of the classical tradition. It is a matter of being open to all kinds of possibilities and ready to enjoy and appreciate a clasical work or a hybrid, whether one's personal preferences incline toward one or the other.

City Planning. Even though briefly, we must pause to consider the art of planning and building cities and towns, because this important aspect of culture in New Spain often goes unnoticed. In general terms, it might be said that the plans follow a modern —that is, a Renaissance—criterion using the so-called grid system, a network of streets and avenues from north to south and from east to west creating regular, well-proportioned blocks. Of course this rigid concept ran into the problem of natural irregularities, useful or not, and in some instances the

ancient indigenous plan served as a basis, as in Mexico City. Here, whether for political, historical, traditional, or some other reasons, the basic orientation and general lines of Tenochtitlan, with its canals, streets, highways, or avenues oriented to the four cardinal points, persisted. Curiously enough—and this was doubtless the principal reason—the urbanistic concept of the great indigenous cultures coincided with the modern, Renaissance concept of the Spanish city builders. The medieval city, developed by chance around a castle or cathedral, made use of irregular radiating streets following a pattern called the cracked plate, a concept quite inadmissible for the modern intellect, ruled by rational order above all. In confronting the problem in New Spain, the Spanish turned to the modern solution, a further proof of their Renaissance leanings. The oldest sections of Mexico City are laid out according to the lines of Tenochtitlan: the Plaza of the Constitution (the Zócalo) was always an open space; the National Palace occupies the position of the ancient palace of Moctezuma; the buildings of the Central Department are on the spot of the nobles' houses; the building of the Monte de Piedad is erected on the spot that was occupied by the old Palace of Axayácatl; and the Cathedral is at the southeast corner of the great courtyard of the pyramids and temples of Huitzilopochtli and Tláloc. Many other parts of the present city can be identified with Tenochtitlan, but these examples will serve to make the point.

City squares were given special consideration by the Spanish urbanists; directives from Phillip II in this regard exist. The vast size of the squares in Mexican cities and towns is in part owing to the fact that one of their functions was to provide enough space to "hold games of jousting" (juegos de cañas) on horseback, reminiscent of medieval tournaments. However, the square also provided a conspicuous setting for the principal church or cathedral, the city hall, and the houses of the most prominent citizens. In the directives from the Spanish king, it was recommended that the square be oriented diagonally on a north-south axis, so that two corners fall on the axis; the streets and avenues opening off this north-south line would be parallel to the sides of the square. This plan, which for the most part was not followed, was based on the idea of protecting cities as

far as possible from winds and rays of the sun. This last concern also prompted the recommendation that streets be narrow. However, the actual terrain won out, generally to advantage, and the city planners of New Spain carried on as they wished.

Walled cities were rare and were built chiefly along the coast, as in Veracruz and Campeche, for the modern concept admitted only cities that were open on all sides. When one stops to consider the great number of towns and cities founded in the sixteenth century, the magnitude of the urbanistic undertaking in New Spain is astonishing, proving it an exceptional country in this as in other matters, since none other in history accomplished a like activity in such relatively short time. Certainly, the art of city planning in New Spain followed the most modern concepts of the time, which was the Renaissance, yet at the same time coincided with the rational schemes of indigenous planning based on religious principles.

BAROQUE ART

In due time, medieval forms and reminiscences disappeared, although not entirely; Moresque survivals took on new vigor, and a Christianized indigenous spirit succeeded in making itself evident. All these tendencies, tastes, and desires for artistic and aesthetic expression found their course in the most suitable form—those of the new period, the Baroque.

Within Baroque art there are many different shadings, from classical and mannerist tendencies to the most unrestrained baroque, which has been called "ultra-baroque," in which class the churrigueresque would be included. Between the one extreme and the other lie a whole range of combinations as well as the very free expressions that only recently have been considered seriously as works of art, a kind of popular baroque. On the other hand, it is only natural that from the end of the sixteenth century through the seventeenth, baroque forms should have undergone modification, although remaining full of life and character, and that by the middle of the eighteenth century they had succeeded in developing the baroque possibilities to the full in their complicated forms drawn from fantasy, a general phenomenon in Europe as well as in New Spain.

But in America, everything took on a special tint, if not a striking originality, a fact that is not always easy to verify without plunging deeply into that marvelous forest which is Baroque art in New Spain.

Cathedrals. In considering the great cathedrals of the country, it should be kept in mind that almost all of them, at least the six or seven most prominent, were built to replace earlier cathedral structures generally of a very modest kind. An exception is the ambitious sixteenth-century project in Pátzcuaro, Michoacán, with its five naves radiating like the outstretched fingers of a hand. But because it was so ambitious its construction was suspended for technical reasons. The cathedrals that we see today signify the predominance of the Church in its full force and artistic expression.

It is enough to look at just a few cathedrals, their exteriors and interiors, to see the complete extent of the development of baroque art in New Spain. The oldest, from the end of the sixteenth century, is the Cathedral of Mérida, Yucatán. Its portals are Renaissance in character as is the whole concept, including the interior with its heavy columns and vaults, and yet there is a certain archaistic air about it. Medieval art persists in the beautiful interior structure of the Cathedral of Guadalajara, completed in the early decades of the seventeenth century; yet its exterior is correctly classical—baroque. The towers were added later, and belong to Romanticism.

The architecture that sets the tone for the most severe, most classical, baroque is the cathedral of Puebla (fig. 78). Thanks to the efforts of Bishop Palafox, it was almost entirely built in some nine years and was dedicated in 1649. It lacked only one tower, which was added later. It is a splendid building, beautiful in its mass, with two high towers as the principal elements of the composition and a huge dome covered with glazed tiles. The three main portals are in a combined order, Doric and Ionic, and are adorned with reliefs, statues, and decorations in white stone that stands out sharply against the walls darkened by time. The justness of proportion in all details gives the architecture great refinement. On the walls the play of light and shadow from the projections and voids detracts from the strict

classical severity. The interior is in harmony with the exterior (fig. 79); the supports are square pillars flanked by half columns in the Tuscan order, channeled and counterchanneled. They support the round arches of the side aisles and the ribbed barrel and groin vaults of the somewhat elevated nave. In accordance with Spanish tradition, the choir should be situated in the nave, and so it is in the Cathedral of Puebla. It is a beautiful choir with wooden stalls decorated with inlaid tracery of abstract design recalling Moresque art.

The baldachin at the crossing was designed by Tolsá, and belongs to the period of Neoclassicism, when doubtless the touches of gold were added to the stone. But the neoclassic forms, in this instance rather baroque, harmonize well with the original seventeenth-century design. Also adding to the sumptuousness of the interior are the glided iron grills of the lateral chapels. The sacristy also is interesting, with its great baroque mural paintings by Baltasar de Echave y Rioja creating an exceedingly rich environment.

As a whole, the Cathedral of Puebla is one of the most impressive monuments of its kind, especially in the homogeneity of its forms, which stems from the fact that it was built in a relatively short period of time.

In spite of the grandeur and unity of the major church of Puebla, the Cathedral of Mexico City surpasses it in the first quality, if not in the second (fig.80). It has other original aspects and a richness of form that make it a singular monument of baroque architecture, in spite of its obvious classicism. It must be borne in mind that its construction extended over a period of some two and a half centuries, spanning the entire history of the art of New Spain. Actually, the first work began in the second half of the sixteenth century and, in spite of the fact that the final dedication was held in 1667 when all of the vaults were in place, the towers, dome, and other parts belong to the period of Neoclassicism and its completion coincides with the dawn of national independence.

As seen today, the exterior of the Cathedral of Mexico is unrivaled in its majesty. Seen at a distance, the lines of the aisles extend longitudinally at different levels, crowned by balustrades and pinnacles. These great horizontal lines are in-

terrupted only by the transept portals and are terminated on the south by the vigorous towers. The horizontality is broken also by the very elegant dome. Thus the composition is sober, solemn, majestic, and intensely moving.

Seen from the front, the simple masses of the tower bases and the buttresses between the principal portals are tied to the structure by inverted consoles that soften the harshness of the right angles. All the portals are made up of two stories and a terminal section, but the central one is higher than the other two. All three are decorated with splendid marble reliefs, and in the center the three-quarter columns leave spaces for niches with statues. The doors are spanned by round arches. The Tuscan order of the lower story is entirely correct, and the Ionic order above is no less well proportioned; both rise from simple bases. The columns are channeled, but those above are enriched by a zigzag ornament on the lower part of the shaft. The side portals are topped by urns and medallions with neoclassical garlands to create a rich and elegant complement. The termination of the central portal, also neoclassical, is composed of a curved pediment above which rises the square form of the clock. This, in turn, is crowned by excellent neoclassical statues representing Faith, Hope, and Charity, executed by Tolsá.

The two-story towers, terminated in original fashion by bell-shaped forms, rise from the upper part of the church and best display their elegance and splendid beauty when seen from an angle. The first story, in the Doric order, is pierced by rounded archways and is compact and massive in effect. The second story, on the other hand, in the Ionic order, is slim, original, and very elegant. Four pillars at the corners, backed by pilasters, support the entablature, but inside this cubic form exists another of elliptical plan with columns and pilasters running its entire height and openings cut through at two levels. This arrangement produces a singular effect: when the tower is seen at an angle, the highlights and solids interplay and the supports free themselves from the mass so that the entire tower seems to be open. To this must be added the effect of the balustrades and the excellent statues, lively in movement, that crown the tower. Then, overall, is the bell-shaped top supported by a drum with elliptical *oculi*, decorated with bands, garlands, and

medallions. At the peak is a cross mounted on a sphere. The towers are absolutely monumental, and as such carry the impact of first-quality architecture. The architects are worthy of being remembered: the first is José Damián Ortiz de Castro from Jalapa; the second, the Valencian sculptor and architect Manuel Tolsá, who effectively brought the various parts of the cathedral to their completion.

Tolsá was the designer of the dome. Its supporting drum is octagonal and has Ionic columns and pilasters; the openings are topped by curved pediments. It is decorated with candelabra and reliefs with the emblem of the Catholic Church surrounded by garlands. A balustrade crowns the drum, from behind which the somewhat elevated dome rises, terminating in a collar with balustrade and pinnacles. This is surmounted by the slim lantern, which is opened up by windows and *oculi* and completed by a cornice and a small dome on the crest of which is a flaming candelabrum. Few works of this kind exist which can match the elegance of this dome, whose beauty springs from the justness of its proportions.

In plan, the cathedral has five aisles, but the outermost aisles are occupied by chapels. The apse projects from the north of the rectangle. This posterior part is the most severe of the exterior composition, and the portals at both sides of the projection of the apse make one think of the architectural forms of Juan de Herrera in the Escorial in Spain. The original project of the cathedral was drawn up by Claudio de Arciniega, but the later work of Juan Miguel de Agüeros was also important, as were the contributions of various architects who worked on the church until Tolsá finally completed it.

The interior of the church is impressively grand (fig. 81). The central aisle is higher than the side aisles and is roofed with a barrel vault opened on the sides by the lateral arches. The side aisles are covered by groin vaults, and the chapels have vaults with Gothic ribbing. The supports are formed of square piers with clustered Tuscan half columns and channeled shafts. These continue above the capital to form round arches, producing an exceptional effect. The size of the piers and the high vaults creates a sober and majestic impression that is notable enriched by the ultra-baroque elements in gilded wood,

as, for example: the Altar of Pardon; the outstanding balconies crowning the choir on either side, which, richly carved and supported by caryatids, surround the piers and seem to weave among them; the great soaring organs; and the magnificent rail made in China of *tumbago* which closes off the choir. Arranged around the walls inside the choir are the elaborately carved wooden choir stalls, and at the back, hanging above, is a great painting by Juan Correa, of the Apocalyse. Unfortunately part of the choir and part of the Altar of Pardon were destroyed by fire in 1967. Between the altar at the crossing and the grill of the choir, an enclosure is formed with balustrades and bronze sculptures. In the crossing there existed originally, in the seventeenth century, a ciborium over the high altar which was later transformed and enriched in the eighteenth century. But this ciborium was destroyed, and in the nineteenth century a classicistic one was erected in its place; this, in turn, disappeared a few years ago. Now an altar without baldachin has been constructed from Tecali alabaster. According to modern taste, the ciborium interfered with the view of the magnificent ultra-baroque retable in the Chapel of the Kings; today the elaborate sumptuosity of this monument radiates splendidly (fig. 82).

The Retable of the Kings is a creation of Jerónimo de Balbás, who worked on it from 1718 to 1737. It was the first important work in New Spain to make use of the kind of pillar or pilaster called an *estípite*, one of the principal elements of ultra-baroque art and one which characterized the style that has become known as churrigueresque. The retable, with its figures of kings, entirely fills the immense space of the apse, and is richly carved in wood and gilded. It is overwhelmingly impressive, as if the spectator found himself before a wonderful grotto. The emotion it evokes transports one into a fantastic, dramatic world and at the same time is one of pleasurable elation. It is here that the ultra-baroque found its first and fullest expression in New Spain, and its influence was felt at once throughout the entire country. Gem among gems for its beauty and primacy, the retable of the Altar of the Kings is the obligatory point from which a study of ultra-baroque art in New Spain must begin.

By contrast, the stone doorways leading into the Chapter

Room and the sacristy are of strict classical severity, a beauty certainly different from that of the Altar of the Kings. Above the crossing rises the dome with neoclassical murals by Rafael Ximeno, which create an excellent effect in their light colors and composition. The principal subject is the Assumption of the Virgin, for to this the cathedral is dedicated. These paintings were destroyed by fire in 1967.

To penetrate into the sacristy is to plunge into a mystical and sumptuous world. Its vaults have Gothic ribs, and its walls are covered with four enormous baroque paintings from the end of the seventeenth century, two of which are by Juan Correa: *The Assumption of the Virgin* and *The Entry of Christ into Jerusalem*. The other two are by Cristóbal de Villalpando: *The Militant Church* and *The Triumphant Church*. Rarely is the aesthetic emotion so strongly moved as by this magnificent precinct. And the unity is created out of a harmony of artistic forms that are for the most part irregular.

Then too, one must also notice the chapels with their wooden grilles. Some have splendid gilded retables, such as in the Chapel of the Angels, the exceptional beauty of which is indisputable.

It is enough to have called attention to a few of the aspects and most important elements of the Cathedral of Mexico, a monument without rival in America and an extraordinary work within the repertory of baroque art.

During the eighteenth century a number of Baroque cathedrals were constructed, and each one has its own original character and stature: those of Chihuahua and Zacatecas in the north, that of Oaxaca in the south, and that of Morelia in the center of Mexico. Among these, in order to recognize Baroque art at its zenith, I must single out the great façade of the Cathedral of Zacatecas (fig. 83). It is made up of three stories, the uppermost being a panel, the sides of which take the form of a shield. Ornament invades everything. Some of the columns are Solomonic (with twisted shafts); others submerge their simple shafts in foliage; and all have Corinthians capitals. Statues in niches between the columns further enrich the portal. The carving is relatively flat, in the manner of Moresque stucco decoration (*ataurique*). The lowest story contains the doorway, which is in the form of a round multi-lobed arch. In the second section, the choir window appears like a complicated *oculus*, recalling

the rose windows of Gothic cathedrals. In the third story, three niches plus the inter-columniations are arranged on the same level to complete the portal to this point, and then the façade is extended to take on the shield shape. No description can do justice to the striking effect of this work, especially when it is seen in full sunlight and the shadows of the cornices, columns, and niches join with the larger openings to create powerful accents and all the ornament vibrates and glows like the richest jewel.

Remembering just the Cathedrals of Mérida, Puebla, Mexico, and Zacatecas would be enough to retain the image of baroque art's evolution in New Spain, from the most severe and classical to the exuberent ultra-baroque. But it is not recollections or ideas that produce the authentic aesthetic emotion; this can be had only in the objective experience before the real work of art.

Churches and Chapels. Only insofar as one knows Baroque art and its high point can one speak of something that goes beyond it—the ultra-baroque. The eye is dazzled by a series of authentic marvels; it is difficult to choose examples from such a vast, rich, and original production which constitutes so brilliant a chapter in the history of Baroque art.

There is a first stage, spanning the seventeenth century, in which the forms are contained within classical orders and proportion, even though they are freely interpreted and other liberties are taken to add such things as Solomonic columns, to create projections, to activate cornices, and to concentrate ornament here and there. Within this limit, the term Baroque art can be used with propriety, understood as a free creation which uses elements and certain principles from classical architecture. But when the liberty is such that it goes beyond all limits— using basically new forms like supports in the form of *estípites* or converting supports into mere decoration—when classical orders are hardly recognizable in the ornamental exuberance that invades everything and structures are proportioned capriciously, how then is this art to be called? It can only be described comparatively, and this justifies our describing it as ultra-baroque. Within this denomination there are, however, various styles, such as the churrigueresque, some of which are

rather Moorish in appearance, others unmistakably Mexican, like the so-called popular styles, and finally, others are of rococo inspiration. So it is impossible to cover them all in a single glance; we shall have to consider concrete examples.

In Mexico City, there are sufficient examples to represent both trends. If we turn our attention first of all to baroque works, especially to portals, a good many are to be seen. The churches of Santa Teresa, San Bernardo, San Lorenzo, La Enseñansa, and Regina, among others, have excellent baroque portals, yet all are different. All are finely proportioned, and most have bulky projecting cornices and moldings that rise and fall, curve or spiral. The ornamentation is concentrated in the lower parts of the shafts of pilasters and columns, in window frames, in spandrels, friezes, and panels. Pilasters and columns are in the spiraled Solomonic style, and the Ionic and Corinthian orders are freely interpreted. Also, the indentations of rusticated masonry breaks up the form of doorjambs and pilasters, and various forms of reliefs, niches, statues, and terminations enrich the relative severity of the composition, which also often includes broken, rectangular, or curved pediments.

In Guadalajara, the beautiful portals of the Church of Santa Monica are excellent examples of the ornamental invasion's being kept within the limits of order (fig. 84). Yet, the Solomonic columns with Corinthian capitals are covered with vine leaves and bunches of grapes, and the decoration invades the upper portion too, where the base is made up of panels and the center is adorned with the two-headed eagle and angels with floating drapery.

In the city of Oaxaca, the façade of the Church of Santo Domingo airily supports its three stories between the cubic masses of the towers (fig. 85). These are low, of a single vertical form topped by small lanterned domes covered with glazed tile. Verticality reigns, as if to compensate somewhat for the modest, though robust, proportions of the towers. Windows, made up of double arches separated by a colonette, lighten the mass. In spite of the fact that all sections of the façade make use of the Corinthian order, sobriety is the dominant note. The engaged columns provide space between them for a series of niches with statues. In the second story there is a vigorous re-

lief; the third contains the choir window. The termination of the façade takes the form of a broken pediment with raking cornices which give importance to the enclosed emblem of the order; above this rise three figures backed by a panel in the form of a shield. It is a severe and strong façade.

The variety of baroque forms is infinite. In the same city of Oaxaca, the Church of the Soledad has a façade whose baroque character begins in the ground plan itself, for it opens out like a folding screen. In its three levels plus the decorative termination, niches with statues are combined with reliefs, the principal attraction being beautiful carving perfectly executed.

But thus far we have considered only exteriors. If we enter some of these churches, the vision changes and suddenly we are in a world of architectural fantasy. Mexico City furnishes convincing examples in the Churches of Regina, with its gilded retables in churriqueresque style, and in La Enseñanza, whose interior is completely unified, its walls being almost entirely covered with gilded carvings. This is also true of the Church of Santo Domingo in Oaxaca, whose façade we have already considered. Its interior is of a magnificence worthy of an Oriental temple. Immediately on entering, one's attention is attracted to the vault of the choir on which, in a complicated polychrome and gold leaf relief, is the genealogical tree of the family of Santo Domingo, the Guzmanes, culminating in the celestial vision of the Virgin with the Child Jesus, surrounded by angels (fig. 86). This relief in itself is of great artistic value. But the decoration does not stop here, for large polychrome sculptures are placed against the pilasters of the piers, and others appear above the ribs of the penetrations of the vault and merge with loops, shells, floral ornaments, and other elements whose curves and counter-curves are highlighted by golden bands. Upstairs in the choir, a still greater quantity of figures and ornaments, angels playing musical instruments, flowers, and strapwork meets the eye. Once the level of the choir is reached, the eye is absorbed in contemplating the vault, where strapwork and medallions with large and small figures cluster together at the crown, and from the walls project great reliefs of polychromed and gilded figures. If the feeling of sumptuosity is to be encountered anywhere, it is here in this choir, from which

one looks down upon the profusely ornamented nave of the church, although this has suffered modifications and not all is of the same quality. But the complex is compelling, and the effect is marvelous. The principal retable, which completes the whole, was finished only in 1959.

One of the most admirable works for its unity and quality is the famous Chapel of the Rosary in the Church of Santo Domingo in the city of Puebla (fig. 87). "The eighth wonder," it was once called, and in truth it is of striking merit. Finished in 1690, it is a magnificent example of this type of interior with capricious and exuberent ornament of gilded and polychromed stucco, which was to achieve its most original expression in Tonantzintla. The structure of the Chapel of the Rosary is very harmonious, with its round arches and generally robust proportions. Its plan is a Latin cross, and over the crossing rises the dome, which extends the sense of space. The nave is decorated with large paintings by Rodríguez Carnero, encased in very rich frames of complicated scroll work. These coursing shapes invade the vaults, the arches, everything. The pendentives are adorned with angels, plaques, niches, and statues, which continue through the drum of the cupola and serve as a transition leading to the soaring dome itself. In the crossing is a ciborium over the altar which hides the wall at the back; other reliefs, full of grace and character, are to be found there too.

In the same church of Santo Domingo, there is an excellent seventeenth-century gilt retable constructed according to an agitated baroque scheme which, since it is relatively sober as compared with others, helps to give an idea of the leap taken in the forms and the freedom with which they were handled when all limits were removed and churriguersque and other ultra-baroque retables made their appearance (fig. 88).

The contributions that New Spain made to art are of various kinds. In the first place, the sixteenth-century monasteries were remarkable for the singularity of their formal eclecticism and for their original architectural solutions, such as the open chapels, the chapels of the posas, and the great crenelated atriums or forecourts—all of which constituted new functional entities, quite aside from their grandeur or their scale. Second, the cathedrals take their place among the great works of Baroque

art, as do the numerous churches and chapels which, scattered throughout the countryside, gave a new aspect to the landscape. Third, the ultra-baroque architecture is one of the great expressions in the panorama of this art. There is probably no country in which the number and richness of works reached the level achieved in New Spain. The general history of Baroque art would not be complete without a consideration of Mexican works. Think of the diversity of form, the architectural solutions, the novel and splendid production of churches and gilt retables that took form in the eighteenth century. Some examples will suffice to justify my statements.

The Metropolitan Sagrario in Mexico City, constructed at the side of the cathedral, is an extraordinary work (it is a chapel chiefly for the Host). Justly, in my opinion, the architects of the time decided to construct new buildings in accordance with the ideas and tastes of their own particular historical moment, and in this instance, in spite of the fact that the forms are very different from those of the cathedral, in some mysterious way they harmonize. This architect was Lorenzo Rodríguez, and the Sagrario was built between 1749 and 1768. The plan is a Greek cross, and over the crossing rises the imposing dome, which becomes the culminating point of the entire composition. The corners of the building are much lower in height than the aisles and posed a problem in unifying the composition of the façades. This was effected by walls with baroque profiles that mount steeply in a pyramidal form from the corners to the wall buttresses flanking the doors. The portal decoration is confined between these buttresses. It is composed on two levels, both of which are dominated by vertical elements; four large *estípites* with niches between them on the lower level; six somewhat smaller *estípites* above. The entrance is a round arch, and the moldings on either side rise, break, and curve to form an irregular panel above the door containing niches, statues, and reliefs. These moldings are, in a sense, like clusters of colonettes, and recall Gothic supports. The intermediate cornice that separates the two levels is broken by projections, and rises in a curve at the center. The entire upper level is covered with *estípites,* niches, statues, and reliefs; its cornice is crowned with active profiles, statues, and pinnacles, thus completing the com-

position. The two portals of the Sagrario, on the south and east, are like stone retables which contrast with the walls of red *tezontle*; in fact, they serve as exterior terminations of the aisles. Also graceful and of fine design are the lateral doors and the windows in the façades of the corner pavilions.

The interior of the Sagrario is interesting for its plan, its general proportions, and the effect of the dome. At an earlier time it contained gilt retables, the principal one of neoclassical style by Patiño Ixtolinque. But the necessary work undertaken to put a new foundation under the building, which was threatened with ruin after long years of neglect, has nearly done away with everything. However, the principal retable is there, and new side altars have been built.

Other works that merit attention are the Church of the Santísima and the Church of the Santa Veracruz in Mexico City.

Not far from the capital, the ancient Jesuit seminary of Tepotzotlán contains one of the most complete and exceptional ultra-baroque churches (fig. 89). (The entire complex has been beautifully restored and serves as the Viceregal Museum.) Its rich churrigueresque façade and its single tower are very impressive works. The great portal decoration is another splendid "exterior retable" in stone. The finest parts are the lower two sections adorned with *estípites*, intercolumnar niches, and the choir window with its typically ultra-baroque profile. The termination of the portal section is so high that it almost competes with the tower; it includes more *estípites*, shields, and reliefs, and culminates in pinnacles and a statue. The tower is beautiful in itself; the stones of the base are cut in rusticated fashion, and the corners of both the upper stories are decorated with double *estípites*.

The part that is truly most admirable is the interior of the church, especially the crossing, for the walls are entirely covered by splendid gilt churrigueresque retables that emphasize the well-proportioned architectural structure, dating from the end of the seventeenth century (fig. 90). When the sun shines through the windows and kindles the gold of the retables, the effect is overwhelming; a supernatural, mystical atmosphere is

created, and one can understand the end that the aesthetic expression set out to achieve.

Other small chapels in Tepotzotlán are no less impressive, above all, the Camarín de la Virgen. The polychrome and gilt ornamentation, particularly original and strong, ascending the walls and invading the dome, is among the most admirable to be seen. In this *camarín* (chamber), the character of the ornament is of a type recognizable as mestizo; it has a Mexican accent that distinguishes it from the rest, a tendency that reaches its highest expression in another monument, Tonantzintla.

By way of contrast, the seminary building is severe, but its courtyard and arched halls decorated with oil paintings have the special charm of simplicity without affectation.

In this series of ultra-baroque marvels, the Parochial Church of Santa Prisca and San Sebastián in Taxco, Guerrero, stands out like a jewel, and majestically dominates the mountainous landscape from the prominence on which it is built (fig. 91). Its exterior is rich and well composed, with its high towers, its portals, and its dome covered in glazed tile. Further, its related buildings extend over the Street of the Arch, which passes at a lower level, giving unusual interest to the complex. The great portal is capriciously composed, with Corinthian columns and sculpture on the lowest level and Solomonic columns on the second at either side of a huge relief. The choir window is in the upper part, and the portal terminates in an arch formed of moldings. In its complexity and richness, this portal is a good example of the ultra-baroque, yet makes no use of churrigueresque *estípites*. The towers are in two sections, the lower one somewhat taller, and are decorated with pilasters, reliefs, and statues in such a way as to produce a strikingly original effect. The interior of the church is one of those miracles with which history surprises us from time to time, because the years have respected all the retables, both principal and lateral, and all is to be seen as when it was constructed (fig. 92). The nave is high, and its architecture is strong and well worked out. Corinthian pilasters and counter-pilasters with panels support the round arches, and the vault is penetrated by the arches along the side. The complex is astonishing in its order

and richness; everything is sumptuous, clean, and perfect. The principal retable is composed on two levels, but the lower is so high that the upper part seems only a termination. The great *estípites* nearly disappear beneath the opulent ornament which invades everything to the point that the full-length statues of Santa Prisca, the Immaculate Virgin, and San Sebastián are hardly distinguishable. This retable is a masterpiece of ultra-baroque art, as is the whole church. The plan of the church follows a Latin cross. On the left of the nave is the Chapel of Padre Jesús and on the right the baptistry and archive, with the side entrance between them. Behind the apse is the sacristy, which is itself an admirable work. Its walls—as are others in the church—are covered with large paintings by Miguel Cabrera. The architect of the building was Diego Durán, and it was paid for by the wealthy mine owner, José de la Borda. It was begun in 1751 and finished in 1758.

The regions of Tlaxcala and Puebla are fortunate in many ways, but especially for their great works of architecture. The eighteenth century was prodigious in these areas, and the artists who conceived the churches and chapels rivaled one another in originality.

After the Parochial Church of Taxco, one should visit the Sanctuary of Ocotlán in Tlaxcala; this is to go from a monument finely executed in stone to one constructed from clay and tile. The truth is that not only is the tile church not inferior, but on the contrary, the exterior is just as attractive as, if not more so than, the other (fig. 93). The towers point to the sky like needles, their upper parts white like the portal, which is compressed between the tower bases. In plan, the towers are composed of a square with an added curve, like piers with applied half columns, and they are covered with hexagonal red tiles. The bold contrast of red and white and the elaborate silhouette give the monument an original effect and a feeling of light-heartedness. The façade between the towers is a great niche which becomes at the top a colossal shell. Within this niche is the two-story portal with *estípites*, pinnacles, sculpture, and intercolumnar pilasters, which, in their turn, are also richly crowned and decorated. The choir window opens up in the form of a star, and is framed by a carved drapery. All this forms a

perfect background for the sculpture of the Virgin which stands out sharply before the opening. But it is not only the contrast of colors or the somewhat theatrical composition of the portal that make the Sanctuary of Ocotlán an original variant of ultra-baroque art, but, rather, the free manner, ingenuous and delightful, with which all the details are worked out. The interior of the church is interesting, but even more attractive is the little *Camarín* of the Virgin behind the main altar (fig. 94). Of octagonal plan, it is covered with a delightful dome, and thus forms a retreat which in its ornamentation becomes a fantastic world. On all the walls are paintings by Juan de Villalobos showing scenes from the life of the Virgin, framed elaborately; in the corners are Solomonic columns topped by figures of angels; the rest is covered with a mestizo—Mexican —kind of polychrome and gilt decoration that recalls the little chapel of Tepotzotlán and also Tonantzintla. The decoration reaches up to the corners and draws the attention to the vault of the dome, which is another one of those marvelous surprises. The ribs are framed with bands or pilasters covered with stucco work, and in each one of the sections, with their capricious windows, full-figure reliefs of richly dressed saints push their way through the floral ornament. It all comes together in the uppermost circle, composed of more radial figures who seem to crowd against one another. The effect of the little chapel is sumptuous and unique—it is a work of great originality. The sacristy is also interesting and well prepares the spirit for entry into the chapel, which was the creation of an Indian artist named Francisco Miguel.

Continuing in the pursuit of the most original aspects of ultra-baroque art in new Spain, such as the *camarines* of Tepotzotlán and Ocotlán, we come to the masterpiece of this new art, distinctive in being the expression of a community characterized by a strong personality: the Church of Santa María Tonantzintla in the state of Puebla. Seen from the outside, it is a modest structure, even though its façade of unglazed red and glazed colored tiles, its offset little tower, and its dome covered with glazed tiles give it the charm of popular architecture. But to enter is to plunge into the most extraordinary forest ever created by man (fig. 95). The profuse decoration and its

special character produce the miracle. Nonetheless, the structural lines of the church are preserved and even emphasized in the nave. At the crossing, however, almost all sense of structure disappears beneath the scrolls and rampant leaves, from which push little angels, cherubim, masks, and a multitude of other figures. Some wear helmets and many-colored plumes; others are dressed in polychrome costumes and peer down with curious expressions. The cherubim and little angels have enormous painted eyes, wide open and transfixed. Even in the arches, pendatives, and the vault of the dome—no place is left out—they peek from all sides from among the imagined tropical vegetation. The polychrome and gilding in splendid combination contribute much to the fantastic effect, which is completed by some gilded retables, also from the eighteenth century. One is either simply stopped by the total surprising effect or begins to examine the details and thus loses himself in an endless pursuit; always there is one little angel not seen before who has an expression even more absurd than the others, or another fantastic figure who looks down with his unblinking stare. If there is one place in which mestizo taste has been able to take off on its own, it is in Tonatzintla. For there, candor, ingenuity, grace, and shrewd artistic sense have been given full play through the brilliant colors, glowing gold, and free, sensitive, inventive, and imaginative form. Tonatzintla is a kind of synthesized expression of what the people most preferred, of their ideas of luxury, the limits of their fantasy, their way of imagining another world different from this one, a world in which all the cherubs have rose-colored skin and are vaguely classical in beauty and positively local in dress. Gold, color, plumes, scrolls, leafy ornaments, fruit, flowers, and arabesque form the background of the celestial figures, linking a very special aesthetic taste with religious feeling. And all this results in an exceptional monument which unites ancient local traditions with the newer European traditions to produce a truly creative expression.

There is still another monument in the region of Puebla, quite different from those we have considered and certainly no less splendid and surprising. It is the most "Puebla" church ever built: its exterior is completely covered with the product of one of the typical industries of Puebla—glazed tile. I am,

of course, referring to the Church of San Francisco Acatepec (fig. 96). Its façade opens up like a folding screen. It is made up of three stories; on the lowest, Corinthian columns are grouped on either side of the entrance, which is a round arch set within a conch made up of straight and curved forms. The second and third stories rise on the same axis and follow a similar composition of supports but make use of very freely treated *estípites*. The choir window has a capriciously formed frame, and above is another window in the form of a star. In the first two stories are niches with statues, and in the third are volutes and counter-volutes which unite and terminate the composition. This splendid façade of glazed polychrome tile is mounted, so to speak, on a wall of glazed and unglazed tile which terminates in a cornice, almost at the same level as the great portal. From this level rise the bell tower on the left and a not very tall tower on the right. The effect is both striking and refined, for the colors of the tiles—blue and white, yellow, green, and red— enliven and blend the forms; the forms themselves are of well-defined shape and profile, preserving a kind of order which, although possibly ingenuous, is attractive and exciting. It is the only church entirely covered with polychrome ceramic, and only the famous House of Tiles in Mexico City can come close to it. The interior was seriously damaged by fire in past years but is being reconstructed along the original lines and in the same spirit, which is intimately related to that of the ornamentation of Tonantzintla (fig. 97). An indisputably original work, Acatepec makes its entry into the inventory of eighteenth-century marvels, and its mestizo character recalls also another tradition of art which it reflects—the Moorish.

This mestizo character, which we might call simply Mexican —meaning, among other things, that it reflects some characteristics of the East—is to be encountered also in another work of exceptional quality in the city of San Luis Potosí—the Chapel of Aranzazu. There, confronted by the vigorous polychrome forms and unusual *estípites*, one is reminded of Hindustani art. One could not ask for greater exaggeration, and yet the effect of the whole composition is harmonious and could even be said to have a certain sobriety, in spite of the luxury of the decoration. But there are also other beauties of a different kind to be found

in San Luis Potosí, such as the Church of the Carmen, whose principal façade has a character all its own and whose churrigueresque interior portal is as wonderful as a great gilded retable, except that here the gilt is absent and the perfection of the plaster or stucco work appears in all its splendor. It is indescribable.

One of the most spectacular portals is that of the Sanctuary of Tepalcingo, Morelos, not only for its monumental size but for the complication and character of its ornamentation, which is rich and strong and can be described as something between primitive and barbaric (fig. 98). It is exceptional in the panorama of ultra-baroque architect from the last quarter of the eighteenth century, and only when it is contemplated in actuality is it clear why it must be considered among eighteenth-century wonders.

More surprises await us in the state of Guanajato and Querétaro; there are some classical examples of rococo art and of exaggeratedly French styles. But this is not all. The Church of Valenciana in Guanajuato keeps its gilded ultra-baroque retables within a well-proportioned structure. In comparison with other similar works, they may seem a bit weak because of the refinement of the carving, but nonetheless they are fine and beautiful. A work that bears no rival either in Guanajuato or in the entire country is the interior of the Church of San Agustín in Salamanca. Every opening in the nave is supplied with a gilded retable, and each is of a distinct design. They are almost planar in character without projecting reliefs, and thus give amplitude to the nave while at the same time richly ornamenting it. In some of them, instead of pilasters there are vertical compositions of capricious shapes with medallions and reliefs and various decorative elements. In one, the leafy ornament, recalling French rococo decoration, forms a lacework of gold, the panels of wood being cut out so that the shapes are seen against a dark and empty background to produce a singular effect. At the crossing, however, the effect is exactly contrary to that of the side chapels. There, the gilt retables have the most protuberant forms of any imaginable, and the windows form an integral part of the compositions. In place of niches there are great ledges which support sculptures in the round

depicting religious scenes from the Old and New Testaments. The curtains, crowns, and other elements of a rich ultra-baroque retable give a sumptuosity to the whole, which has a somewhat Portuguese character or cast. A visit to this church in the late afternoon—when the long shadows begin to invade, wisely blotting out the parts that one would rather not see, when the artificial lights begin to illuminate the scene and the gold glows —is unforgettable. Overwhelmed by the *ambiance*, the mind is entranced and enters into an aesthetic spell without equal. San Agustín in Salamanca is a true marvel.

In the city of Querétaro, notable works abound, and close attention must be given to at least three of them. First of all is the extraordinary patio of the old Monastery of San Agustín with its two floors of arched corridors. The remarkable caryatids which rise above the supports with their arms extended over the spandrels, the hermae in the form of *estípites*, the undulating upper cornice, and the pinnacles—all give it a special and individual character distinct from any other monument. Further, the carving is beautifully executed, and the total effect is overwhelming and fantastic in its vigor and originality. Santa Clara creates its effect through the quality of its gilt retables, which gain refinement rather than lose vigor from their "Frenchified" design. Particularly unusual is the door that opens onto what was the convent, with the balcony above covered by a splendid iron grille. Original in form, it produces a memorable effect. The carving of the retables is magnificent and vigorous, and the metallic glitter of the gold as it reflects the light makes the projecting forms stand out and creates striking contrasts. A rival to the Church of Santa Clara is that of Santa Rosa, which belongs to another convent, admired on the exterior for its extraordinary free-standing buttresses at the side, which are linked to the wall by capricious inverted scrolls. The interior is sumptuous, with golden retables covering all the openings between the piers on both sides. Both the lower and the upper choirs are of distinctive composition: the first story is ornamented with elaborately framed paintings placed at different levels to cover all the wall surrounding a rectangular opening that is shut off by a simple but excellent iron grille. There is another grille above, extending from wall to wall, which marks

the upper choir, and above this is a colossal fan of perforated gilded wood which conforms to the arch of the nave. It is one of the most singular and gorgeous nun's choirs. The most striking effect is, however, to be found in the lateral retables which include the windows; there the light floods in to strike the forms and produce the contrasts so necessary for baroque art. Many of the elements of the retables and choir of this church recall rococo forms and other aspects of French baroque art, but here they combine to form a new world which the French artist would never recognize as his own. These last complete the list of acquisitions, transformations, and inventions of ultra-baroque art in New Spain.

To bring this section to an end, or, better, to close it "with a golden brooch," we must pause for a moment before a final interesting and beautiful work: the Chapel of the Pocito in Villa de Guadalupe, Federal District (fig. 99). Its plan is not only interesting, it is truly exceptional. Other churches and chapels were built in the form of a Latin cross; some, such as the Metropolitan Sagrario, in the form of a Greek cross. The Chapel of the Pocito, so called because it was built on the site of a spring of miraculous water, is constructed in the shape of an oval with four projecting radial chapels; along the central axis, there is a circular space in front and an octagonal space in the rear. The plan is the most baroque of all Mexican architecture, and produced an active, interesting, and unusual structure. The architect of the work was Francisco Guerrero y Torres, who began it in 1777, just a few years before the founding of the Royal Academy of San Carlos in Mexico City, and finished it in 1791, when the neoclassical movement was getting under way. Thus it is the last important ultra-baroque work built in Mexico. The most interesting part of this chapel is the exterior composition; the variously curved walls are decorated with rich stone carving and partly covered with red *tezóntle*. Above the walls rise parapets, belfries and pinnacles with rhythmic profiles, covered with blue and white glazed tiles in zigzag patterns. Amid these adornments that crown the façade rise the three lanterned domes, one behind the other, with the principal one, slightly elevated, in the middle. All are roofed with blue and white tiles. There is nothing comparable to the

effect, the emotion, produced by this beautiful chapel, in which the fantasy of forms and combination of colors bring to mind the luxury of the Orient. In it a new synthesis is formed in which a taste for color and for dynamic form reaches its highest glory. The details also are admirable: the star-shaped windows and the principal portal within the circular space at the front which serves as a vestibule. The portal is composed in two levels. The entrance is spanned by capricious archways and bordered on either side by projections and Corinthian colonettes, between which are tile-lined niches. On the upper level is a star-shaped window before which stands a statue of the Virgin of Guadalupe; the entire area is filled with carvings of cherubs and floral ornament. The projections, colonettes, and niches of the first story are repeated above, creating vertical lines that lighten the composition, which terminates only in the crowning tile-covered wall pierced with stars. The composition is strikingly original and of perfect unity and keen architectonic sense, in spite of the fantasy of the forms and colors. It is a true gem without peer in Mexican ultra-baroque art.

We could have considered another church with a baroque plan in the form of an oval—the old Convent of Santa Brigida —but, regrettably, it was demolished to make way for the widening of the present Avenue of San Juan de Letrán in Mexico City. Like the Chapel of the Pocito, Santa Brigida was also a work of late ultra-baroque art.

Civil Architecture. A visiting foreigner once called Mexico City the city of palaces, admiring the number of palatial residences that stretch along the borders of its streets and avenues and surround its squares. Actually, not only in Mexico City but in many other cities of the country, splendid buildings remain that give some idea of civil architecture of the Baroque period in New Spain: Puebla, Guadalajara, Morelia, Pátzcuaro, Guanajuato, San Miguel de Allende, San Luis Potosí, Oaxaca, Taxco, Alamos in Sonora, and many other cities preserve works worthy of any world capital. Even in the towns, one is surprised to come upon a former residence of some nobleman or rich Creole, or city halls which, because of their importance, are called municipal palaces. Further, some of the main houses c

old haciendas, in spite of the fact that they were country residences, were as luxurious as the city palaces. Rather than get bogged down in a long list of baroque civil works, I think it more useful to consider only a few significant monuments.

First in importance—and a real palace—is the so-called Hotel Iturbide on Madero Avenue in Mexico City (fig. 100). Originally constructed as the residence of the Marquis del Jaral de Berrio, it later passed into the possession of the Marquis de Moncada. At one time the hero of Mexican independence Agustín de Iturbide resided in it, and later it was transformed into a hotel; it is now an office building. It has kept the traditional name of the liberator and by his name it is generally known. The façade and general scale are monumental; it is composed of a high first story, which includes the balconies belonging to the mezzanine. On the second (the principal) floor, richly decorated doors open onto the balcony that runs almost the length of the building. The upper story has separate "pavilions" at each corner that have two elaborately framed windows with balconies and somewhat recall the towers that were formerly used on noble houses as a military vestige. But the exceptional aspect of this design is that these end pavilions are connected by a loggia or gallery made up of flattened arches and adorned with elegant carving, garlands, a parapet of inverted arches, and pinnacles. The proportions of the portal emphasize its height, giving it an elegance agreeing with that of the entire façade. Above the lintel is a panel with carving, moldings, and volutes. The precision and good taste of the composition of the façade, the elaborately carved stone frames of the doors, windows, and panels, their contrast with the smooth wall surfaces covered with red tezóntle—all give an effect of luxury and grandeur not to be found in other buildings of this kind. The façade is a first-class monument in itself, but, in addition, the building retains in excellent condition its no less monumental and elegant patio (fig. 101). The ground-floor arcade of the patio is composed of round arches, and in order to create a space high enough to include also a mezzanine story, the columns are raised on high pedestals, which makes them seem very slim. Also, in the spandrels of the arches are medallions and carvings which recall plateresque

works. The arches of the second story, which is the principal floor, are three-centered: the so-called "basket-handle" arch. But at this level only the far end of the patio has arches; the other walls rise from the ground-floor arches and are broken only by windows with carved stone frames and balconies. The top floor is similar in design, except that, instead of the arches of the loggia, a series of columns supports a flat architrave. No baroque patio is more elegant than this one, for in its proportions, the discretion of its ornament, its composition, and its monumentality, it is a masterpiece—as is also the façade. If any building recalls Italian palaces, it is this one, for it is the most refined and elegant type of baroque architecture which, in spite of its luxury, retains a kind of sobriety. In the patio one senses a beauty quite different from that to be found in monastic cloisters, which indicates that it has maintained the character of a residence without equivocation. And to all this must be added the beautiful portal of the chapel. Possibly the architect of this monument was Francisco Guerrero y Torres, who was also the creator of the Chapel of the Pocito.

In general, the noble residences follow a plan of a main courtyard with passage ways around the four sides, and another courtyard in the rear for horses. The ground floor and mezzanine were used for workshops, offices, and activity related to the administration of haciendas and properties. On the principal, or second, floor were the living quarters opening onto loggias; the chapel, the antechamber, and the great salon which was always on the street side. At the back were the dining room, the baths, and the kitchens.

Another exceptional residence in Mexico City was the home of the Count of Santiago de Calimaya (in Pino Suárez No. 30). This is a work of the last quarter of the eighteenth century (1779), and its baroque style is vigorous, without decadent weaknesses. The façades facing the two streets—it is on a corner—as well as the courtyard are splendid, even though in size it is not to be compared to the Hotel Iturbide. The head of a serpent projects from the foundation at the corner, an authentic Aztec sculpture placed here possibly as a symbol. The carvings of the portal and the window frames are excellent, and a magnificent door of the period, made from joined and carved wood,

is still preserved. The façade is topped by a kind of frieze which is continuously interrupted by gargoyles in the form of cannons —bellicose symbols of power. This is one of the great mansions whose architectural quality justifies Mexico City's being called the city of palaces. The palace now houses the Museum of Mexico City.

Also, the house of the Count of San Mateo de Valparaíso in the capital, today occupied by the National Bank of Mexico (at the corner of Isabel la Católica and Venustiano Carranza), is a notable work. In its rich but somewhat sober façades, the window and door frames and the stone panels are combined with flat smooth tezóntle-covered walls, and the whole is topped by pinnacles. At the corner, rising above the two stories of the façades, is a tower with windows and a niche in the outer corner. The courtyard is one of the most interesting parts of the building for it makes use of the play of spanning and crossing arches and has an extraordinary double stairway that rises in a spiral. The architect was Francisco de Guerrero y Torres, who built the residence between 1769 and 1772.

One could go on adding other noble houses in the capital, such as that of the Count of Heras Soto (at the corner of Chile and Donceles); those of Mayorazgo de Guerrero, one in front of the other (at the corner of Correo Mayor and Zapata); the so-called House of Masks (in the Ribera de San Cosme), with its fine pilaster *estípites* beneath the gargoyles; and that of the Count of San Bartolomé de Xala (in Venustiano Carranza No. 73), a work of Lorenzo Rodríguez finished in 1764. But it would be an interminable inventory. Nonetheless, I must single out the house of the Count of the Valle de Orizaba, the so-called House of Tiles, which has been occupied for many years by Sanborn's (on Madero Avenue), because it is a monument that has an Oriental flavor as well as great unity in its exterior and interior, both excellent in proportion (fig. 102). Its façades are well composed, with the window frames and door frames in carved stone and all the wall surfaces covered with blue and white glazed tiles. Above the cornice on the second floor rises a parapet with ceramic pinnacles that are very beautiful, and directly above the principal door there is a great niche. The courtyard has octagonal columns, a Moresque reference, as are

the tiles, and is decorated with flat moldings and friezes, and contains a handsome fountain. The stairway is splendid and has as added richness the magnificent fresco painting by José Clemente Orozco *Omniscience*. The powerful forms of this artist find here a baroque framework with which they can harmonize; they reinforce the splendor of the building, which is one of the high points of civil achitecture in New Spain.

In Puebla, one could make an extensive inventory of first-class examples of colonial residences, for they have been preserved in greater number than in Mexico City. But the character of Puebla architecture might be represented by the beautiful Casa del Alfeñique, today a museum, a work of the architect Antonio de Santa María Incháurregui, who built it at the end of the eighteenth century (fig. 103). Its portal and the window frames are worked out in relief, and the cornices seem active with their capricious projections, some jutting sufficiently to serve as the floors of upper balconies which, moreover, unite in a kind of overhanging marquee. The effect of all this white architectural tracery, richly ornamented and complex in shape, contrasting with smooth walls covered with simple red tiles alternating with glazed tiles, is extraordinarily beautiful, gay, luxurious, and of rather precious fragility. It is this quality which has given the house its fame, for it looks for all the world like a Moorish sweet made from sugar and almonds.

Also in Puebla is another remarkable monument, the Palafox Library, constructed in 1773 with an elegant portal containing a great doorway, *estípites,* shields, and pinnacles. The interior is a monumental salon with ribbed vaults and windows in the lunettes. The floor is of "olombrilla," a combination of simple red tiles contrasting with glazed tiles. But most notable is the fact that the library preserves completely its eighteenth-century wooden bookcases as well as a gilt retable at the end of the room, which is a true gem of the carpentry of the period. The whole complex and its atmosphere, as well as the collection of old books itself, which contains many bibliographical treasures, make this library a very significant work.

But if one is to have an idea of baroque civil architecture as applied to first-class institutional buildings, three great works in the capital must be considered. The former Customs House

of Santo Domingo, today an office building, has in its great stairway an unfinished mural painting by David Alfaro Siqueiros. Then there is the College of San Ildefonso, today the National Preparatory School, number 1, in whose courtyards and stairways are mural paintings by Orozco, Siqueiros, Leal, Charlot, Revueltas, and Alva de la Canal, for it was here that the first important Mexican murals were painted (although one must include also the mural executed earlier by Rivera in the Anfiteatro Bolívar, a construction which, although in the baroque style of the eighteenth century, was built in the first years of the twentieth). In addition, in the salon called El Generalito, the splendid choir stalls which once belonged to the choir of the Convent of San Agustín have been installed and recently restored. Lastly, there is the College of the Vizcaínas, with superb façades and patios, that occupies an entire block (fig. 104). It was partly surrounded by apartments originally constructed to be rented as an aid to the college. These apartments are of a kind called "cup and saucer" because they are composed of only two rooms, one over the other, linked by a simple wooden stairway. Generally, the lower room is used as a workshop, and the upper one for living. Baths and other services are collective.

In the three buildings we have just discussed, the most vigorous and sober kind of baroque architecture has been seen in all the splendor of its rude, unaffected forms; the solidity and colossal size give the impression of their having been constructed to last forever.

This presentation of civil architecture has been very brief when one considers the richness available, for this class of architecture forms another magnificent chapter in the history of Baroque art, whose forms and materials were treated in New Spain with great mastery and individuality.

Sculpture and Painting. An important difference exists between the baroque sculpture of the seventeenth century and that of the eighteenth century. The first maintains a composure, a certain calm and aplomb, even to the drapery of the figures, which comes from a classical Renaissance tradition. The second is much more animated, the attitudes are more lively, and

figures are attempted with greater movement and floating drapery, sometimes much exaggerated with splendid effect. Then, one must distinguish between the stone sculpture of the exteriors and the gesso, gilded, and polychromed works of the retables. It has been remarked that sculpture as such did not exist in the Baroque period of New Spain, but such an opinion is misleading. Actually, the sculpture was so closely allied with the architecture that it is not always easy to determine the line between the one and the other. This close relationship, which exists also with painting, is the result of a principle which maintains that the arts should be welded into a single magnificent whole to achieve the greatest effect. It was the rationalist principle of neoclassical art that tried to separate the arts by "putting them in order," so that one could be clearly distinguished from the others and, although related, the arts could be juxtaposed. Baroque sculpture, on the other hand, must not be looked at in isolation except in a few exceptional instances; it suffers when wrenched from its original function in a complex.

Some exceptional works of the seventeenth century set a very severe standard, deeply anchored in tradition, for baroque sculpture—for example, the magnificent relief on the façade of the old Church of San Agustín in the capital, now the National Library, and the reliefs over the principal doors of the Cathedral of Mexico. The relief of San Agustín (fig. 106) surrounded by a framework of Solomonic columns formed into a panel, occupies a well-determined central position. The image of the saint is colossal, and the difference between him and the other members of the order is clearly marked by means of the size in which they are executed. The saint stands above three heads of Manichaeans; the first order of monks kneels on either side, with others standing in the background; angels supporting Saint Augustine's mantle complete the composition, which includes in the lower part two inscriptions. The character of the figures and of the drapery of their habits is an attempt at a naturalism in agreement with modern Renaissance principles, but the composition is flattened, rendered thin in such a way as to recall medieval Romanesque or Gothic reliefs. But this very quality gives a kind of vigor, and the perfection of the carving provokes a genuine emotion in the spectator, who

realizes that he confronts a solemn and monumental work. The choir stalls that belong to this Church of San Agustín are today in the so-called El Generalito Salon in the National Preparatory School of San Ildefonso, as mentioned above. They constitute the most exceptional wood carving of its kind produced in Baroque art (fig. 107). They are unequalled by other similar works, such as those in the choir of the Cathedral of Mexico, the existing remains of the choir of the church in Xochimilco, or the choir stalls of the Cathedral of Durango. They look splendid where they are today, for it is a handsomely proportioned room with vaults and high windows. Arranged on a platform along the walls, the choir stalls are displayed like a rich, carved tapestry in wood. The hall has recently been restored, and the architecture shows off well with its great wrought iron candelabras, its red carpets, and the dark color of the choir stalls standing out against the terra cotta color of the walls, which are hung with portraits of doctors in their robes. It is an impressive assembly in its sober sumptuosity. When one's attention is drawn to the carving of the stalls, the marvel of the reliefs, covering the panels in distinct superimposed planes until they reach the pinnacled cornice, begins to emerge. The carvings present elaborately framed scenes from the Old Testament; the figures move with animation, and their gestures are generally effective and striking. The carver gave them a special grace, departing from conventional naturalism to achieve a vigorous image that is genuinely moving, as in all works of true art.

Of quite different character are the gilt and polychrome relief sculptures that decorate the interior of the Church of Santo Domingo in Oaxaca; they are splendid, both those in the lower part as well as the compositions in the choir itself, especially two large reliefs.

What more can one ask of the sculpture of the eighteenth century than what we have seen in the great portals of the Metropolitan Sagrario or the superb gilt and polychrome retables, such as the Retable of the Kings in the Metropolitan Cathedral and those of Tepotzotlán, Taxco, and Salamanca? Although these are works whose structure and monumental disposition are architectural, they are fundamentally sculpture in stone or

wood. In general, the images, the figures of angels and others, do not, with certain exceptions, achieve a supreme quality in detail, but they serve their function perfectly and their grace, movement, and polychromy save them for the most part, and place them among the most attractive works to be seen. In the Retable of the Kings of the Cathedral of Mexico, the principal figures have great dignity, and the angels in the upper part move and gesture with grace and light. But then, if we go on to Tonantzintla, are these or are these not relief sculptures that invade this fantastic realm? They are distinctive and filled with character and ingenuous spontaniety, and for this reason come closer to contemporary taste. Finally, the *estípites* themselves, such as those for the high altar of the Parochial Church of Taxco, are they or are they not sculpture? Do they go beyond the function of architectural support? It might be said that there are no masterpieces in Mexican baroque sculpture insofar as separate works are concerned, even though in a detailed investigation one might encounter more than one surprise. But what greater masterpieces could one wish for than the façades and retables in their entirety? How much skill and authentic expression are to be found in the details! One is forced to admire the enormous production of this sculpture which might be classed as symbolic-decorative.

Painting forms an integral part of the retables and the decoration of churches and chapels, when it is not offering for our consideration a portrait of a great personage or independent religious pictures of various sizes. The painting produced in the seventeenth century deserves special attention because of its great quality and character and because it represented a kind of golden age of baroque painting in New Spain. One current of contemporary taste and ideas has been at pains to deprecate this kind of painting without understanding it, without studying it with attention; for this reason, it requires reevaluation. Italy and Flanders influenced Spain, but Spain knew how to give her works their originality, force, and character. The painting produced in New Spain by the peninsular pain⸱ evinces these antecedents, but traces gradually disappe⸱ the Creole artists began to flourish and create their ⸱ tive manner.

Most of the paintings which are considered in what follows are in the *Pinacoteca Virreinal*, now in the old church of San Diego, Mexico City; there are others in the Museum of History in Chapultepec Castle.

The great painting of *The Assumption of the Virgin* by Alonso López de Herrera, called the divine, is an excellent work that clearly shows the roots of both Spanish painting and the painting of New Spain (fig. 110). The composition is divided into two parts, an upper and a lower. In the upper part appears the image of the Virgin surrounded by angels, a handsome matron with a floating mantle of delicate beauty and refined execution that stands out against a light background; the lower part, with the Apostles, is dark in tonality. Thus the painting assumes a striking luminosity, and the whole composition is unified. Even in detail the particular drawing of the figures is delicate, and the hands of the Virgin are especially characteristic of the divine Herrera, whose masterpiece this *Assumption* is. Herrera was active through the first half of the seventeenth century.

Merited fame was and is still accorded Baltasar Echave Orio the elder, the first of three generations of painters bearing the same name but distinguishable by their style and their maternal family names. Echave Orio, whose works have an Italian accent, was a true master. His large compositions, like *The Martyrdom of Saint Ponciano*, are great concepts realized with profound understanding and executed with skillful drawing, movement, effects of light and shade, and a true sense of drama (fig. 111). His *Adoration of the Kings*, composed on the basis of the great implied diagonal that sweeps through the principal figures, is a work of great quality (fig. 112). The Italianate beauty of the Virgin and Child, the dignity of the king who kneels to kiss the foot of the Saviour, and the careful placing of the secondary figures give a solemnity to the scene. The drawing is excellent, and the quality of the painting is first-rate, rich in the effects of the king's robe, sober in the somewhat rigid folds in the Virgin's dress, and bold in contrasting the dark background with the principal figures to make them stand out forcibly. The most profoundly and dramatically moving among the works of Echave Orio is the *Agony in the Garden*, which also

has a baroque composition based on a great diagonal that runs from the extreme lower right corner to the upper left of the painting (fig. 113). The kneeling Jesus rests his hands on a rock; his tunic is red, and this warm tone serves as a basis for the head, placed centrally on the canvas; the bleeding and grief-stricken face is full of inspiration. It is the finest and most vigorous, the sweetest and most dramatic rendering of the face of Christ in all the painting of New Spain, and is a masterful realization, as is the entire painting. In the extreme upper left, the dark sky opens and an angel appears with the bitter chalice; the light that bursts from this area illuminates and sets forth the figure of Christ, giving it prominence against the dark background. If to achieve its purpose art must arouse the emotions of the spectator, the work succeeds marvelously in this primary function. It is a wise and profound painting, authentically felt, positive and dramatic in its beauty. It alone would be sufficient to mark Echave Orio a true master.

His son was Baltasar Echave Ibía, also called the Echave of the blues because this is the color that frequently characterizes his paintings. Born in Mexico, he followed personal directions and ideas different from those of his father. At times he is more subtle, less vigorous than his father, but when his work is not rhetorical it is very fine and sensitive. Some of the paintings attributed to him are possibly not by his hand, so it is better to concentrate on only two of his authentic works. *The Immaculata* of 1622 (fig. 114) is an ambitious painting of archaistic Flemish inspiration. Placed against a light background, the figure of the Virgin occupies the central part of the canvas. Her face is rounded, her hands delicate. Her gown and mantle, although floating, are rigid but rich in quality and decorative pattern. It is a surely celestial image, surrounded by cherubs carrying symbols of the litany or plaques. A very interesting aspect of Echave Ibía's work is his use of landscape, for this genre does not appear in the painting of New Spain except in some backgrounds, not independently in its own right. In the lowest part of the painting we are considering, there is a fantastic landscape in the middle of which is a graceful siren, curiously masculine in appearance because the painter did not risk giving a clear form to the breasts. This modesty is typical of

the painting of New Spain and of Spain as well, where even in the images of Christ and Saint Sebastian the luxury of the nude was rarely permitted. This *Immaculata* is a fine and spiritual work, but very intellectual; it achieved its religious, inspirational end by creating an atmosphere and figures which follow an ideal. Entirely different from this is the *Saint John the Baptist*, a smaller painting but more attractive in its concept, with the figure placed at the left in the forward plane, and a landscape filled with interest as a background. Further, the execution has a new quality, for the brush strokes are looser and full, and the saint himself has individual character and naturalness. The landscape, in tones of blue, is conceived with imagination. It has been related to the works of Patinir; at least the tonality and fantasy justify the suggestion, but the quality of the material and the brush strokes are different. With its elegant figure of Saint John with his lamb and the cross with its floating banner and the landscape background, this painting is certainly of superior quality.

Next we come to the works of Luis Juárez, another Creole artist who flourished in the first half of the seventeenth century and who was a direct disciple of Echave Orio. He possessed an excellent knowledge of his craft, transmitted by his master, but his personality is different: less vigorous, more delicate, and of tender inspiration. A comparison might be made between Christ in the Garden of Gethsemene by Juárez and the same subject painted by Echave Orio that we considered earlier. Neither the composition nor the dramatic gestures reach the level of quality and vigor achieved by the master, but in compensation there is in Juárez a sweetness, a transparency of tone, and an ideal beauty that give great charm to this and other works by him. His draperies are generally thin and linear, and his angels are very characteristic, with gilding, vaporous hair, and elegant forms. Another subject that Juárez treated was *Saint Ildefonso Receiving the Chasuble* (fig. 115), in which he succeeded in unifying his talents and carrying them to their limit. Well constructed, with a vertical axis on the left creating a kind of golden section and a diagonal that runs through the body of the saint to reach the inclined head of the Virgin, all the figures are active except the saint, who in a mystical transport extends his

hands and raises his eyes to heaven. The idealism shown in the figures of the angels and of the Virgin herself is impressive, and the face of the saint is depicted in distinctive fashion. The general tone of the painting is light, but there are contrasts of dark, and, by means of the two angels that carry the miter in the forward plane at the left, the painter succeeds in creating a sense of the third dimension. It is a carefully executed work, spiritual and of excellent quality.

Having treated until now only painters in an Italianate or Flemish Renaissance tradition, we come to a vigorous artist who introduces baroque painting of a much more Spanish character, following the direction of Caravaggio and the manner of Zurbarán and Ribera, the so-called tenebrists. This is Sebastian López de Arteaga. He was a notary of the Holy Office, for which he painted a *Christ on the Cross* (fig. 116) of intense chiaroscuro and baroque movement in the body. The painting for which López de Arteaga holds an exceptional place in this history is *The Incredulity of Saint Thomas* (fig. 117) a splendid work comparable to similar paintings by European masters. It is not insignificant that the painter came from Seville and developed in his native city, because the Spanish school of tenebrists was centered there. In the painting under consideration, the body of Christ, nude to below the waist, radiates its corporeal beauty in a powerful light. The head, of extraordinary beauty, is constructed with an elegance that pervades the entire figure. The rest of the body is covered with a red mantle, and the posture is masterful, with firmly planted feet which are brilliantly lighted to display their excellent, strong drawing. Saint Thomas bends over and extends his right hand, guided by Christ himself to touch the wound; the expression which invades his noble features is one of sincere astonishment. In the background, on a level with the Divine Countenance, a group of persons is shown; the one on the extreme left is said to be the painter himself. All the heads are fine, but the most important is that of the old man above Saint Thomas, who is shown almost in profile. The yellowish tones of his sk⟨in and the⟩ whites and grays of his hair and beard contrast with ⟨dark-⟩ness to effect a striking relief. A painting of the hig⟨h alle-⟩gory, the masterpiece of the painter, it is also one of

important paintings of New Spain. Everything about the work reveals the mastery of its creator; the nobility of the form, the warm tonality, and the accentuated chiaroscuro, as well as the virile beauty of Christ, make this painting one of the most moving in the history of Mexican art.

The novelty of López de Arteaga's painting created a strong impression and formed the basis of a new school; from this point on, painting in New Spain followed a different practice. The first artist who should be considered in this regard is Pedro Ramírez, if for no other work, at least for his *The Delivery of Saint Peter,* now in the Viceregal Museum at Tepotzotlán (fig. 118). Once more the tenebrist school achieved a striking success. Against a dark background, the kneeling figure of Saint Peter appears at the left; his head is in itself an excellent piece of painting, strong and magnificent. Even more important is the liberating angel standing at the right, a beautiful androgynous figure, expressing both a masculine vigor and a feminine delicacy. The robe and mantle float airily, leaving bare an arm and a part of one leg, sufficient to suggest a certain attractive sensuality. This work was well received and seems later to have inspired other artists, who did not, however, achieve the mastery and quality of this. It is a strong, beautiful painting without a single weakness and is certainly Ramírez's masterpiece.

Now we come to the works of José Juárez (the son of Luis), which are not many but are varied. There are notable differences between his two large compositions *Saints Justo and Pastor* of 1635 and *The Martyrdom of Saint Lawrence.* There is perfection in the first of these—it is ideal and conventional. The second is theatrical, crammed with figures, and of accentuated chiaroscuro. Another of his works, of excellent quality, is *The Holy Family* (1655) (Academy of Fine Arts in Puebla). It is inspired by a painting of the same subject by Rubens, although the Creole artist introduced variants and, above all, modestly covered the childish forms of Jesus and Saint John the Baptist, who in Rubens' work appear nude. It is a good painting, attractive and well executed. But the choice work for recognizing the qualities of José Juárez is *The Adoration of the Kings* (1655) (fig. 119). It is a well-rounded painting; its composition is pyramidal, with a central axis and bold diagonals. But there

are other qualities to be found in the drawing of the particular forms and the mastery of the execution itself, in the luxuriousness of the costumes and the beauty of the figures. Using chiaroscuro, but never to the extent of being an extreme tenebrist, Juárez manifests here a reflective spirit. The general tonality is somewhat cold; light edges the prominent forms and emphasizes the figures of the Virgin, the child Jesus, and two of the kings, one kneeling and the other standing; the Negro king appears almost in silhouette in front of the background landscape. The rich fabrics, adornments, and accessories seem almost to be chiseled they are so scrupulously executed. The standing figure of the king with a turban at the right is magnificent and radiates presence. There are no weaknesses in any detail; the heads and hands are well studied and the composition is monumental and admirable. It is one of the masterpieces of the painting of New Spain.

The last of the important painters of this epoch and of this tendency is Echave y Rioja, the grandson of Echave the Elder. With him, painting takes on a theatrical character, following the trend initiated by José Juárez in his *Martrydom of Saint Lawrence*, but somewhat weaker in drawing and in the facility of achieving effect. His *Saint Peter Arbués* (1666) is a grandiose concept, but weaknesses of various kinds are very evident. In *The Entombment of Christ* (1668), however, the effect is purely tenebrist without any consistency in the drawing and in the form.

Although there are many other artists in the golden age of painting in New Spain, we have, I believe, considered the principal ones. Others come later who maintained art at a certain level. For example, Juan Correa (worked between 1674 and 1739) and Cristóbal de Villalpando (1650–1714), whose paintings cover the walls of the sacristy of the Cathedral of Mexico and whose baroque works perfectly fulfill their function. Their compositions have a certain grandeur and effectiveness, but function more as part of a complex than as independent paintings. Toussaint has justly noted that Correa and Villalpando initiated a new manner of execution and effect. In many of their paintings they replaced tenebrism with light colors; their figures are active and decorative, elegant and airy,

but of little substance. The drawing is able but not always of the highest quality. The angels and archangels of Villalpando are typical of the painter—tall, robust, and graceful with theatrical gestures and clad in gorgeous jewels and costumes that make them very attractive and highly decorative.

Two other Creole painters carried seventeenth-century baroque painting to its limit, always maintaining fine quality: Nicolás Rodríguez Juárez (1667–1734) and his brother Juan (1675–1728), descendants of Luis and José Juárez. Prolific artists, their production is, however, unequal. Nicholás created some works derived from tenebrism and others in light tonalities that seemed to follow the ideas and tastes initiated by Villalpando. The portrait of Viceroy Duke de Linares, is by Juan Rodríguez Juárez (fig. 120). It is a good example of his ability. A copy with variations exists by Francisco Martínez (1723) (now in the Museum of the Obispado, Monterrey). The viceroy is shown standing, full of dignity, with his embroidered robe and great white wig in keeping with the fashion of the time. His face shows character and is well drawn. It is a work of quality. Juan has been considered superior to his brother and was more prolific. The principal paintings in the Retable of the Kings in the Cathedral of Mexico are his; they are well conceived and composed, although the forms leave much to be desired in their detail. Some of his independent works of individual figures show better drawing and more careful execution, and sometimes a distinctive quality and charm in their suavity, as for example, his *San Juan de Dios.*

In the city of Puebla there was a flourishing school of painting in which particular prominence was attained by a family of miniaturists that bore the name of Lagarto and was made up of various artists: Luis, Andrés, and Luis de la Vega Lagarto. Their works are exquisite, perfect in drawing, and masterfully executed. There was also a Flemish artist who developed his work there, Diego de Borgraf. His capacities in drawing were manifest in two styles: in a fine painting in light tones, *The Appearance of Saint Francis to Saint Theresa* (1677) (Sacristy of the Church of San Francisco, Tlaxcala) and another painting of *Saint Francis* (private collection), a moving work in dark tonality.

Still to be studied are the influences of European painting on New Spain. The role that Rubens played is important and becomes obvious in one painter or another, but there are also relationships with other artists whose compositions were known through engravings.

With the ultra-baroque art of the eighteenth century, painting took a new direction, more decorative, devoted to effect, and weak in all its details. The representative figure is Miguel Cabrera (1695–1768) a native of Oaxaca whose frame was extraordinary and lasted throughout the nineteenth century.

The suave and idealistic tenor of Cabrera's painting coincided with romantic taste and sentimentality at a time when men were no longer concerned with vigorous faith and its dramatic expression in art, but with soft sentiments and idealities and their sweet pictorial manifestation. Cabrera was not only prolific but maintained an active studio which produced many works by disciples, possibly touched up by the master, in accordance with all his formulas. He had great skill in composition, and his coloring is by preference in tones of gray, red, and blue. Nonetheless, some of his works have quality, such as those in the sacristy of the Parochial Church in Taxco, some portraits, and his large painting of *The Virgin of the Apocalypse* (fig. 121), which is very typical and rather attractive. His painting representing Sor Juana Inés de la Cruz in the National Museum of History, Chapultepec, is well known (fig. 122). She is seated before her work table among shelves of books. Rather than a portrait, for it was executed a long time after the death of the great poet and was inspired by an earlier work by another painter, it is the ideal image of the nun. The face is fine, the attitude dignified; but in spite of its effect and the good impression it produces, it is somewhat weak as a painting.

Other painters, such as José de Ibarra (1688–1756), a native of Guadalajara, retained a certain dignity in their works, in spite of the ideas and tastes of the time. Some of the portraits of nuns in the habits and paraphernalia for taking their vows are delightful and full of charm.

The development of almost two centuries of baroque painting in New Spain produced an infinity of artists and works. To be sure, no painter of the stature of Rubens, Rembrandt, Zur-

barán, or Ribera, much less of Velázquez or Goya, emerged, but the works from the golden age which we have considered might figure honorably, and some at the same level, in a comparison with works by European masters. That the art of painting decayed in the eighteenth century is certain, but the period is not completely barren of good works; in them can be detected a new spirit, distinct from the European models, which indicates other possible directions in Creole painting. One can note that popular or independent art produced at least one exceptional, although anonymous, painting representing the Plaza Mayor (Zócalo) of Mexico City (National Museum of History, Chapultepec) on a special day when the viceroy in his horse-drawn coach was on his way to the cathedral (fig. 123). The view is from the roof of what is now the National Palace, and the square, with the market called El Parián in the background, is filled with people and goods. The execution is ingenuous, but it is this itself which gives the work its charm; as a document it is of inestimable value. So far as the ideas and taste of contemporary art are concerned, this painting is worth more than many others from New Spain; it is, indeed, first rate.

NEOCLASSICAL ART

With the advent in Europe of new tastes and new ideas about art, based on the revival of forms and artistic criteria of classical antiquity considered a part of the new rationality, a movement arose that was to put a quick end to Baroque art—the Neoclassical. Winckelmann is the most representative aesthetician and theoretician, and his *History of Ancient Art* (1764) is a capital work for understanding the spirit and the concept of the new tendency. Nonetheless, although very classicist, Neoclassical art is in a way a new aspect of the Baroque. On the other hand, it is also the first phase of Romanticism, attempting to establish a new and firm tie with classical antiquity. It was at this time, in the second half of the eighteenth century, that many academies were founded, including many of those in Spain and, finally, the Royal Academy of Fine Arts of Mexico, founded by Carlos III in 1785. The intention of this worthy institution was to teach "true art" with precise canons. A group

of masters came to Mexico: Antonio González Velázquez, architect; Manuel Tolsá, architect and sculptor; Rafael Ximeno y Planes, painter; and Joaquín Fabregat, engraver. The idea for the founding of the academy came from an artist, a superb engraver of medals, Jerónimo Antonio Gil, whose works are of the highest quality. He was employed by the Mexican mint.

In the beginning, neoclassical art was considered a taste imposed by the state but, gradually as time went on, it coincided with the ideas of the enlightenment, modernity, and national independence. Neoclassicism became popular and was fully accepted because it was a symbol of new times, being anti-traditional and international, philosophical and modern in character.

Ecclesiastical Architecture. Neoclassicism already had followers in Mexico before the founding of the academy, such as Ortiz de Castro, master of works for the cathedral, who planned the towers which Tolsá would complete. Tolsá played an important role in the ecclesiastical architecture of this period, which was not a lengthy one, for it came to an end in the second decade of the nineteenth century with the struggle for independence, which was finally triumphant in 1821. Tolsá was responsible for the final work on the Cathedral of Mexico, as mentioned elsewhere. The cathedral would not be what it is today without him. This monument was fortunate in that its very long period of construction extended to the end of the viceregal period and into the beginnings of Neoclassicism. Because of this, the original severely classical-baroque building was finally completed with classical forms, giving it a special kind of unity. The termination of the façade with the clock is by Tolsá, as are the statues; he also built part of the towers, the fine dome, and the balustrades which crown the church; all this is of no small importance. He also designed the ciborium of the Puebla Cathedral and planned other neoclassical churches and altars.

Many architects were active in this period, the most distinguished one next to Tolsá being the Creole from Celaya, Francisco Eduardo de Tresguerras (1759–1833), also a sculptor and painter. His influence in the center of the country was very important; he planned and built many works, and many others have been attributed to him. His principal work was the

Church of the Carmen, in Celaya, Guanajuato, which he suc-
ceeded in finishing in only five years, from 1802 to 1807 (fig.
124). It is a monument of considerable distinction with its
single tower built at the beginning of the nave directly over the
Doric portico of the entrance. The architectural form is vigor-
ous as well as elegant; the proportions of the principal elements
and details are marked by correctness and show judgment and
good taste. In the side entrance, Tresguerras achieved a kind of
French baroque elegance and delicacy as also in the tile-covered
dome. The interior of the church is elegant in its unity and
grandeur, with its white and gold altars in the new taste which
wreaked such havoc on many baroque works.

The Church of Loreto in Mexico City (1809–1816), the
work of the architects Ignacio Castera and Agustín Paz, should
also be considered, being a neoclassical monument of impor-
tance. It has an enormous dome and small towers, a composi-
tion that recalls the plan by Ventura Rodríguez for the Church
of San Francisco el Grande in Madrid.

Neoclassical taste was so powerful in Mexico that many
baroque works were destroyed, especially the retables, which
were considered to be gross piles of gilded wood. But this was
also a sign that the new currents were anti-traditional, revital-
izing, and expressed the will of the Mexicans to embrace mod-
ernity; these were also the ideas fundamental to Mexican in-
dependence.

Civil Architecture. It is not by chance that civil architecture
now took on a new importance. The most significant monu-
ment of the period is the Palace of Mines, a work of Tolsá,
built in Mexico City between 1797 and 1813 (fig. 125). A
splendid building of great beauty, it is the most important of
its kind in America, and one of the few really fine neoclassical
buildings in the world. The three exterior façades of the build-
ing, two stories high with a mezzanine, its elegant portico, all
its elements—its Doric columns and moldings—are knowingly
proportioned and executed with true mastery. Nor is it "cold"
architecture, as has been said; on the contrary, it is positively
exciting if one has a genuine taste for this art. The courtyard is
monumental, with corridors or loggias on two floors (fig. 126).

The lower has arches and rusticated masonry; the other uses slender Ionic columns supporting low arches that are smoothly faced. The grandiose stairway is a notable work in itself, and the chapel on the upper floor completes the whole. This latter has ceiling paintings by Ximeno depicting *The Miracle of the Pocito,* and *The Appearance of the Virgin of Guadalupe,* to whom the chapel is dedicated (fig. 127). If there is any place that carries the full impact of what the Neoclassical wanted to do and succeeded in doing, this palace is it. Its shapely articulated forms vibrate in the sun, and its projections produce deep shadows; from this the architecture draws its splendor. It is a fully realized work, like some Renaissance palaces.

Tolsá also planned another original work, the Hospicio Cabañas in Guadalajara, which was going to become something like a Mexican Escorial. In our own time it has gained greater importance through the mural paintings executed there in the former chapel by the great Mexican artist José Clemente Orozco.

Tresguerras completed various civil constructions and works in engineering, such as the Bridge of the Laja in Celaya, but his most refined work is the house of the Counts de Rul, in Guanajuato (fig. 128). Its beauty has always provoked admiration. The two-storied façade is elegantly simple, with horizontally grooved masonry on the ground floor and deeply channeled Ionic pilasters and columns on the second. The center section is topped by a pediment with a beautifully carved relief with shields projecting from the tympanum. The effect on entering the courtyard, built of rose-colored stone in beautifully conceived proportion, is without parallel. Its octagonal plan, its columns, moldings, and discrete ornamentation are almost like a miniature in their refinement and are yet not without vitality. It is a perfect and exquisite monument.

Sculpture and Painting. The masterpiece of neoclassical sculpture is the equestrian statue of Carlos IV which Tolsá completed in 1803 (fig. 129). Possibly the sculptor had in mind the image of a similar statue by Girardon, now lost, which represented Louis XIV, but this does not detract from the genuine warmth and force of the work. The king, dressed as a Roman emperor, is astride a robustly modeled Percheron. The effect of

the whole is majestic; yet, when seen in detail, the sculpture pleases and excites the more, for the vigor with which the arms and hands, and the head of the horse, are treated show the touch of a born artist. Without doubt this is one of the few equestrian statues that belongs at the highest level in the history of art.

By Tolsá also are the statues of Faith, Hope, and Charity that stand above the clock on the Cathedral of Mexico, as I have mentioned. He also sculptured an image of the Virgin, which is in the Church of La Profesa, in which the forms move with a softly baroque rhythm. A great architect and a great sculptor, Tolsá merits more than just a local consideration in history.

Neoclassical painting had as its representative Rafael Ximeno y Planes (1759–1825), a well-trained artist in the Spanish tradition of Tiepolo and Mengs. Light colors took the place of tenebrism in the painting of New Spain, and bold foreshortening and strong and direct drawing were substituted for the weaknesses of Cabrera and his school. Ximeno revived mural painting in Mexico, as other neoclassical artists were doing in Europe. He painted the dome of the Cathedral of Mexico according to the new concepts (destroyed by fire in 1967). The principal subject is *The Assumption of the Virgin*, which appeared on the north side. The general composition was built up from circular bands or rings of clouds and groups of figures of saints and angels placed at different levels, all shown in well-developed aerial perspective. Ximeno was a great draftsman, and the studies for the painting of the dome show his particular talent and skill. The same artist painted two pictures for the ceiling of the chapel in the Palace of Mines. The best is the one that represents *The Miracle of the Pocito* (fig. 127), which is especially interesting because it includes groups of Mexican Indians, seen through neoclassical eyes to be sure. But it was the first time that they had a place in formal painting. Two portraits by Ximeno are particularly unusual and fine. One is of the engraver Jeronimo Antonio Gil. It is painted in light colors and the drawing is first rate, conveying the character of the man with precision. The other is a seated portrait of Manuel Tolsá (fig. 130), magnificently executed in warm tones. One might say that it recalls certain portraits by Goya, whereas that

of Gil, a Tiepolo or Mengs. At any rate, they are two excellent paintings.

Ximeno left disciples, and one of them, José María Vásquez, painted the delightful portrait of Doña Luisa Gonzaga Foncerrada y Labarrieta in 1806 (fig. 131), which in its drawing, excellent execution, and representation of the fashion of the period, is a beautiful and representative work of the time.

An artist from Puebla, José Luis Rodríguez Alconedo (1761–1815), was the last important painter of New Spain. He has been called the Mexican Goya, but this is an exaggeration. Two of his works are sufficient to mark his place in history: his *Self-Portrait* (fig. 132) and *Portrait of Señora Hernández Moro*, both executed in pastels and now in the Academy of Fine Arts in Puebla. The drawing, the grace, the knowing treatment of material, and the effects achieved by Alconedo in these works reflect his personality, his skill, and his sensibility. He had been a silversmith working in chased silver, and the silver plaque with the likeness of Carlos IV (National Museum of History, Chapultepec) is one of his notable works.

Engraving. Engraving in the Neoclassical period must not be overlooked. First of all, there was the engravings in metal of medallions and coins, an art in which Jerónimo Antonio Gil was equal to the best. The medals commemorating the foundation of the academy and the erection of the statue of Carlos IV are very fine. He also produced notable works in prints made by metal engraving. The beautiful engraving showing the Plaza Mayor of Mexico City, with its new neoclassical disposition for the installation of an oval in the center to set off the statue of Carlos IV, is of great perfection and real charm (fig. 133). The architectural parts were worked out by González Velázquez, the drawing for the engraving was by Ximeno, and the plate was executed by the engraver Fabregat. It is, in a sense, a summary of the moment. The point of view, from the southeast corner of the plaza, was well chosen. From there the new arrangement can be seen, and the building of El Parián on the left does not disturb the view of the whole setting as it stood in 1796, the date of the engraving.

The masterpiece of neoclassical engraving is the plan of

Mexico City conceived by Don Diego García Conde and engraved in a series of large plates by José Joaquín Fabregat, with ornaments designed by Ximeno. It is dated 1807. It was the first scientifically drawn plan of the capital, and the task of reproducing it was carried out well by the engraver, so well that it remains a durable work of high artistic and scientific quality.

As a whole, the Neoclassical period in New Spain was brilliant. The short time it existed was nonetheless sufficient for it to leave a series of notable works and a profound influence. It did away with baroque art and, as has been said, "It restored good taste," but in actuality it was itself only one more new historical taste, as transitory and fleeting as the others.

SUMMARY

It has been necessary to treat the art of New Spain with some fullness, considering the limits of this work, in order to point out its qualities through a few select examples of indisputable artistic and aesthetic quality. Nonetheless, a great multitude of works and a variety of expressions have been left out which the interested person might discover for himself.

The works of New Spain can be grouped into three great periods, great because of what they accomplished in their own terms. Medieval-Renaissance Art combined archaistic Romanesque and Gothic forms with the classic forms of the Renaissance. In the amalgam lies its great character, for it produced original works of true importance in the new solutions adopted, in the heroic proportions, in the sheer number of works, and in the touches of native character that prevailed. All these things helped to distinguish the works from contemporary European art. Baroque art went from the vigorous forms of a severe classicism to greater, ultra-baroque, complications including the churrigueresque, to become a fundamental chapter in the history of art. In it there was an increase of mestizo originality, of Mexicanisms, encountered in no other part of the world. An art of great sumptuosity and richness, it expressed perfectly the life, taste and the ideas of the viceregal period in its long central development, its growing economic and cultural force, and the display of attendant ostentation. Neoclassical art, which

produced in a very short period works of great importance, grandly expressed the modern currents of taste and thought that opened the doors to the future independence of Mexico.

One could not ask for a more brilliant epoch in art than that of the viceregal period in New Spain. Few countries can offer a production so full of interest, for original and first-class works are to be found at every turn. Those who think that only the ancient indigenous art of Mexico is important are wrong. Each —the indigenous and that of New Spain—is a part of the Mexican past, and together they produce the exceptional character of Mexican Art. But history does not pause here, nor does the production of great works of art. On the contrary, as an independent nation also, Mexico has contributed new creations of first rank to world art.

Selected Bibliography

In English

Anderson, Lawrence Leslie. *The Art of the Silversmith in Mexico, 1519–1936.* New York: Oxford University Press, 1941.

Baird, Joseph Armstrong, Jr. *The Churches of Mexico, 1530–1810.* Berkeley and Los Angeles: University of California Press, 1962.

Edwards, Emily. *Painted Walls of Mexico.* Austin and London: University of Texas Press, 1966.

Fernández, Justino. *Mexican Art.* London: Spring Books, 1965.

Kelemen, Pál. *Baroque and Rococo in Latin America.* New York: Macmillan Co., 1951.

Kubler, George. *Mexican Architecture of the Sixteenth Century.* 2 vols. New Haven, Conn.: Yale University Press, 1948.

Kubler, George, and Soria, Martin. *Art and Architecture in Spain and Portugal and their American Dominions, 1500–1800.* Baltimore: Penguin Books, 1959.

McAndrews, John. *The Open-Air Churches of Sixteenth Century Mexico: Atrios, Posas, Open Chapels, and other studies.* Cambridge: Harvard University Press, 1965.

Ricard, Robert. *The Spiritual Conquest of Mexico: An Essay on the Apostolate and the Evangelizing Methods of the Mendicant Orders in New Spain, 1523–1572.* Translated by Lesley Byrd Simpson. Berkeley and Los Angeles: University of California Press, 1966.

Toussaint, Manuel. *Colonial Art in Mexico.* Edited by E. W. Weismann. Austin, Tex.: University of Texas, 1967.

Weismann, Elizabeth. *Mexico in Sculpture, 1521–1821.* Cambridge: Harvard University Press, 1950.

In Spanish

Anales del Instituto de Investigaciones Estéticas. Mexico City: U.N.A.M. Various volumes from 1937 to present. Contains numerous articles based upon original research.

Anderson, Lawrence. *El Arte de la Platería en México.* Mexico City: Editorial Porrúe, S.A., 1956.

Angulo Iniquez, Diego. *Historia del Arte Hispano Americano.* Barcelona: Salvat Editores, 1950–1956.

Atl, Dr. (pseud.); Benitez, José R.; and Toussaint, Manuel. *Iglesias de México.* 6 vols. Mexico City: Secretaría de Hacienda y Crédito Público, 1924–1927.

――――. *Catálogo de Construcciones Religiosas del Estado de Hidalgo.* 2 vols. Mexico City: Secretaría de Hacienda y Crédito Público, 1940–1942.

――――. *Catálogo de Construcciones Religiosas del Estado de Yucatan.* 2 vols. Mexico City: Secretaría de Hacienda y Crédito Público, 1945.

Couto, Bernardo. *Diálogo sobre la pintura en México.* Mexico City: Fondo de Cultura Económica, 1947. Critical edition by M. Toussaint.

Dirección de Monumentos Coloniales. Mexico City: Instituto Nacional de Antropología e Historia. See the various published studies.

Estudios y Fuentes del Arte en México. Mexico City: Instituto de Investigaciones Estéticas. Various volumes dedicated to the art of New Spain. See the complete catalog of the Instituto de Investigaciones Estéticas, U.N.A.M.

Fernández, Justino. *El Retablo de los Reyes: Estética del Arte de la Nueva España.* Mexico City: Instituto de Investigaciones Estéticas, U.N.A.M., 1959.

Gante, Pablo C. de. *La Arquitectura de México en el siglo XVI.* Mexico City: Editorial Porrúa, S.A., 1954.

MacGregor, Luis. *El Plateresco en México.* Mexico City: Editorial Porrúa, S.A., 1954.

Maza, Francisco de la. *Los retablos dorados en Neuva España.* Enciclopedia Mexicana de Arte, vol. 9, 1950.

――――. *Arquitectura de los coros de monjas en México.* Mexico City: Instituto de Investigaciones Estéticas, U.N.A.M., 1956.

――――. *La ciudad de Cholula y sus iglesias.* Mexico City: Instituto de Investigaciones Estéticas, U.N.A.M., 1959.

Morena Villa, José. *La Escultura Colonial de México.* Mexico City: El Colegio de México, 1942.

――――. *Lo mexicano en las Artes Plásticas.* Mexico City: El Colegio de México, 1948.

Rojas, Pedro. *Tonantzintla.* Mexico City: U.N.A.M., 1956.

Romero de Terreros, Manuel. *El Arte en México durante el Virreinato.* Mexico City: Editorial Porrúa, S.A., 1951.

Toussaint, Manuel. *Arte Colonial en México.* Mexico City: U.N.A.M., 1962.

————. *Paseos Coloniales.* Mexico City: U.N.A.M., 1962.

————. *Pintura Colonial en México.* Mexico City: U.N.A.M., 1965.

Villegas, Víctor Manuel. *El gran signo formal del Barroco.* Mexico City: Instituto de Investigaciones Estéticas, U.N.A.M., 1956.

3

MODERN ART

ROMANTIC ART

The first wave of Romanticism in Mexico was associated with independence and was expressed in neoclassical forms. The struggle for emancipation from colonial rule created a strange but understandable hiatus in native artistic creation. For this reason it is particularly useful to turn our attention for a moment to the works of some foreign artists in Mexico. Through their works we can come to know the life and customs, the landscapes, and even the economic interests of this part of America that Spain had guarded jealously and that had finally been opened to greater possibilities and to closer relations with other countries of the world.

Among the foreign artists who worked in Mexico in the first decades of the nineteenth century, some few must be at least mentioned. First of all is the Italian Claudio Linati, who introduced lithography into Mexico and later published in Brussels (1828) his fine book *Civil, Military and Religious Customs of Mexico*, with excellent colored lithographs of local dress accompanied by a sensitive, critical text. Linati's book serves today as an introduction to the period of independence in Mexico. A painter of genuine interest was J. Moritz Rugendas (1801–1858), whose series of paintings on Mexico, some of which are to be seen in the National Museum of History, Chapultepec, executed with ease and skill, form another document of inestimable value for an understanding of the life and customs of the time. Octave D'Almivar, an adventurer and painter, left a magnificent view of the Plaza Mayor as it looked at the time of the first empire of Agustín de Iturbide, 1823 (private collection). Daniel Thomas Egerton (1800?–1842), an English painter, published an album with views of Mexico (1840) and left unpublished many works on the country.

Madame Calderón de la Barca in her letters, published under the title *Life in Mexico* (1843), another almost obligatory introduction to the study of nineteenth-century Mexico, rightly complains about the abandonment in which she found the academy. Not until a study of the arts was undertaken as a part of

the vast progressive program in the government of General Santa Anna was the academy reorganized and began a new life that extended to the first years of the twentieth century. The renovated institution opened its doors with a distinguished faculty in 1847.

Most of the paintings we shall consider are in the Palace of Fine Arts, Mexico City; others are in the new Museum of San Carlos.

Academic and Popular Painting. The Spanish master Pelegrin Clavé (1810–1880) was brought from Rome to teach painting in the academy. Underlying his work was a classicism in the manner of Ingres and the early German Romanticism of the Nazarenes, among whom he admired Overbeck. Thus he directed his followers in the path of very sentimental religious painting, with ideal beauty—that is, the classical—as a goal, and reserved the classical expression of Ingres for himself. In this style he produced several excellent portraits, such as the one of Señorita Echeverría (fig. 134), the one of Andrés Quintana Roo, and those of the architect Lorenzo de la Hidalga and his wife (private collection), which rivaled the best of Europe in their drawing and execution.

In the light-toned works of his followers, well-composed and well-drawn subjects were generally taken from the Old Testament or scenes in which the soft figure of Jesus replaced the tragic face of Christ. Clavé and his followers enjoyed considerable success because this kind of painting agreed with the romantic and sentimental spirit of the time. But that was not sufficient, because the critics wanted them to paint Mexican subjects; so Clavé, acting always with ingenuity, had his followers produce academic works on subjects drawn from the history of the ancient indigenous world. One of these furnishes a good example: *The Discovery of Pulque,* by José Obregón (1832–1902) (fig. 135). Judged today from the standpoint of a very different attitude, these seem to be very mistaken works, for they tried to idealize the native types in accordance with classical models, and so the Mexican Indians appear in theatrical scenic reconstructions dressed like Apollos and vestals. Only

in a few figures does a weak realism, as it was called, or natural-ism show forth.

Clavé also tried his hand at mural painting and, together with his followers, decorated the dome of the Church of La Profesa, but the paintings were destroyed by fire in 1915. In general, those who consider themselves the most advanced tend to deprecate academic painting for its idealism and sentimental subject matter, whereas the most conservative continue to pre-fer it as if it were the true art. The error of either view is ap-parent. The first forgets that academic painting is the expression of a particular epoch and that works of excellent quality exist within it and, in Mexico, even innovation may find place; the second shows a faulty sense of history and of present-day aware-ness.

Clavé's rival was the Mexican painter Juan Cordero (1824–1884), also an academic painter trained in the classical school of Rome. He returned to Mexico after having executed some very large canvases, such as *The Woman Taken in Adultery* (Museum of the Colegiata de Guadalupe) and others on his-torical themes, such as *Columbus before the Catholic Sover-eigns.*

Cordero had painted a fine canvas in Rome, *Portrait of the Sculptors Pérez and Valero* (1847) (fig. 136), which was an innovation in its introduction of two Mexican types in a classi-cal composition. Such characters most certainly did not fit into the concept of ideal beauty. Cordero also painted portraits of General Santa Anna and of his wife Doña Dolores Tosta (1855), which is possibly the most interesting he produced. It is a full-length portrait which is in one of the salons of the National Palace. The composition recalls the great aristocratic portraits of other days; and the elegant gold brocade gown adorned with camelias and pearls, the diadem, the throne, and canopy at the left—all give it an imperial tone. The execution is excel-lent, but the coloring and a certain hardness in the forms give the painting a character which, although novel, goes rather beyond the bounds of classical principles and taste. Cordero furthered the renewal of mural painting, and two of his works —the dome of the Church del Señor de Santa Teresa (1857),

and the dome of the Church of San Fernando (1859), both in Mexico City—well display his skill and personality. But these works like those of Clavé in La Profesa, were very traditional in their form and subject matter, and the critics asked for paintings of local history, its life, customs, and heroes, using types which were really Mexican. But this was not possible; it would be necessary to wait almost a century. The leader of the new philosophical movement, in step with his time—with positivism —was Doctor Gabino Barreda, a friend of Cordero. Inspired by him, the artist painted in the National Preparatory School (1874) the first mural on a philosophical subject, now no longer to be seen, showing Science, Industry, and Commerce casting out Ignorance and Envy. It was the theme of *El Progreso*.

Clavé and Cordero stand for academic painting as maintained by masters of high quality, but along with them came others, such as José Salomé Pina (1830–1909) and Santiago Rebull (1829–1902), who dominated artistic education, classical and romantic, until 1902. Felipe Gutiérrez (1824–1904) was an interesting painter because he successfully attempted naturalism, following the model closely without idealization. His two paintings, *Saint Bartholomew* and *Saint Jerome* (fig. 137) are excellent. Gutiérrez painted the only female nude of the period, *The Amazon of the Andes*, which recalls Courbet.

As the century advanced, the strain of Romanticism in academic painting became more marked and sentimental. Manuel Ocaranza (1841–1882) was a good painter, delicate and sensitive. Two of his paintings, *The Wilted Flower* and *Love's Mischief* give an idea of his work. José Ibarrarán (1854–1910) conformed to the style of his time in *Christian Martyr*. On the other hand, Gonzalo Carrasco (1859–1936) more closely follows the naturalistic leanings of Gutiérrez, and his *Job on the Dung Heap* is a work of fine quality. Historical subjects also appear. Félix Parra painted Fray Bartolomé de las Casas (1876) and a *Galileo* (fig. 138), the latter of superior quality; Leandro Izaguirre painted *The Torture of Cuauhtémoc* (1892) (fig. 139), which carried academic painting of a naturalistic kind to a level at which it could preserve its dignity. In general, naturalism produced better results than classical idealism, for with it

Mexican costumes and types could achieve a certain character, as in *The Wake*, a fine and dramatic painting by José María Jara.

With the decay of academic painting near the end of the nineteenth century, and with the death of Rebull in 1902, the studies of the academy were left without direction. The Spanish painter Antonio Fabrés was brought to Mexico, and he headed the institution from 1903 to 1906. Fabrés was a skilled and disciplined artist who restored and ordered the school in many ways; his concept of painting, however, rather than being in any way innovational, belonged to the last expression of that romantic naturalism that we have come to call photographic in its detailed reproduction of objects. His major work, *Los Borrachos* (1904) (Museo de San Carlos) recalls in its title the work of Velázquez, but it depicts a group of happy musketeers, with capes, lace, and broad-brimmed plumed hats, who have enthroned one of the group, half naked, in the role of Bacchus. The expression and the theme were decadent, but Fabrés was a sound master who taught drawing with precision. Another somewhat archaizing strain was present in the high quality works of Germán Gedovius, which were inspired by seventeenth-century Spanish and Dutch painting; his large painting with a reclining nude (private collection) sums up all the spirit of the end of the century.

The final expression of Romanticism had as its representative a worthy, profound, and able artist—Julio Ruelas (1870–1907). A great draftsman, he was an illustrator, a vignettist, and a first-class engraver. Some of his works appeared in *Revista Moderna*, on which some of the most distinguished poets, writers, and thinkers, representing the avant-garde of the time, collaborated. Ruelas adhered to well-executed naturalism but used it, along with archaic costumes and other accessories in decorative form, symbolically. Everything is symbolic in his work, expressing his central preoccupations: life, death, and the tragic sense of existence. Woman, dressed or nude; eroticism; skeletons; skulls; and spider webs are frequent themes in his works. He also painted portraits and allegories, such as the little painting *La Revista Moderna* (1904) (private collection), in which, before an imaginary landscape, the principal collab-

orators of the famous publication appear greeting their patron, who is mounted on a white horse; some are centaurs, others are satyrs, one is a winged devil, and some of the others have been transformed into birds. The strangeness of the environment, the oddity of the figures, and the excellent execution create an effect of an ideal world, yet one which is confronted by reality in the equestrian figure of the patron. The prints of Ruelas are of highest quality. One of them is called *Criticism* (fig. 140); in it a little monster hovers above and penetrates the head of the artist himself, shown here in a self-portrait. With Ruelas the Romanticism of the nineteenth century was over. Already in his works appear forms of Art Nouveau.

We have followed academic and romantic figure painting of religious, historical, philosophical subjects and costume pieces, finally into a philosophical, symbolic, and fantastic phase. But now we must go back and consider what, to my way of thinking, is the most important expression of the century: landscape painting. The major exponent is a first-rate painter, José María Velasco (1840–1912). He was a disciple of Eugenio Landesio (1810–1879), an Italian master recommended by Clavé who was brought over to teach landscape painting in the academy. Landesio was an excellent painter and teacher, and his disciples produced excellent works. He himself executed many paintings in Mexico because he was impressed by the monumental aspect of nature in America; he was interested in unusual aspects, such as the Valley of Mexico, the haciendas, and the aqueducts. An able draftsman, he executed his works with great technical perfection; his golden tones gave a certain romantic theatricalness to the local landscape.

Velasco not only profited by the teaching of his master but very early gave signs of his own personality. Rather more classical than his teacher's, his painting is largely restricted to the colder tonalities of blues and grays enlivened with a wide range of greens. He had an extraordinarily fine sense for color distinctions and could masterfully execute large compositions. Landscape painting was the most modern tendency in Europe. This attracted Velasco; for him, however, it was necessary to give expression not only to the landscape itself but to history, and so with remarkable intuition and expressive subtlety he syn-

thesized the two things, succeeding both in being modern and in expressing history without idealistic falsity. *An Excursion on the Outskirts of Mexico City* (1866) (fig. 141), besides being a handsome composition, includes many figures which intentionally represent all levels of social life in Mexico. His first great work was on a subject that was to make him famous: *The Valley of Mexico* (1875), seen from the hills north of Villa de Guadalupe. The city and lakes extend into the distance, and on the horizon appear the lake of Texcoco and the volcanoes. It is a grandiose composition in which the great curve of the earth and the rolling clouds of the sky engage in a game of counterpoint in a harmonious orchestration. But Velasco surpassed himself in another masterful work, simply entitled *Mexico* (1877). It is also a view of the valley but from another side, chosen to give greater distance and achieve a more imposing monumentality. There, among the mountains, an eagle is flying carrying a snake in its beak. Contrasts of light and dark are graduated to establish the different planes with precision, and a superb mass of clouds in the sky majestically crown the view. Thus Mexico, in such an allegory, is the land of the eagle and serpent, of vast mountains and plains, of volcanoes, of clouds, of grandeur and solemn beauty. The landscape becomes symbolic, and is transformed into an overwhelming work. Velasco studied botany, and this study, together with his pictorial objectivity, was carried into another of his major works, *The Bridge of Metlac* (1881) (private collection). Besides showing a monumental and fertile nature, it includes a marvelous collection of plants from the region as well as its principal subjects: the bridge, an engineering work; and the railroad, all signifying El Progreso. With his other works, such as *The Cathedral of Oaxaca* (1887) and the views of Teotihuacán, it can be said that Velasco covered the entire course of Mexican history from the indigenous past through the viceregal period to the present, characterized by progress and materialized in the railroad from Veracruz to Mexico City. The catalogue of Velasco's works is extensive; it includes small paintings of great refinement and large paintings of monumental character. Velasco tried to renew his own work in *The Hacienda de Chimalpa* (1893), a painting in which he exag-

gerated a certain harshness and simplification of form, yet at the same time limited his color to achieve certain silver grays and other wonderful effects. In his last years he returned to his Valley of Mexico, which he painted repeatedly in his most characteristic manner, although he moved from his tight objectivity to broad masses, rolling clouds, and transparent atmosphere. The work of Velasco introduced the whole of Mexico into the panorama of painting and can be justly seen only when compared with the best of the European landscape painters of the time: Corot, Théodore Rousseau, Courbet. Velasco is the central and important point of the Romantic century in Mexico.

Alongside the production of academic painting, there flourished in many parts of the country a kind of painting that has been called "popular"—that is to say, painting which developed spontaneously, outside the academy, and whose painters depended more on their own abilities than on what they had learned. Most of this painting is portraiture, but of importance also are the religious paintings in the form of little *retablos* or votive panels; then, too, there are the allegories which reflect on life and death. One of the most interesting regions in this regard is Jalisco, where José María Estrada (1810?–1862?) worked. His portraits have a winning charm for their grace, their depiction of the costumes of the time, and for the character that he gave to his sitters, whether they were children, handsome women, gentlemen, or priests (fig. 143). One does not look in these works for anatomical perfection, perspective, or idealism, but rather for grace, character, spontaneity, a certain ingenuousness, and the observation and inventiveness of the artist. This painting is never lacking in a sense of color, and sometimes reaches extraordinary refinement in its execution and noble sentiment. The academic painters painted the aristocratic portraits of the capital; the provincial painters left us a sincere portrait of the well-to-do from various parts of the country.

More naturalistic than Estrada and more formal and finished, are the works of Hermenegildo Bustos (1832–1907), from Guanajuato (a large part of his work is in the Palace of Fine Arts, having been collected by Francisco Orozco Muñoz).

His self-portrait (1891) is sufficient to justify calling Bustos a great painter in his class. He does not have Estrada's grace, it is true, but his drawing is keenly objective, meticulous without being petty, and his execution is of very high quality.

It is unnecessary to say that, except for a few identifiable and notable artists, most provincial painting is anonymous, which in a way is really of secondary importance since it is always attractive and some of it is documentary—for example, the small painting *A Banquet to General Leon in Oaxaca* (1844, National Museum of History, Chapultepec). Provincial painting extends all the way from great spontaneity, as in the religious votive panels, to the academic tendency seen in the work of José Justo Montiel in Orizaba or of Arrieta in Puebla; but it is always faithful to the life of its time and is animated by the finest sentiments. Modern criticism has rescued this painting from oblivion and from contempt, for it coincides with many of the tastes and concepts of our own time, and thus history has been enriched. The true lover and scholar of art will know how to distinguish without exaggeration works which merit attention whether they originate in academic painting or in this provincial or popular kind; each has its value, and together they form the picture of Mexico in the romantic epoch of our grandfathers.

Sculpture. The academy produced few works of quality in sculpture. The master was Manuel Vilar (1812–1860), a Spaniard trained in Rome in the classical school, who brought together a group of followers of some distinction. Vilar himself was not fortunate in his works, and only his *Columbus*, in the Plaza de Buenavista in the capital and his great statue of Tlahuicole, the first to be done of an indigenous subject (1851) (Museum of San Carlos) can save his reputation. But his followers made up for it. There is an excellent bust of Maximilian (National Museum of History, Chapultepec) by Felipe Sojo, modeled from life, which assumes dignity from its sober, classical treatment. Martín Soriano made the *Saint Luke*, which is still in the old Medical School. But the masterpiece of academic sculpture is the *Cuauhtémoc* (1887) by Miguel Noreña (1843–1894), in the Paseo de la Reforma of the capital, although its

qualities are not readily appreciated unless it is observed from close by and with attention (fig. 144). From a distance, the silhouette and stance are imposing, but also the detailed forms are treated with the greatest breadth and nobility, and the expression of the face is very moving. The classical hand of Noreña is apparent at its best in the feet, which are the work of a skilled master. The pedestal of the *Monument to Cuauhtémoc*, an excellent work of the engineer Francisco M. Jiménez, is ornamented also with two bas-reliefs, one of them by another excellent sculptor, Gabriel Guerra. They refer to Cuauhtémoc's encounter with Cortés and the torments of the hero (fig. 145). Near the end of the century, one of the followers of Noreña who had helped him cast the statue of Cuauhtémoc, Jesús F. Contreras (1866–1902), began to distinguish himself. In a way, he was to be the last interesting figure of the school, and as such his romanticism seems intensified. He is the author of the two marble statues that are today exhibited in the Alameda Central of the capital, *Desespoir* and *Malgré-tout*, works rather more appropriate for a museum. Both show his end-of-the-century romantic agony, and are handled with skill and sincere feeling.

One can say that sculpture in the nineteenth century was maintained with dignity, on a high level, and within a classical taste, except at the end with Contreras, who strove for a kind of expressionism in his *Malgré-tout*. The subjects for the classicists were historical; the more personal works of Contreras, on the other hand, expressed existential states of mind. The French titles may seem surprising, but they accorded with the taste, with its strong French influence, dominant at the close of the century.

Architecture. The neoclassical school of the first academy disappeared with time. About the middle of the century a Spanish architect came to Mexico, Don Lorenzo de la Hidalga (1810–1872), who built several works of importance which, for the most part, have had an unfortunate history. First, he built the ciborium for the Cathedral of Mexico; this was well designed but of mediocre construction; it was destroyed in our time. He erected the National Theater (1844), which was an excel-

lent work for its time, but it disappeared in 1900 when the present Avenue of 5 de Mayo was extended to the Alameda. The old Guardiola Building was replaced by another modern one, and his project for a *Monument to Independence* (1843) in the Plaza de la Constitución, was never realized. The only work of de la Hidalga that is still to be seen—and with pleasure —is the dome of the former Church of El Señor de Santa Teresa (1855), which he built over the neoclassical structure of Gonzalez Velázquez after the original had collapsed in an earthquake of 1845 (fig. 146). The new dome by de la Hidalga, the interior of which is painted by Cordero, is of elegant and slim proportions, resting on a two-story drum and terminating in a lantern. It is interestingly developed inside, being made of two vaults; the lower one springs from the first story of the drum, and is opened up by a huge oculus that allows one to see the second vault of the dome itself, lit by windows in the second story of the drum. De la Hidalga was an able and intelligent architect whose distinctive trait was his work's elegance of proportion.

Javier Cavallari (1811–?), an Italian master, came to teach architecture at the academy. He undertook a great many works and educated many students who distinguished themselves, among whom was de la Hidalga himself. However, aside from the façade of the academy building, he left no works behind— only his name remains on record.

The nineteenth century did not produce many, or important, architectural works, a fact which is possibly explainable by the vicissitudes of Mexican history. Not until the last decades of the past century and the first decades of our own were structures of quality undertaken; some were grandiose, like the Legislative Palace, which was never finished and which finally disappeared, except for its central dome which was transformed for the Monument to the Revolution. But the nineteenth century did a great deal of damage, especially in the provincial cities, because many fine baroque buildings were torn down or modified in order to build new and feeble works with insipid façades. When the architectural boom final began, the architects were foreigners. An Italian, Silvio Contri, built the Central Post Office and the old building of the Secretary of Com-

munications; Adamo Boari, also an Italian, built the National Theater, now called the Palace of Fine Arts, which is an interesting work in more than one way and of considerable importance in the movement called *Art Nouveau* (fig. 147). The interior is, in part, a later work by the architect Federico E. Mariscal. The interior of El Centro Mercantil should also be noted as a part of Art Nouveau in Mexico; it is an elegant and superior work, nowadays quite spoiled. Two Mexican architects built monuments: Rivas Mercado built the *Monument to Independence*, and Heredia the *Monument to Juárez*, both in Mexico City. Then there began to emerge from the storehouse of history the different styles, neogothic and a weak neocolonial. As a whole, the currents in the nineteenth century were academic and classical in principle, but no longer with the strength of the neoclassical. Later, it was L'Ecole des Beaux-Arts which dominated, and there was a final Romanticism when Art Nouveau appeared and some few efforts were made toward a neo-Mexican style.

Graphic Art. The academic master of the engraving of prints was an Englishman, George Augustus Periam, whose followers achieved great technical perfection but produced mediocre works. As for the engraving of medals, which had such a glorious past, some excellent medals were still produced, such as that made by Cayetano Ocampo for the academy in 1881, and some beautifully designed coins with the likeness of Maximilian were engraved by Sebastían Navalón, a disciple of the academic master Santiago Baggaly.

Of greater interest is an engraver who, although he belonged to no particular school, was skillful and clever: Gabriel Vicente Gaona, from Yucatán, known as Picheta. In Mérida in 1847, a curious periodical was launched, *Don Bullebulle*, "published for a society of *bulliciosos* (noisy people)," and in it Picheta published his critical-historical works. His drawing is not always good, but it is saved by his ingenuity and a certain charm. It belongs to a type that was developed in Europe, beginning with Goya and continuing with Daumier and others. The technique with which Picheta executed his engravings was admirably suited to the expression of his irony and good humor.

Without a doubt he is a forerunner of Posada, not in his forms but in his critical spirit.

Lithography was the most important graphic art not only because of its use by Romanticism and for political criticism but because the artists themselves were especially adept. Works like *México y sus alrededores* (1855–56), with lithographs by Casimiro Castro, J. Campillo, L. Anda, and C. Rodríguez, are of great merit. Iriarte, Villasana, Salazar, Blanco, and Escalante were great draftsmen, and their lithographs, at times political caricatures, at other times poignantly romantic illustrations of the literature of the time, were, first of all, works of art within their class. But a little later, mechanical means of reproduction took the place of engraving and lithography, which dropped out of the field of art as normally considered, not to reappear until they resurged with new vigor in our own days.

MODERNISM

Under the art of Modernism, as the movements signifying renovation were called in Mexico, various new and worthwhile expressions can be grouped. Chronologically the term applies to the two earliest decades of our century, but historically it refers to the end of one period and the beginning of another. It is by no means an accident that in the second decade the Mexican Revolution took place.

Painting. Ruelas must certainly be included under this movement; if in one sense he represents the last of the romantics, in another he expressed many attitudes and concepts of the following period in his symbolic formulations and his preoccupation with human existence and its drama. His attitude and spirit will reappear later. Another of the currents which was later to achieve success was begun by another precursor, Saturnino Herrán (1887–1918), an artist of fine sensibility who represented what in France was called synthetism, the most significant figure of which was Gauguin. But Herrán arrived at synthetism through the Spanish painter Zuloaga, and his work has different antecedents. Certainly with Herrán and the new period, one no longer spoke of academic painting, of the

faithful representation of nature and objects, or of ideal classical beauty; no, one tried to express reality in a clearly poetic and subjective sense, using a synthetic manner—that is to say, abolishing detail and simplifying everything in order to emphasize character. The new concept consisted in the *unfaithful* expression of nature in order to achieve a truer expression of the artist's vision. By "poetic" must be understood "creative," that which is a free expression in response to the model. Tradition represents; modern art expresses. This constitutes the difference in the two concepts encountered in the change from traditional art—representational and naturalistic—to modern art —expressive and humanistic—which came into its own in the twentieth century.

A fine draftsman and excellent colorist, Herrán was attracted by a new subject matter, the Mexican life around him at its various levels—the drama, tradition, fiestas, the work of the people, and history itself. He was the first among the painters to turn his attention toward himself and his own world, and he discovered there a new beauty, that of the Mexican people, which he expressed in its full truth and character. Thus, mestizo and creole types display their splendid beauty, as in *The Rebozo* (1916) (fig. 148) in which a feminine nude is combined with the fruits of the country and typical costumes—the rebozo and the sombrero of the charro—shown against a background in which the Metropolitan Sagrario appears as a symbol of tradition. The painting is full-bodied, the brush strokes broad but careful, and the drawing noble. Further, the soft attitude of the girl and the entire composition suggest an attractive kind of life, rich, sentimental, and nostalgic. The *Creole Girl with Mantilla* (1915) (private collection) and the *Creole Girl with a Mango* (1916) (private collection) are based on the same idea. One of the paintings of more profound effect is *The Cofrade de San Miguel* (1917); it tellingly expresses a feeling of sincere piety in the face of a mature man bearing a crucifix and displaying on his chest a scapulary that glistens with singular effect. Two very large works give an accurate idea of the development of Herrán's art. The first is possibly his masterpiece, *The Offering* (1913) (fig. 149); the other *The Jarabe* (1917). In *The Offering*, the forms are sharply cut with

feeling; in *The Jarabe*, they are fluent and simplified. *The Offer-ing* is a well-composed work, richly colored in warm cadmiums. In a barge, a family carries *zempazúchil* flowers to the dead; an old man and a youth stand, and a woman with a child crouches in front. The composition is organized around a cen-tral axis with diagonals; everything is harmonious in the simpli-fied drawing and in the various areas of color. An atmosphere of dignity and melancholy reigns over the scene, in which Mexi-can types are depicted in true character, for they are well under-stood and felt as belonging and familiar. In 1913 the life of the Mexican people appeared in a modern work for the first time and in a form both new and excellent. But Herrán did not stop here. Between 1916 and 1918 he made a series of studies for a monumental frieze that he planned to paint on the walls of the National Theater, then under construction (fig. 150). It had as its subject *Our Gods* and he conceived of it historically. Christ is superimposed on Coatlicue; from one side a group of naked Indians bring offerings, and from the other Spaniards march toward the center. There is neither Indophobia nor Hispanophobia—in fact no phobia at all; they are the two pasts of Mexico, sensed and brought to mind as they are. But the art of this great draftsman is shown principally in the group of naked Indians, who display the elegance of their magnificent bodies. Some of the studies exhibit a remarkably fine and un-usual tenderness. From this time on, native beauty had no rea-son to be ashamed of a dark skin, and could appear alongside others, whether traditional or new. Herrán's sensibility, his great gift as a draftsman and painter, and the newness of his entire work—all place him in the forefront of synthetism.

There were new trends also in landscape painting. A bit late with respect to Europe, there appeared an impressionist painter, Joaquín Clausell (1866–1935). Impressionism was the inno-vation of the last quarter of the nineteenth century. It was based on a concept different from that of tradition; instead of re-producing objects, it attempted to paint the light that makes phenomena apparent. For this it was necessary to devise a dif-ferent technique, using small spots or brush strokes of color which at a distance reproduce the impression of reality. The effect was striking; the canvases radiated a luminosity that had

never been seen in painting. Landscape itself was an important subject, as was genre painting—the painting of daily life. Impressionism provoked a great deal of discussion because the public, and even certain critics, did not like to see forms become vague; they failed to see that it was the totality, the atmosphere created by light, that was so marvelous. They did not like subjects drawn from contemporary life any better, because they were accustomed to traditional themes. Now, everything became paintable; earlier, only certain subjects could be depicted in a determined form. Now, portraits were of a man or of a woman or both together without thought of importance; before, only certain personages were depicted. It was a major change: democracy as the subject, and light as the principal actor. Two celebrated phrases should be remembered: that "the air of paintings is not breathable air," because it belongs to art, not to nature; thus art was "nature seen through a temperament"—that is, seen and re-created by a man, and was not nature itself.

If we remember the academic concept by which Velasco achieved his splendid work, we can understand that Clausell, in painting the Mexican landscape in an impressionist manner, created a new vision precisely because he was working in a different epoch. The impressionism of Clausell had a very personal character, quite different from that of European works; it is more vigorous throughout, and his color is more contrasting (fig. 151). He painted large and small landscapes of different regions, close to and far from the capital. Xochimilco, Santa Anita, San Angel, and Chapultepec inspired many paintings, as did the Pacific coast and the lagoons of Zempoala, where he accidentally met his death. His large paintings are striking in the mastery that he attained, but it was in the small ones that he conveyed a more intimate and tender, but always vigorous, feeling.

Another impressionist, Gilberto Chávez, represents a personal shading within the movement which reached its logical culmination in pointillism. This technique, rather than using tiny brush strokes, employed diminutive dots which, seen at a distance, created rich and new effects; then too, forms were clearly defined in order that the coloring within the different

areas might harmonize. The greatest exponent of pointillism was Seurat; in Mexico, Romano Guillemin painted excellent landscapes in this manner.

Even without pointillism, landscape painting in Mexico would have had an original creator within the concept of synthetism in Doctor Atl (Gerardo Murillo, 1875–1964). Gifted with an enthusiastic temperament, a great traveler, walker, and explorer, a man of culture and wide artistic experience, Doctor Atl created a modern vision of the Mexican landscape. He spent whole seasons on the snow-covered peaks of the volcanoes, which he painted many times; and from the heights of the mountains he gave new interpretations to the Valley of Mexico (fig. 152). He invented Atl colors, a new painting material, and used to good effect the curvilinear perspective developed by Luis G. Serrano. Then, later, he flew in an airplane over his beloved volcanoes and executed paintings from the point of view available only from the air, calling this "aeropainting." Atl simplified his forms and details, and limited or incised them in the manner of synthetism, in some ways like Gauguin and the figure painting of Herrán. His drawings are generally of first quality, and his coloring is brilliant, personal, and new. His interest in volcanology brought him good luck, for he watched a new volcano come into being—Paricutín—and he painted it in a series of often dramatic works. Doctor Atl's work has grandeur and monumentality: his achievement counts along with those of his most esteemed contemporaries. With Velasco, Clausell, and Doctor Atl we have three different and imposing visions of Mexican landscape. This variety is what gives art its richness, not the miserable adherence to a single form or concept, deprecating all else, which is a sure sign of a lack of feeling or understanding for any form of art.

Other painters might be included in what is called Modernism, but it is enough here to refer to only the principal actors in the initial renewal of Mexican painting. With Ruelas and his anguished meditations on existence; with Herrán and his creative vision of the beauty of the Mexican people and his historical consciousness; with Clausell and his new vision of landscape; and with Doctor Atl and his powerful expression of the Mexican

landscape—with all these we have the most important renovating tendencies. Nonetheless, there was another, and it went still further.

Graphic Art. Engraving came to be an art of great importance in the illustration of songs, stories, prayers, and all kinds of events that are generally included in *corridos*—which served both as journalism and popular history. The first person to distinguish himself in this medium was Manuel Manilla (1830–1890?), whose scattered work has not been well identified or for the most part studied. Nonetheless, from the engravings attributed to him, one can gain a sufficient idea of his skill and the differences which existed between him and the engraver who, without a doubt, surpassed him to become the artistic figure of major quality at the end of the nineteenth century and the beginning of the twentieth. I am referring of course to José Guadalupe Posada (1852–1913), whose inspired work has extended into Mexican art of our own time. Both Manilla and Posada worked with the publisher Vanegas Arroyo, from whose print shop emerged a multitude of publications that fed popular curiosity, good humor, truculence, and piety. These publications, on paper of poor quality in booklets or on single colored sheets, contained the extraordinary engravings on wood, copper, or zinc of Manilla and Posada which today are prized documents of the period. Posada worked on the periodicals, *El Centavo Perdido, El Jicote, El Teatro, La Gaceta Callejera, El Boletín*, and others published by Vanegas Arroyo which were loaded with a strong dose of political criticism: *El Argos, La Patria, El Ahuizote, El Hijo del Ahuizote, Fray Gerundio*, and *El Fandango.* This use of art as criticism of politics and of social life of differing levels already had a tradition in Europe from the time of the English caricaturists of the eighteenth century, and from Goya's raising the genre to its highest level in his *Caprichos.* Later came the French illustrators, whose major representative was Daumier: at the end of the nineteenth century, the Germans came into prominence, especially in the famous periodical *Simplizissimus.* In Mexico, lithography was introduced by Claudio Linati, who was also the first to use it for political criticism in a periodical, *El Iris.* All the nineteenth-

century draftsmen discussed above cultivated the genre, and in engraving there was the already-mentioned Picheta in *Don Bullebulle*. This long tradition, which belongs as well to that trend in modern art called expressionist, had an outstanding exponent in Posada. In the first place, one has to take into account the fact that Posada was a great draftsman and an able technician; he used a wide variety of styles in his work, depending on whether the engraving was in wood, in copper, or in zinc. He took advantage of each, and his skill and artistic sense in handling form to relate blacks, whites, and middle values were superior. But most important was the freedom with which Posada expressed himself toward the academic and naturalist tradition; he took a decisive step toward the new kind of expression that treated natural form in accordance with the need of the artist to express his idea, his vision or imagination, without limitations of anatomical proportion or naturalistic perspective. Consequently, he would place in the forepart of an engraving a small figure because it had little importance for the event, and, in turn, make a figure farther back or in the background large because it was the principal person and the key to the subject. Further, at least half the works of Posada are imaginative, and, in these he expressed himself with even greater liberty. This is to say that Posada moved toward a profound sense of the symbolic and expressionist art of our own time, and for this reason we see him as a precursor. And he did this consciously, it seems to me, because he was not ignorant of academic art, nor was he incapable of expressing himself according to its rules and ideals—some of his engravings of national heroes and of bullfighters follow natural and objectively observed proportions—but academic procedures did not serve him in giving free reign to his powerful imagination. In determining his own expressive means he gave an idea of what art would become in the future.

Posada illustrated the covers of pamphlets containing songs, stories, and prayers, but his major and most original works illustrate *corridos* based on historical events of the past and of his own time and circumstances. In these, irony, good humor, and truculence served as a springboard for his fantasy and his expressive skill. The most horrendous crimes, accidents, mir-

acles, fortunate or wretched love affairs—these are the subjects with which he worked wonders. But the extraordinary reached a high level in those works that constitute a large part of his production—the *calaveras* (skulls). These represent his vision and interpretation of the other world, of a fantastic beyond that embodies, transformed and transfigured, this world of daily life and history. Through the medium of his world of the *calaveras,* he had even greater liberty to criticize this world of real life—it was equivalent to the part played by the dream in the *Caprichos* of Goya. Posada also invented an odd character, Don Chepito, who, like Daumier's Robert Macaire, served as a kind of mouthpiece for his criticism through ridicule and humor. Don Chepito falls in love with married women, is beaten, gives political speeches, acts as a bullfighter, and is launched through the air. He is a sympathetic character in his complete freedom and as an example of the absurd. Posada also illustrated the *Ejemplos (Examples)* of Vanegas Arroyo, another series of moral diatribes.

Posada's life extended to the beginning of the Mexican Revolution, which became his last great subject and which he illustrated in a complete series of superb engravings, many of them critical in nature. In its entirety, Posada's work constitutes a broad view of Mexican life at the end of the nineteenth century and the beginning of the twentieth, and, as a truly realistic view, it is not flattering; on the contrary, it exposes many vile aspects of man, many censurable attitudes, but it always treats *man,* not political parties, and thus achieves universality. This is a real and true vision of life, elevated to an artistic and aesthetic category expressed in accordance with a new and free concept of art in which the ridiculous, the truculent, the ironical, the marvelous, and the fantastic serve to give force to reality and truth in accord with the artist's vision. Although part of Posada's work moves toward Modernism and part falls within that category, he is not a modernist but a great modern artist who in his tendencies and form of expression belongs to contemporary art of the twentieth century.

It is illuminating to look more closely at a few particular works of Posada. In *Collision between a Streetcar and a Hearse,*

the broken coffin in the foreground exposes the corpse; the streetcar and the carriage are shown in small scale to complete the composition, in this way allowing the idea to come out clearly, even though the proportion of the objects is arbitrary. And it becomes a criticism of electricity, mechanical means, *progress*—the modern world which shows little respect for what is most sacred. In *The Three Graces*, a shopkeeper, a dandy, and a monk are shown dancing as ironically treated symbols of commerce, capitalism, and the clergy. In another engraving, *A Son Killing His Mother*, Posada's artistic skill is evident; the composition is classical, with axis and diagonals, in spite of the fact that the drawing of the figures is very free. In *The Entrance of Madero into Mexico*, the first man of the Revolution and his wife, seated in a carriage saluting the public, are shown in the lower part; but the two figures stand out by their size, since they form the principal subject, whereas the rest is depicted very small. The largest and most important engravings come from the last period of Posada's work. The imposing *Big Spur against the Knife* (fig. 153) shows only the likeness of a rooster, head erect, in an arrogant attitude. The forms are treated with precision and assurance, and the fine hatching (the little parallel lines) and the dots give it a notable consistency. This engraving in its force and treatment recalls some works of Picasso, and it is not an exaggeration to think of the latter's *Man with Lollipop* (1938) and other similar works.

It is, however, in the world of the *calaveras* that Posada rises to the greatest expressive and aesthetic heights. His famous *Calavera Catrina*, which Diego Rivera included in his mural in the Hotel del Prado, is most elegant in its concept and drawing, with the great hat decorated with plumes and flowers; but at the same time, it is a criticism of vanity and a reminder that all terminates in dust. The *Calavera Huertista*, which some attribute to Manilla, is an excellent work in which a monstrous spider with the face of a skull clutches a bone as scepter and the skull as symbol of the world. It is an allegory of the sinister power of death. From various points of view, in both its form and the idea it expresses, the *Calavera Zapatista* is, to my way of thinking, Posada's masterpiece (fig. 154), but some critics have

questioned its authenticity. The horseman, dressed as a *charro*, is a skeleton who clutches a banner emblazened with the symbol of death, and he rides a wretched but furious horse that gallops in frenzy. Between the horse's hoofs are piles of skulls and bones. With his typical costume and mustaches, the horseman recalls the chief of the agrarian revolution, Emiliano Zapata; his course is one of death, and yet, with unheard-of valor, he tramples on death. Once again we encounter Posada's irony, and the skulls serve the artist's trenchant criticism. The forms could hardly be better, more original, or more powerful. Posada has undertaken a very difficult kind of composition: he has loaded the upper part with large dark forms to make the horseman and his banner stand out, and yet he has been able to maintain the equilibrium as well as to underline the significance of the lower part, which retains a dynamic motion under a sky suggesting an obscure design. Form and idea are ably expressed. In another engraving, the *Calavera of Don Quijote*, a skeleton horseman, his lance at the ready, gallops furiously on a skeleton horse while little skeletons fall to the ground in his path; some flee, but others are thrown into the air. It is a choice print in which Posada criticizes ironically the quixotic—that is, the puritan—spirit. Finally, let us consider one last print: the *Calavera of the Bicycles*. Here some skeletons happily take over the mechanism of that modern vehicle the bicycle. The cyclists are characterized by symbols and headgear. The principal one is an old man with a long white beard, wings, and a halo—time, who runs over a skeleton, dressed in a plumed helmet, representing tradition, the past. At the left, a skeleton is shown with saintlike rays around his head. At the right are three more cyclists: Liberty with her Phrygian cap, Aristocracy with mustache and plumed hat, and Capital in a high silk hat. Two little skeletons, one with a *charro* sombrero and the other in skirts, try to follow the course of the others on their bicycles. The meaning of the subject is obvious: the celestial and terrestial powers circulate on the symbol of progress, the bicycle, running over the past, tradition, and whatever gets in their way. The figures are ridiculous, but they are very real and convincing symbols. Thus Posada once more, through his irony

and ridicule and his extraordinary fantasy, criticizes modern times, mechanism, and cruelty.

These few examples give some idea of the engraver who surpassed in his genius all traditional limitations and created a new expressive language of the highest kind. Further, his was a visual criticism of the historical, social reality of his time and, as such, takes on a universal significance. Posada is not simply a popular printmaker, as he has sometimes been considered, but a great artist on a level with the best of those of the twentieth century.

SUMMARY

In the century of Romanticism in Mexico, painting came to be the major expression in its quality and in the quantity of works produced. Academic painting took on a somewhat special character, and some innovating subjects were introduced which ushered in a conscious Mexicanism. Historical subjects were granted greatest importance, and mural painting was renewed, used first in a traditional way and then with a philosophical cast in accord with the ideas of positivism and progress. The portraits of the time are of particular interest. But it was landscape painting that achieved the greatest force and modernity in the works of an artist of first quality—Velasco.

Also of importance were some works of sculpture and lithography. But provincial—or popular—painting, remote from academic canons, gave a special interest to nineteenth-century art. Architecture was secondary in the period, and began to expand and gather force only at the end of the century with the renovating spirit of Art Nouveau.

The new expressions that became current at the end of the nineteenth century and the beginning of the twentieth—especially those which fall within the first two decades of our century, might be called both as a momentary and a historical phenomenon, Modernism. But this term is too general because it suggests only that the art was modern. Impressionism and postimpressionism had representatives in Clausell, Guillemín, Herrán, and Doctor Atl. Expressionism and fantastic art were

the province of Ruelas, and reached their high point in Posada. On the one side, the art was concerned with the discovery of Mexican life and beauty, in its customs, native types, and land-scapes; on the other, it was concerned with reflections on ex-istence in a universal sense and with historical criticism. Such are the currents of Mexican art that immediately precede the great creations of our own time.

Selected Bibliography

In English

Calderón de la Barca, Frances Erskine. *Life in Mexico*. Howard
T. Fisher and Marion Hall Fisher, eds. Garden City, N.Y.:
Doubleday, 1966.

Charlot, Jean. *Mexican Art and the Academy of San Carlos*.
Austin, Tex.: University of Texas Press, 1962.

Montenegro, Roberto. *Mexican Painting 1830–1860*. New
York: D. Appleton-Century Co., 1933.

In Spanish

Catálogos de las Exposiciones de la Academia de San Carlos.
Manuel Romero de Terreros, ed. Mexico City: Instituto de
Investigaciones Estéticas, U.N.A.M., 1962.

Couto, José Bernardo. *Diálogo sobre la pintura en México*.
Mexico City: Fondo de Cultura Económica, 1947. Critical
edition by M. Toussaint.

La Critica de Arte en México en el Siglo XIX. Ida Rodriguez
Prampolini, ed. Mexico City: Instituto de Investigaciones
Estéticas, U.N.A.M., 1963.

Encina, Juan de la. *El paisajista José María Velasco*. Mexico
City: El Colegio de México, 1943.

Fernández, Justino. *Arte Moderno y Contemporáneo de Méx-
ico*. Mexico City: Instituto de Investigaciones Estéticas,
U.N.A.M., 1952.

———. *El Arte del Siglo XIX en México*. Mexico City: In-
stituto de Investigaciones Estéticas, U.N.A.M., 1967.

Fernández, Justino, and O'Gorman, Edmundo. *Documentos
para la Historia de la Litografía en México*. Estudios y Fuen-
tes del Arte en México, I. Mexico City: Instituto de Investi-
gaciones Estéticas, U.N.A.M., 1955.

Linati, Claudio. *Trajes civiles, militares y religiosos de México*.
Mexico City: Instituto de Investigaciones Estéticas,
U.N.A.M., 1956. Facsimile reproduction of the original work
published in 1828.

Posada, José Guadalupe. *Monografía de las obras de José Guad-
alupe Posada, grabador mexicano*. Frances Toor, Paul O'Hig-

gins, Blas Venegas Arroyo, eds. Mexico City: Publicada por Mexican Folkways, 1930.

——. *José Guadalupe Posada, ilustrador de la vida mexicana.* Mexico City: Fondo Editorial de la Plástica Mexicana, 1963.

Revilla, Manuel G. *Biografias* (Artistas). Biblioteca de Autores Mexicanos, T.I., 60. Mexico City: Agiieras Editor, 1908.

Revista Moderna de México. 1903–1911.

Toussaint, Manuel. *Saturnino Herrán y su obra.* Mexico City: Ediciones México Moderno, 1920.

4

CONTEMPORARY ART

Mexican art of our own time, especially mural painting, is closely linked spiritually and ideologically with the social and political movement that brought about a renewed life in the second decade of the century: the Mexican Revolution. Yet in truth it went beyond nationalism to achieve a universal quality. With an aching conscience and a poor physical condition, Mexico felt itself oppressed from the end of the nineteenth century, in spite of the fact that the Porfirian Peace culminated brilliantly in 1910, celebrating the Century of Independence. The following year the revolution broke out, and the struggle lasted almost ten years, even though the new constitution established its ideals in 1917. It was not only a matter of a political movement trying to free itself from a regime that had continued longer than desirable, but of a consciousness of a whole new vision of life and culture embracing all aspects of existence. It was a renewing movement, profound and genuine, that, in tune with its time, anticipated similar movements that later burst forth in other countries. In politics, economics, philosophy, history, and art, the new ideas and feelings that began to take shape awakened a new consciousness that struggled for a new order and new expression in everything. Mexico turned its gaze upon itself and discovered the richness and the possibilities of its own being. Thus, the revolution and art took on consciously Mexican and popular accents that have continued to the present.

But the nationalist ideas went well beyond their own limits and finally took on a humanistic character of universal scope. Nowhere else is this better expressed than in contemporary mural painting. To study and understand this art is to consider and submerge oneself in the spiritual, social, political, philosophical, and historical problems of our time, not only in Mexico but in the panorama of world culture. On the other hand, it is necessary to have some knowledge and awareness of the problems of history, particularly Mexican, to understand contemporary Mexican art, just as it is necessary to have some idea of the development of new currents in art in general to appreciate the importance of the great Mexican works of this century.

Mural and Easel Painting. A desire to revive monumental painting had existed since the eighteenth century. Tiepolo, Mengs, David, and Goya worked at it in Europe; Ximeno, in Mexico. The most original and important were the paintings by Goya in the Chapel of San Antonio de la Florida, on the outskirts of Madrid; in addition to the original expression of the artist, these introduced a great popular scene relating to a miracle of the saint. Later in the nineteenth century, Delacroix, Ingres, and others persisted in mural painting without succeeding in seriously reviving it. In Mexico, throughout the nineteenth century there existed the desire, expressed especially in criticism, that this great art be revived; the attempts of Cordero and Clavé and their followers came as a response to this wish but were not sufficient. Mural painting has appeared in those historical periods of great change and spiritual disturbance when there was something new and profound to express, as in the Renaissance. Although under Neoclassicism there was a brilliant but transient burst of activity, it can be said that when Mexican mural painting appeared in 1922, this genre had been dead in effect for a very long time.

The Mexican Revolution coincided with important innovations in art. New concepts permitted a freedom of expression contrary to representational and naturalistic traditions in art, capable of giving a new view of beauty and history untrammeled by classical cannons; for a long time Mexico had wished to express in art its history, life, ideals, and beauty. Then too, the circumstances were propitious—there were freedom, new ideals, and, above all, artists of major stature, who, fortunately, emerged at the opportune moment. The result of three or four decades of creative effort is evident in the great works which were realized and which figure among the most important contributions that Mexico has made in our time to world culture, if they are not the most important. Only by understanding contemporary art as well as the problems and the vital and spiritual conflicts of our time, can one do justice to this art, which is of the highest category. Otherwise, one falls into vulgar attitudes, the offsprings of ignorance or narrow criteria, which are not capable of bringing the works into proper focus. One must be prepared to understand art from a historical viewpoint—per-

sonal preferences can come later. Mexico revived mural paint-
ing and created new and imposing artistic expressions that must
be given attentive consideration. That they should express ideas
and attitudes which are extremist, revolutionary, and of vary-
ing sorts is natural because life is fundamentally a matter of con-
flict. Without conflict there would be no life; that this fact
should be expressed in art is not only natural but healthful, be-
cause culture flourishes only under freedom.

The two great creators of Mexican mural painting are dead—
José Clemente Orozco and Diego Rivera. David Alfaro Siquei-
ros continues to be active, Rufino Tamayo has enriched the pro-
duction in recent years, and others have continued in the wake
of the earlier generation. The movement has, above all, artistic,
aesthetic, and spiritual importance; further, if the works are to
be studied in depth, they must be considered in their variety of
expression and content, at times contradictory, and not in terms
of a single end, politically defined. Politics forms a part of life
and as such is appropriately included in artistic expression, but
it is not in any sense its principal aspect, in spite of how it
may at times appear. Quality of artistic expression is what
counts, and the character of this expression is critical-historical,
philosophical, and, ultimately profoundly humanistic and uni-
versal in its import, transcending any other interests. So, to con-
sider the great personalities and some of their most significant
works—certainly all cannot be considered here—is to enter a
marvelous world which affords many kinds of surprises.

Diego Rivera (1886–1957) is without a doubt one of the
great creators in contemporary art. It is fitting that he should
be considered first of all, because his work allows us to follow
the development of twentieth-century painting through one of
its most important currents, one with a classicist basis which
broke with the tradition of post-impressionism. Rivera's educa-
tion as a painter began in the old Academy of San Carlos in
Mexico City, but he soon rebelled against the teaching of Fabrés
and left for Europe in 1907, where he lived until 1921, except
for a brief period when he returned to Mexico at the
1910, returning to Paris in the middle of the followir
These were the years of great changes and innovation
From the very beginning Rivera gave indication of his

and later he was able to master all tendencies. Impressionism with Renoir and especially post-impressionism with Seurat, Gauguin, and Cézanne opened new possibilities to him. A great draftsman and colorist, he leaned toward Renoir for his sensualism, to Seurat and Gauguin for their synthetic formulation, to Cézanne for the geometric constructions, the structural quality of his paintings that finally developed into cubism. Also evident was the freedom of Fauvism (*fauves* means "wild beasts") which set out in 1905 to start everything anew following the dictates of sense or instinct, as they said; the outstanding figure of the Fauves was Matisse. European artists had discovered the qualities of African sculpture, which coincided with their own interests; in 1907 Picasso painted his great work, *Les Demoiselles d'Avignon*, a high point in his Negro period, so-called because of its inspiration from African sculpture. Actually, it was the beginning of cubism. Nor should the presence of Modigliani be forgotten, who made drawings for a portrait of Rivera.

Rivera absorbed the new currents and produced works of quality. His first important contribution to contemporary art was within the movement of cubism, together with Picasso, Braque, Juan Gris, and others. Cubism carried the new vision to its most intellectual extreme, constructive and basically classical. It was concerned with structures; it proposed that painting be the expression of an essential geometrical structure derived from objects, vision reduced to an ideal scheme. Since they were no longer concerned with creating the optical illusion of "natural" space, the painters suppressed a sense of the third dimension, depth, and perspective, and emphasized the surface of the painting in its height and breadth. On this fundamental surface, the planes of the figures, juxtaposed, combined, or superimposed and "transparent," became the necessary elements. But the important fact was that cubism in its analytical beginnings abandoned also the traditional single point of view of objects. Instead, cubism analyzed objects from different angles, fragmenting them and reconstructing them in a new formal harmony, in which various parts of the object—seen from above or below, from one side or another, or possibly in sections—constituted the painting. The presentation of different

views of an object at one single moment in the painting was called "simultaneity." Thus a face, for example, might be presented both from the front and in profile, seen from above or from either side—all at the same time—and be represented in geometrical forms and planes. Color was limited at the beginning, to keep the attention from being distracted from the "essential." The golden section—a proportional formula in which one part is smaller than the other by 0.618 to 1.000—came to be very important, as it had been for all classical artists from the time of the Greeks.

The results were shocking: the artists had painted the essential structure of objects from various points of view, the objects were in the painting, but the public did not recognize them or at least had to work hard in order to find them. The public was accustomed to naturalistic presentations, and now it was confronted with ideal expressions of the "essence" of objects. The repertory of actual objects used by the cubist painters was severely limited: interiors, "portraits," tables, glasses, bottles, pipes, compotes, guitars, cigarettes. Rivera's cubism is very personal and not very close to what was called "analytical," but tends rather to what appeared later and was called "synthetic." This permitted freely curving forms, various textures, and color. The freedom of the Fauves and analytical rigor came together in a broader expression in this "synthetic" cubism. Rivera painted his *Bridge of Toledo* and *The Viaduct* in 1913 in light colors; his *Man with the Cigarette* (1913) (fig. 155), *Portrait of a Painter, The Poet*, and others are later. All are excellent, but little by little his coloring becomes rich and he introduces Mexican hints, such as the fragment of a serape from Saltillo in *The Alarm Clock* and an *equipal* (a Mexican arm chair) in others. Finally, in 1915, he painted *El Guerrillero*, also called *Zapatista Landscape* (private collection), which is an exceptional work composed of a sombrero, a serape, a gun, and a cartridge belt, all seen against the background of a Mexican landscape. This bold and original work in the midst of the preciosity of French cubism is Rivera's cubist masterpiece. His *Majorcan Landscape* recalling Mexico, in rich and dazzling color, is a choice cubist work. These innovations, heterodoxies within the movement, are products of Rivera's strong person-

ality. He later abandoned cubism to follow more personal directions. Yet one can say with certainty that the history of cubism would not be complete without a consideration of Rivera's excellent paintings of this period.

By 1915 the artist had found his own manner of expression, which was neither traditional nor extreme, a kind of poetic naturalism, free, with an accent derived from post-impressionism and from all his personal experiences. Some drawings from this time are of a quality comparable to any other great master of history, especially his pencil drawing *Self-Portrait* (1918) (Zigrosser Collection, Philadelphia), which is a masterpiece in itself. Rivera traveled through Italy, as years earlier he had through other countries, completing his direct experience of the history of art, and returned to Mexico in 1921 to undertake the work in mural and easel painting that was to extend over a period of nearly forty years, astonishing in its extent and the number of first quality works.

The first important mural of the century was painted by Rivera in 1922 in the Anfiteatro Bolívar of the University of Mexico. He used an ancient and difficult technique, encaustic, first incising the outline of his drawing on the surface. Still fresh in mind were his recent experiences; forms are combined and are predominantly curved and geometrical, but they depend also on his own naturalistic manner, which was full of character. The subject is philosophical: the first energy from which all is produced and to which all returns. On one side are masculine attributes and attitudes; on the other, feminine. In spite of the eclecticism of this mural, it contains some of the greatest inspirations of the artist, as in the figure of Faith, which is profoundly noble and moving. The painter added gold to his range of colors, giving it an interesting and somewhat archaic effect.

Rivera sought for and achieved a style which would be free and modern and yet would be accessible to the senses and the understanding. With extraordinary talent for constructing compositions, a masterful draftsman as well as colorist, he had two principal characteristics—his intellectual and inventive capacity and his refined sensuality—both of which sustain and give life to his monumental concepts. He executed his first fully developed work in the courtyards of the Secretary of Education

building in Mexico City. Here he painted labor in mines, sugar mills, foundries, agriculture, fiestas. He depicted the dividing of the lands, the First of May, the market, and gave expression to many aspects of Mexican folklore. In the stairway he painted the entire stretch from the lower to the upper floors with panels in which the forest seems to overtake everything, reminding one somewhat of the Douanier Rousseau, although the style is quite different. In the upper hallways he painted—or one might better say, "sang"—the Mexican Revolution with evident idealism and sharp criticism of the past. The negative powers are capitalism, militarism, and clericalism; the positive forces are the worker, the peasant, the soldier, and—obviously—the Mexican people. In these large, magnificent panels, Rivera shows himself to be a great painter. It was his first work executed in fresco, which from that time he handled with great mastery.

Rivera's masterpiece, it seems to me, is the fresco cycle in the Salón de Actos of the National Agriculture School in Chapingo, near Texcoco, a short distance from the capital, painted in 1926 and 1927. There he fully displayed the extent of his skill and possibilities as an artist. Later he would enrich his work with new subjects, all directed toward making more explicit the task he had undertaken there, but he would never go beyond the level he achieved in Chapingo. The rather small salon is a baroque structure which earlier served as the chapel of an old hacienda. The plan is rectangular; the ceiling is a barrel vault with penetrations, and the space is subdivided by pilasters, cornices, arches, and lunettes. There are windows in the lunettes to the right and round oculi in the right wall. There are also a vestibule and a wall closing off what was once the choir. Rivera took advantage of existing conditions and conceived the subject of his work in this manner: on the right side, he depicted the biological development of human life; and on the left, the historical-social development. The panels on one side correspond to those on the other; for example, in one panel, life germinates; in the corresponding opposite one, revolutionary ideas. This process of germination continues throughout both series of developments, leading to the subject of the end wall. There appear the symbols of the four elements and man, who finally dominates nature through modern technology,

using it for his own benefit. The painter shrewdly reserved the panels on the right for the biological development, placing there against the light from the oculi a series of nudes, some of which, as in that of germination, are masterly in drawing and in the subtlety of their coloring and technique, convincingly poetic and moving. The panels on the left are more abstract in their treatment, and in the lunettes above are symbolic, monumental hands of supreme quality. The wall at the end is composed to relate to the rest, and for this reason the great nude of Mother Earth is placed on a level with the cornices. In the lower part, the symbol of water is another fully formed nude of excellent handling. When the spectator turns toward the entrance, he sees on the wall that seals off the old choir the reclining female nude symbolizing Mother Earth, sleeping with a plant growing from her right hand (fig. 156). It is a colossal figure of fine and noble form, with a mass of black hair covering a part of the face and a sensual, half-open mouth. The artist has painted the flesh with a variety of tints applied in tiny brush strokes to produce the desired effect, and in his hands this becomes a new fresco technique. This great reclining nude itself becomes a part of history, and even though one might remember a whole series, from the Venuses of Titian, of Giorgione, of Velázquez, the Maja of Goya, and the Olympia of Manet, none of these achieves the monumentality of this figure, and one must think of Raphael or of Michelangelo, whose works were quite different expressively but not necessarily qualitatively. In the vaults are a series of dark-skinned male nudes, symbolizing agriculture, which also are excellent in their drawing and effect. In spite of other symbols and themes of a critical-historical nature, Rivera's concept seems inspired by Comte, who required art to sing the domination of man over nature through scientific and technical means. Rivera achieved the full reach of his talents as a painter in Chapingo; the female nudes that he painted there are the finest that twentieth-century art has produced. The entire complex, impressive, coherent, monumental, and splendid, is one of the great pictorial works of our time.

The paintings in Chapingo and the frescoes in Detroit, Michigan, and in the National Palace of Mexico comprise the

most important works by Rivera, but to these should be added the mural in the Palace of Fine Arts (fig. 157), the one painted in 1940 in San Francisco, California, and the one in the Hotel del Prado, Mexico City.

The walls of the Institute of Fine Arts in Detroit, painted in 1932, express the astonishing industrial development of the United States. They show the interior of the diabolically complicated plants in which the beauty of the machinery glows; the artist has been able in some instances to give it even a sensual appeal. The gigantic technical and scientific development extolled here is like the final step in an evolution that Comte had predicted. Then, in a mural in the Palace of Fine Arts, the man who in Chapingo dominated nature and in Detroit created a portentous technical world succeeds finally in dominating both the natural and the social worlds by means of science and technology. Two worlds are shown in conflict—the capitalist and the socialist—but in the center is the technician who dominates the universe. The San Francisco mural has a different theme—the union of the artistic genius of the South (that is, Latin America) and the industrial genius of the North (that is, the United States) to formulate the culture of the future. And there are other interesting details that do not belong in this discussion.

Rivera's vastest interpretation of Mexican history as an example of a universal theme, is in the National Palace, although some of the themes had already appeared on the walls of the Palace of Cortés in Cuernavaca. In one sense, the monumental stairway of the National Palace is conceived of as a triptych, with the central wall functioning vertically from bottom to top as well as horizontally. In the lowest part are scenes from the Conquest; in the center is the emblem of the Eagle and the Serpent; higher up is Hidalgo and independence; and highest of all appears the Revolution of 1910, with Zapata at the top. It is a synthesis developed through a series of planes at different levels, covered with figures. In the lunettes at the top are other episodes: the Reform, General Díaz, the Revolution, and, at the ends, the war with the United States (1847) and the execution of Maximilian (1867). On the right wall is depicted the ancient indigenous world, a tranquil composition,

delicate in execution and very attractive in color. In contrast, on the opposite wall on the left the contemporary world is shown as chaotic, with the symbolic image of Marx at the top. The complete project of these murals also includes the hallways. Along one side, which contains some excellent panels, the indigenous world is depicted; further along is the Conquest, where Rivera has painted a beautifully executed likeness of Cortés with a strange and woeful physique. This is symbolic of the negative sense in which Rivera has shown the Conquest and Spanish colonization, placing it against the positive quality of the indigenous world of the past and the socialist world of the future. The panels were supposed to have been continued with a depiction of the contemporary world, until they again reached the stairway; on the death of Rivera the work was, regrettably, left incomplete; its continuation would be difficult. The frescoes of the National Palace exist on the highest level, and the artist's interpretation of the history of Mexico gives them grandeur. The full complex is an admirable work.

In the mural for the Hotel del Prado, the history is repeated with variations in a fine composition with some parts of outstanding quality. It is entitled *The Dream of the Alameda*— the Mexican people dreams of its history; but at the end there is something new—a criticism of the postrevolutionary period, in which the artist expresses disillusion.

We have encompassed the works of Rivera in great strides because basically he did not introduce any outstanding novelties in his expression after Chapingo. Some works have been omitted from our discussion, such as the frescoes of the Cardiological Institute, those of the Social Security Hospital Number One, and others, not because they are inferior murals but simply because we cannot carry the discussion of his work further in this brief study. However, some easel paintings of superior quality must be considered to serve simply as examples of the artist's vast and varied work in this medium. Rivera painted great historical, social, and philosophical subjects in his murals, and reserved other aspects and themes of life—more pleasant ones—for his individual pictures, in which Mexican folklore displays the richness of its form and color and its incomparable beauty. He made famous the calla lilies which women bring

to the market on their backs in great bunches; regional dances, types, adornments, attitudes, and customs emerge in explosions of color. He was also notable as a portraitist. We might mention the *Portrait of Lupe Marín* (1938) (Palace of Fine Arts), in which there is an echo of Cézanne's compositions in the inclined axis of the figure, but the painting is completely Rivera and one of his best in form and drawing, in concept, and in refinement of color. Another work, *Dancer Resting* (1939) (private collection), is masterly. A great nude, dark-skinned female form, seated on a stool with her arms raised, is composed quite simply on a vertical axis, without falseness—a magnificent painting of truth. The full forms of the nude stand out against the ultramarine background, the skin made up of an infinite variety of tints. It is a new sensual beauty, noble in concept, tranquil, serene, majestic; and it is not a classical beauty—this is its novelty. These considerations could be much expanded with many other works, but the examples we have touched upon are sufficient, it seems to me, to establish Rivera as one of the great contemporary masters and a master of all times.

José Clemente Orozco (1883–1949) bequeathed an inheritance to Mexico and world culture that demands the deepest consideration. A genius throughout, he is for me the master of greatest stature in the twentieth century, and, saying this, I am aware of Rivera, Picasso, and other outstanding painters of our time, both Mexican and foreign. Entirely different from Rivera, Orozco forms with him a pair of opposites such as existed at other times in history: Raphael and Michelangelo, David and Goya, Ingres and Delacroix. Orozco was formed in Mexico. He gained as much as he could from the old Academy and then turned to the street to paint the life around him. He had direct experiences during the revolutionary years, according to his autobiography, and when he began his mural painting his work was already worthy and his experience as a painter large. He was a free spirit and a sincere humanist; his historical criticism had as its sole purpose the expression of reality and of truth without partisanship. He castigated falsity and human baseness wherever he discovered it with his penetrating gaze and intuition. In its freedom and dramatic expression, Orozco's

work attracts through its exciting forms, and yet invites medi-
tation. He is a painter with a baroque ancestry, for movement,
contrast, and rich colors are essential to his work. He is a
master draftsman, and his drawings suggest color in every
stroke. No one has carried tragedy beyond the level of Orozco,
and the variety of expression in his work is unparalleled.

The group of watercolors of prostitutes that he painted in
1913 constitutes a criticism of the dramatic and sordid aspects
of life, but is never lewd, tending rather toward irony and good
humor. One of these works, *The Lecture*, is of an originality
that anticipates the most refined expressionism of later years—
for example, it might be compared with a similar figure in
Guernica (1937) by Picasso—for although the strokes are
schematic they are filled with character. And the idea of a
lightly clad woman seated astride a chair and declaiming with a
wild gesture is highly ridiculous, ironical, and dramatic. Another
group of important works is made up of drawings on subjects
from the Revolution, documents of the vandalism of a tragic
moment, filled with psychological penetration and a variety of
effects; some are in pen, and others are fine wash drawings.
During these years, he produced some oil paintings as well as
caricatures. But if one looks at the portrait of Señora Rosa
Flores, Viuda de Orozco (1921) (Orozco collection), the
artist's mother, one can judge at once the point his ability and
experience had already reached.

Orozco's vast production of mural paintings cannot be con-
sidered in its entirety here. There is a first period, which ex-
tends from the frescoes in the National Preparatory School in
Mexico City (1922–1927), the mural *Omniscience* in the Casa
de los Azulejos (Sanborn's), Mexico City (1925), the Industrial
School of Orizaba mural (Veracruz, 1926), to the *Prometheus*
in Pomona College, Claremont, California (1930), which was
the first mural to be painted in this century by a Mexican artist
in the United States. In these works, Orozco established an
original and monumental style, treating naturalism with abso-
lute freedom; most important was the character necessary to
express his ideas with the greatest power. In the National Pre-
paratory School, he painted tragic scenes drawn from the Mexi-
can Revolution—the change of order—always critical in their

suggestion, as in *The Trinity*. But probably it is in *The Trench* that he achieved the most profound expression of emotion; it is a perfect and admirable work (fig. 158). In the upper hallways of the school, he developed his social criticism: the peasants are called to a new life and abandon their lands to throw themselves into the revolutionary battle, and the resulting scenes are pathetically moving. A new theme appears on the walls of the stairway: the origin of Latin America. It contains fine likenesses of Cortés and Malinche, the symbols of a new race and new human world, in which the monks give aid to the Indians and the conquistadors build with the help of natives. It is the human, spiritual, and material origin of the New World. In *Omniscience*, the subject is humankind graced by both body and spirit, the latter symbolized by fire, which appears here for the first time in the painter's work. Colossal figures cover the wall at the stair landing and harmonize with the baroque architecture which frames them. The Orizaba mural is dedicated to the sacrifice of the soldiers and the con-structive postrevolutionary phase; it is in the segments of the lower part that the greatest emotion and drama are packed. Finally, this period of huge forms and generally somber colors has its climax in the colossal image of *Prometheus* in Frary Hall at Pomona College (fig. 159). The magnificent torso might be compared to similar figures by Michelangelo, Tintoretto, and El Greco. Prometheus brought fire to mortals and humanized them; but this is not only the illustration of an ancient myth but an appeal to the conscience. It is the most prodigious figure of monumental art in the twentieth century.

After executing murals in New York in the New School for Social Research (1931), Orozco took a short trip to Europe, by which time his work had already reached its highest level. He had gone to see at first hand certain works of the past and the present. Pompeian paintings, Romanesque and especially Byzantine art, the Renaissance art of Spain and Venice—these rounded out his experience; he returned to the United States to paint the murals in the Baker Library of Dartmouth College (Hanover, New Hampshire, 1932–1934). There he renewed his own form of expression. Now his drawing becomes tense or soft according to the idea expressed, and his color explodes

in great brilliant harmonies. He paints the ancient indigenous world, Quetzalcóatl, the Conquest, and the modern world of America, mechanistic and scientific; rising above the spectacle of such a world is Christ the avenger, who destroys his own cross as civilizations fall to the earth. This profound criticism of the modern world merits contemplation. These murals at Dartmouth College, the most important contemporary mural paintings in the United States, mark the beginning of a new and splendid period in Orozco's work. They were followed by the mural in the Palace of Fine Arts in Mexico City (1934), a tragic and moving work in which the artist again underscores his criticism of the modern world, and the purifying fire reappears. The forms are violent, and slashes of white among the colored and black strokes produce an electrifying effect. Orozco paints horror, ugliness, and corruption, exposes historical reality; yet he is not a moralist but rather a realist with an enormous capacity for expression.

Orozco at his highest point—the universal humanist—created his greatest works in Guadalajara, Jalisco. He first executed the paintings on the walls and the dome of the Salón de Actos of the university; then the frescoes in the stairway of the Government Palace; and, finally, his masterpiece, in the former chapel of the Hospicio Cabañas, a neoclassical building designed by Tolsá for the institution founded in the eighteenth century and still functioning in exemplary fashion. Orozco's creations in Guadalajara between 1936 and 1939 are overwhelming. In the university, the wall at the end of the Salón de Actos expresses sadness: the unhappy people react against their leaders while the purifying fire radiates its menacing tongues. The style is new and different from all the earlier works; the brush strokes create forms and invented anatomies which intensify the sense of suffering. The dome is different. The forms are outlined in order to carry at a distance. The theme is man, shown in various attitudes and vital circumstances expressed simultaneously in a figure with five heads— a prodigious image. The monumental stairway of the Government Palace, consisting of three walls and a vault, are unified in spite of the fact that the composition is conceived almost as a triptych. The colossal image of Hidalgo in the center, his

face in a strong light, raises a fist and with a torch enflames the multitudes. The people mill about chaotically among red banners, stabbings, and violence. The left wall is shadowy; obscure bishop-like figures and crosses are merged with the figure of a military man covered with a full red cape. This allegory expresses the strange associations of our time. The right wall shows the contemporary political circus. Forbidding clowns throw hammers and sickles in the air, and others wear swastikas on their arms; one raises a cross, but another is about to hit him with a hammer. Finally, above the arches which lead to the corridor, naked wretches succumb in the fire amid burned wood in the form of crosses. Once more the theme is a criticism of contemporary history, over which rises the liberating symbol of Hidalgo, the man of action.

The interior of the part of the Hospicio Cabañas where Orozco painted, with its severe classical lines, made a perfect frame for the works of the artist. In the lower panels of the single nave, he contrasted, in bold, free forms, the indigenous past and the modern world of the sixteenth century that made the Spanish Conquest possible. Before the boot and the whip, the savage dictators, and the concentration camps, stands the image of the benefactor Bishop Cabañas and the wretched people who flock to him, turning their backs on the demagogues. In the great vault, divided by arches, sixteenth-century Spain, warrior and mystic, appears, and the colossal image of Phillip II covers an entire vault with its clear, schematic lines. In another vault, Cortés rises with great dignity, his body made of steel to suggest modernity; an angel, his genius, speaks into his ear. In the opposite vault, a Franciscan appears with an Indian at his feet, and an angel or genius close to him traces the symbolic first letters of the alphabet on a white cloth. Thus military conquest, evangelization, and the possibilities of the modern world are the aspects that determine the character of the sixteenth century in Mexico. The pendentives and the drum above them, divided into panels in which various human activities are depicted, prepare for the view of the central dome, supported by double columns. It is a segment of a hemisphere, and in it the theme of the entire chapel reaches its culmination. The grandeur and originality of the painting in this dome are unique

in the history of art. It is composed of several male figures in various active postures, dark in color against a red background, for in the center the figure of a man is burning, engulfed in flames, and his light radiates around him. It is a meditation on human existence. Man may be this or that, but to live consciously is to consume oneself with life. The effect of the dome is of unbounded emotion. The figures intertwine to form a circular structure, and in the center burns the fire of the man in flames (fig. 160). Here the whole body of Orozco's thought finds its synthesis; the artist has elevated his expression to the highest aesthetic plane, depicting tragic beauty in all its splendor. Orozco has painted man in the various circumstances of life and history. The first circumstance here is the Conquest; in spite of its importance, however, it is only one episode in history. This and other episodes, as well as the whole of history, come to be a realization of man, good or bad, sinner or saint; but finally he is the creative fire, and this fire consumes him. It is amazing how Orozco can construct a face with a few but expressive brush strokes, so sure that they say everything that the artist wants to express. It is an inspired mastery and a formidable imagination of authentic originality; although other contemporary monumental forms may resemble Renaissance works, murals like those of Orozco have no parallel in the history of great painting.

Orozco changes tone in his murals for the Gabino Ortiz Library, in Jiquilpan, Michoacán (1940). These give a popular, though majestic and solemn, air to the end wall, which is brilliantly colored; the panels on the other walls contain scenes related to the Revolution worked out in black lines on a white background. The allegory on the end wall refers to Mexico. A dignified woman rides on the back of an enormous tiger, but the tiger must tread on spiny cacti. The head of the animal is executed with extraordinary and admirable force, beautifully expressing ferocity. In the center, the Mexican eagle is about to be strangled by a red serpent. On the right are three ridiculous figures, possibly the old ideals of Liberty, Equality, and Fraternity. On the opposite side, a wretched, half-plucked little angel possibly symbolizes religious sentiment. From the top descends another ferocious tiger. The whole stands out

against the unfurled national banner. If the full imagination, inventiveness, and originality of Orozco are to be found in one place, it would be here; in these symbols, he creates the allegory of a worthy Mexico, of a difficult, often dolorous, development menaced by dangers and accompanied only by ideals which are mere relics of tradition. But the national consciousness stands above as a kind of hope.

In 1940 Orozco painted for the Museum of Modern Art in New York a mural in six sections on movable panels which can be rearranged but form a unit. In these the expression is more abstract and the color more delicate, although the forms are strong. He entitled it *Dive Bomber*. A metallic mass recalling the wings of an airplane, falls heavily and crushes the heads of men bound with chains; from behind one of the wings of the dive bomber emerges the tail of the demon. Thus, the war machine oppresses and causes grief and death. An added interest in this work is the fact that the painting can be exhibited complete or in a lesser number of panels and still preserve the expression of the original idea. It is a tragic painting which may be put along side Picasso's *Guernica*.

On his return to Mexico, Orozco painted the murals of the National Supreme Court Building (1941). This panel concerning the workers' movements is original in its composition and forms, and harbors a critical comment even though the red banner is there to symbolize the ideal. Other panels have justice for their themes, symbolized by a fire that comes from above and strikes the false judges and bandits; Justice is still there in this world on her monument but asleep, and the sword and laws are about to fall from her hands. It is a diatribe of penetrating significance. Another horizontal panel at the endwall of the hall depicts a section through the subsoil of Mexico showing the precious metals, ironically presented as dead, and oil that takes the form of a monster; the national flag floats above—the conscience—and a novel ferocious tiger seems to take a defensive attitude. Here again a special meaning appears, for riches are nothing so long as the conscience stands over all, on the defensive.

For the vaults of the Church of the Hospital of Jesus in Mexico City, the first founded in America by Cortés and still

functioning, Orozco had conceived of a vast project, but he was able to realize only a part of it. He painted only the choir and a section of the nave vault (1942–1944). What he left there, however, consecrates the place for art, as earlier it was for history. It is the most baroque composition of the artist and is inspired by the Apocalypse. But Orozco has given everything a contemporary meaning and, by careful symbols, converts the calamities of the modern world into great apocalyptic punishments. He has re-created the demon who takes on a thousand forms and the tortures that fall upon a bloodless humanity.

An artist of varied expressive forms, interested always in new means and new adventures, Orozco painted for a club some portable murals on masonite with pyroxylin. The principal one referred to the illusions of the postwar period; it remains in the Orozco Studio Museum, Guadalajara. Again he changed and employed a new technique in the mural of the Open Air Theater for the National School of Teachers (1947–1948). A curved wall of concrete closes a space surrounded by open galleries; in other words, the space is bounded by strong architectural forms. To harmonize with such shapes, Orozco conceived an abstract, geometric composition that looks like a construction of wire and colored shapes. It has, however, an expressed subject matter—the threat of the modern world to the traditional Mexico of the Eagle and the Serpent. He used silicone as a medium, and applied metal plaques to the serpent in order to achieve certain effects. The mural was executed by a group of assistants who, under the direction of the artist, developed the very precise drawings he had prepared. The result is bold and original. There is no other monumental abstract painting that comes at all close to this one, and it is exceptional also in the work of the artist himself. Without knowing it, Orozco, filled with enthusiasm and constantly innovating, was in these years creating his last works.

For the Museum of History at Chapultepec he painted a mural on the subject of Juárez and his time (1948), in which he returned to a more objective kind of painting without losing his freedom. In the center appears the face of Juárez; in the lower part, the body of Maximilian is carried on the shoulders

of the conservatives of the time, Napoleon III and members
of the clergy; on the right, a soldier with the number 57 on
his cap, jabs at a shadowy figure in a miter; at the left are
other soldiers and the national banner. Juárez and the consti-
tution of 1857 delivered a rude blow to the Church, but the
world berated Juárez for the execution of Maximilian. Now
Orozco makes it clear that such a responsibility must fall on
those who brought Maximilian to Mexico and abandoned him
there to his insufficient forces. The allegory is impressive, and
the face of Juárez and the head of Maximilian are two admir-
able bits; in fact, the entire work is admirable.

The last work of Orozco is in the Chamber of Deputies of
the Government Palace in Guadalajara (1948–1949). The
painting covers part of one wall and the vault, forming a little
more than half a circle. On the wall are depicted the legislators
Morelos, Juárez, and Carranza; in the vaults, Hidalgo is shown
in the center surrounded by slaves, writing a single word—
"Liberty." Here in Guadalajara in 1810, Hidalgo promulgated
the decree that abolished slavery, but the subject has greater
import here because it becomes a symbol of more general
meaning. Hidalgo is depicted as a man of thought rather than
of action, as in the stairway of the same palace; he is an elegant
figure in keeping with the image preserved by tradition. The
slaves are the most wretched possible figures, chained, whipped,
and bleeding; one on the right side, the last one Orozco painted,
opens his enormous mouth to utter a shattering cry. The brush
strokes are laid on freely, and the image is overwhelming.
With some first sketches for a mural in a multiple-family hous-
ing project in Coyoacán, D.F., Orozco brought his vast monu-
mental work to a close.

His easel paintings would be sufficient for considering Orozco
a great artist: symbolic and allegorical, criticisms of the contem-
porary world, of wars and their postwar periods. On the subject
of the Conquest, the series *Los Teules* is superb; there are also
some *Crucifixions*—there are so many works that I cannot begin
to consider them all here. But it must be said that Orozco's
murals constitute the essential part of his work, and that some
of the individual paintings serve as complements helping to
explain them, notably enriching the expressiveness of the forms.

Some of the last paintings express thoughts that had always been fundamental to the artist, such as the one of a disintegrating body raising a still powerful arm, shown against a white background; this we have called *Death and Resurrection* (1943) (Orozco collection). It embodies the sense of vital, cosmic movement essential in the thought and work of Orozco. Everything changes, everything disintegrates, everything recomposes in a constant movement. Another painting, *Hand* (1947) (Orozco collection), shows a colossal hand crushing something, a kind of cloth or white foam that squeezes out between the fingers. It is as if we believed that we held onto something —reality? the truth?—securely, strongly, but it nonetheless escapes us. And finally, *Metaphysical Landscape* (1948) (Orozco collection) is nothing but a bit of land, a horizontal line, and a gray sky composed of a contrasting black rectangle. This is the infinite, and human efforts fail to penetrate it, raising imperfect structures which reach only the most absolute darkness. In other words, it expresses the human limitation for knowing the infinite. These were his last thoughts, consonant with the rest of his work. As a portraitist he left some notable works, such as the portrait of the Archbishop of Mexico, Doctor Luis María Martínez (1945) (Orozco collection). Then too, one must include the lithographs, the wood cuts, and a great quantity of drawings in various techniques and on various subjects as well as studies from models. It can be readily understood that work as vast as that of Orozco is not readily encompassed. This brief look has, however, been worth while as an introduction, not only to his painting but to the exceptional spirit of one of the great masters of history.

David Alfaro Siqueiros (born 1896) must be linked with Rivera and Orozco, because, each in his own way, these three were the principal creators of Mexican mural painting in the twentieth century. Only a bit younger than the others, Siqueiros has a restless spirit that frequently has gone beyond the limits of art to pursue other adventures. His work in painting is not so vast as that of Rivera or of Orozco, but his finest achievements have their place among the first artists of our time in their originality and dramatic force. He was educated in Mexico and in Europe. On his return to Mexico in 1922, he or-

ganized the Union of Revolutionary Painters, Sculptors, and Printmakers of Mexico (Sindicato de Pintores, Escultores y Grabadores Revolucionarios de Mexico), whose manifesto served as banner for the new mural painting. He undertook to paint some murals in encaustic and fresco in the stairway of the smaller courtyards of the National Preparatory School, which he did not finish; they were later damaged, and it was necessary to remove them in part. But the fragments that remain are sufficient to demonstrate the vigor of his personal manner of expression. *The Burial of a Workman* is pathetic and moving. Others of his works, painted in the United States, in which he used such technical innovations as team painting, air guns, and pyroxylin, remain only in memory for they have disappeared. There is one work which is still preserved in Argentina—*Plastic Exercise*. The first mural work completed by Siqueiros in which his artistic capacity is fully evident, is in the stairway of the building of the Mexican Union of Electricians in Mexico City —*The Process of Fascism* (1939). The walls and ceiling are painted with a series of motifs that make them rather gaudy, but the detail is excellent. For example, the figure of the orator with the head of a parrot moves one arm in a "futurist" manner —by displacing the form in a repeated sequence, in a "line-force." It is an excellent bit of painting; the entire work is executed in pyroxylin.

The first time Siqueiros had enough space to expand was in the library of the Escuela México in Chillán, Chile (1941). He curved the walls at the ends of the salon and brought them together with the ceiling to form a unified composition from side to side. It is a heroic concept that has for its subject *Death to the Invader*. One of the walls is dedicated to Mexico; in the center, Cuauhtémoc bends his body backward to shoot arrows from his bow, aimed at a cross in the ceiling, and on the ground lies a dead bearded conqueror. In a group at the left are Morelos, Hidalgo, and Zapata; on the right, Juárez and Cárdenas. The forms are powerful and geometric in structure, and the figure of Cuauhtémoc is distorted to suggest movement. Bold lines and planes in the ceiling tie this allegory with that of Chile on the opposite wall. There the national heroes appear: Galvarino, Bilbao, Recabarren, Lautaro, Caupolicán, O'Higgins, and Bal-

maceda. Out of the din of the mass struggle, a two-headed colossal figure advances with extraordinary impetus, raising his mutilated arms with the hands amputated. The heads are beautifully painted and are tragic in character. Thus, in this work in Chillán, Siqueiros was able to introduce many innovations into his formal expression and to create a dramatic atmosphere consistent with the anti-traditionalist meaning of his subject. He used masonite for the curved walls and a paint based on pyroxylin which produces a very distinctive effect. On his way back to Mexico he stopped in Havana, where he painted a variety of works, the most important of which was *Racial Equality in Cuba* (1943) (private collection). Again in Mexico, he founded the Center for Modern Realist Art in Calle de Sonora, 9, where he painted a mural on the subject of *Cuauhtémoc against Myth* (1944) now in the old Tecpau of Tlatelolco. The hero strikes a tremendous blow with his obsidian knife at the centaur of the Conquest, a formidable standing horse, transformed in the upper part into a conquistador of the sixteenth century holding a cross. In essence, the idea is the same as that already expressed in Chillán. Forms in Siqueiros' works are at times unequal in quality—extraordinary fragments are juxtaposed with figures of slight interest. The artist creates the structure of his forms and then, by means of "glazes" made with the air gun, softens the geometry and creates volumes through contrasting light and shade, in the way that was usual in baroque art. But the whole always has a vital and dramatic impetus of undeniable strength, as is true of his murals in the Palace of Fine Arts in Mexico City (1945). Here, the central part is a genuine mural, whereas the other two panels are separate and portable like large easel paintings, although the group is organized as a single concept. The subjects are: *The New Democracy*, in the central panel (fig. 161); and *The Victims of Fascism*, in the side panels. In the center, a female figure, her torso nude, rises from the crater of a volcano. She wears the Phrygian cap of liberty, and chains hang from her upraised arms. Her right arm seems to unfold and become a powerful fist, excellently formed. In the lower part, a foreshortened dead body completes the composition. The left-hand panel shows

dismembered bodies; here, it seems to me, the artist has mishandled the curvilinear forms and highlights in such a way that the composition is a little confused. The right-hand panel shows a foreshortened figure of a reclining man resting on his chest to show his lacerated back; the drawing of his hands and of his entire body is strong and well constructed, and the work is impressive in its monumentality and drama.

In 1946, Siqueiros began another mural, which was also left unfinished, in the stairway of the Treasury of the Federal District in the Plaza of Santo Domingo in Mexico City—*Patricians and Patricides*, a monumental baroque composition that unites walls and ceiling. It is a kind of judgment on history in which the evil fall among demons and the good are raised. Sometime later, in 1950, he painted two more panels for the Palace of Fine Arts, entitled *A Monument to Cuauhtémoc*. Executed with care, these have many fine qualities. One shows the scene of the martyrdom and is theatrical in effect; the other presents the forceful image of the hero, this time seen in Western armor, with the centaur of the Conquest lying dead at his side. It is the idea from Chillán and the Center for Realist Art appearing again—Cuauhtémoc as a symbol of anti-invasion and anti-tradition. After another mural, in the Polytechnic Institute of Mexico, *Man, the Master and Not the Slave of the Machine* (1951), Siqueiros realized one of his most complete and important works in the hallway of the Salón de Actos of the Social Security Hospital No. 1, in Mexico City (1953). The ceilings and walls are unified because the artist curved the points at which they meet so that all corners disappear. In one aspect, the subject is dramatic—some workmen are looking at the body of a dead companion lying among pieces of machinery; yet in another aspect, it is joyful and lively—some women advance bearing shocks of grain and flowers, and a group of workers pushes aggressively in the same direction. The color explodes, and is happy and festive. On a concave surface at the juncture of the walls and the ceiling, an incandescent human figure appears, descending from above, with head downward and torso foreshortened in perspective. The situation of the figure produces a dynamic effect; when the spectator walks along, the

visual angle changes and the figure seems to be in movement, an effect certainly of interest. It is the symbol of life, the sun, creative energy.

At least as important as his work as a muralist is Siqueiros' production of individual paintings, although some of these are studies for larger works. Many of these are of high quality, dramatic and original. His many self-portraits are of course also important. *The Girl with Blue Hair Ribbons* (1935) (private collection) is a magnificent painting in which the power of the forms, the technique, the simplifications of all the elements combine with the gentle dreaming figure and an evocation of the past to produce a profound emotion. *The Echo of a Cry* (1937), *The Sob* (1939), and *Ethnography* (1939), all in the Museum of Modern Art in New York, are works of a quality to place Sequeiros among the masters of the twentieth century. But there are others, also, of the very first order: *Squashes* (1946) (collection of Carrillo Gil), *The Aesthetician in Drama* (1944) (fig. 162), and *Our Present Image* (1947) (fig. 163). As a portraitist, Siqueiros produced a vast number of works, some of which in particular are first-class. One of these is *Angélica* (1947) (private collection), which is also a study for a mural and embodies the artist's monumental sense of form. The impassioned, and thereby dramatic, accent of Siqueiros' art, his mastery in the use of form, his formal and technical innovations, his interest in using new materials, and his theoretical position—all give his work an unusual quality and powerful expressiveness. He justly deserves his place among the great painters of our time.

Rufino Tamayo (born 1899) is the youngest of the four painters of great stature that Mexico has produced in this century. From the beginning he followed a very personal direction, entirely different from those of Orozco, Rivera, and Siqueiros. He did not live through the same adventures as they, and, with his refined sensitivity and reflective spirit, he tended to react to them, creating quite different forms. Originally an easel painter, he has shown more recently in particular fashion that he has also a great capacity as a muralist. To be sure, he had tried his hand at larger painting in earlier years, first in the

frescoes of the old Conservatory of Music (1933; today the Secretaria de Bienes Nacionales) (fig. 164), and later in the vestibule of the old National Museum of Anthropology (1938), now the Museum of Cultures. But his first complete and success-ful mural painting was that for the Hillyer Library of Smith College, Northampton, Massachusetts—*Nature and the Artist* (1943). In the horizontal panel, the reclining figure symbolizing Nature forms the principal interest. With multiple breasts and well-rounded forms which effectively express the idea, the figure complements and contrasts with the artist, who is painting with his eyes fixed on her but creating a different image. Tamayo thus points out that art is not a copy of nature, recording on the wall a primary and fundamental lesson. Tamayo's means of expression are schematic, skillfully constructed of refined "geometry," with color lending sensuality to the forms and underscoring the originality of conception.

For the Exhibition of Mexican Art that was held in Paris in 1952, Tamayo painted a very large panel, *Homage to the Race* (Palace of Fine Arts), which in subject is nothing more than a flower seller and yet is of masterful concept and of rich and original coloring. In the same year he began two murals for the Palace of Fine Arts in Mexico City, which he finished the following year. One of these is called *The Birth of Our Nation-ality* and is magnificent (fig. 165). A horseman gallops in stampeding frenzy, the geometrical forms of the figure sug-gesting something mechanical and modern; he is a symbol of the Conquest. In the lower part, among the ruins of a decom-posed world, a woman gives birth to a creature; at the right is a structure, and in the sky are two moons, one light and one dark; at the left, a classical column curves under the impact of the stampeding horseman. Once the subject is known, the sym-bols become understandable. But the important aspect of the work is the composition, the forms and coloring of the mural, which attract and move the spectator even before he under-stands the subject. It is original, grand, and refined. In the other mural, *Mexico Today*, (fig. 166), the elements are multiplied. A structure in the middle recalls indigenous and Western forms, and in its interior are scientific apparatus and fire. There are

also other symbols of the modern world, its activities, its technologies, and its mechanics, and all are used by the painter as a pretext for a magnificent play of forms and colors.

A large portable mural, *Man* (1953) (Museum of Fine Arts, Dallas, Texas), is an allegory that expresses a kind of meditation and subject important to the artist's work. A colossal male figure, whose feet become roots that bury themselves in the earth, stands with his back to the spectator with his arm stretched out toward the firmament spangled with stars. The foreshortened figure, shown in an intentionally exaggerated perspective, perfectly expresses the great and intense human effort to reach something beyond. The impossible? But this is not all: at the side of the figure a dog is chewing on a bone; it is another symbol of man; and the reddish tones of the lower part harmonize with the dark blue of the firmament. Thus, recalling Pascal, Tamayo has expressed in original fashion the greatness and the misery of man. Other murals, *Day and Night* and *Still Life*, Sanborn's (Paseo de la Reforma, Mexico City) (1955) are typical of his art, especially the second, in which watermelons form the principal element. For me, one of the best murals that Tamayo has painted until the present is *America* (1956) (Bank of the Southwest, Houston, Texas). A large horizontal panel, it consists of a kind of landscape map composed of human bodies and other motives. It is an allegory of America. The colossal body of a reclining woman is bounded on the left by the sea; on the right are tropical plants and an oil gusher. Above rise two figures: one is male, recalling the Spanish warriors of the Conquest—nearby is shown a cross; the other is female, shown close to the head of a plumed serpent. By these symbols and the forms in general, the artist has suggested Mexico—or, rather, Latin America—but it is clear that idea has to do with all America and its indigenous and Occidental origins. The forms are as capricious as they are sure and expressive, and the rich and harmonious coloring completes them with a sensuality that assure us at once that we are confronting a masterful work in the art of our time.

The last mural painted by Tamayo in Mexico before his long stay in Europe (1957), where he painted a mural in the new building for UNESCO in Paris, is one created for the library of

the University of Puerto Rico (1957) (Rio Piedras, Puerto Rico). The subject is *Prometheus*, who comes to deliver fire to mortal man. Tamayo reached the limits of mystery in his coloring; the larger part of the canvas is deeply obscure, the earth barren, mortals raise their arms like automatons, everything is inert, without life. From above, like a flash of fire or a meteorite, Prometheus descends, the bearer of the life-giving element, the humanizer, who is to transform everything. It is a surprising work, original as are all of Tamayo's paintings, and it attracts, fascinates, and ends by overwhelming the viewer. The same subject of *Prometheus*, in a new version, is the theme of the mural for the UNESCO Building in Paris (1959). In 1962 he painted two murals for Israel, and for the Mexican pavilion at Expo 67, Montreal, he created a magnificent work, *El Mexicano y su medio*. In it man is reaching for the infinite between the plumed serpent and the tiger—transformed into a kind of young centaur. The old indigenous symbols take on a new meaning related to Western culture. Originality of form, symbol, and color makes the work outstanding. Another work of value is the mural Tamayo has painted for the Mexican pavilion at Hemisfair 68, San Antonio, Texas, based on the idea of the confluence of cultures.

Tamayo's work is of great importance in the panorama of contemporary art, and his numerous easel paintings, reflective in character, are as fine as his murals. Tamayo is not an artist of great contrasts. Even in his first works, a distinct personality is evident; his synthesized drawing and rich textures, as well as his original sense of color, were already evident. With these he softly suggests different planes and, when necessary, the third dimension, although his expression is based on two-dimensionality and symbolic color. He went through a long period in which his works were ecstatic, filled with suggestion and expressive of states of soul and reflections on existence. From 1949 Tamayo began to enrich his works with new experiences. He introduced a kind of movement, sometimes directed inward, sometimes outward; his color became more refined and mysterious; a cosmic feeling frequently appeared, provoking a wider and deeper space in his paintings, although not at all naturalistic; his figures took on not only movement but violent

gesture. An able builder of structures, he handles geometry with subtlety and uses it skillfully to set off his always original color. Above all, Tamayo is a great colorist and a master of suggestion. It will be possible here to refer to only a few significant paintings. In the *Niña Bonita* (1937) (fig. 167), typical of one period of his work, the various elements symbolize the life that surrounds the child, who is a living picture of innocence. A group of paintings with animals is one of the most attractive. In *Animals* (1941) (Museum of Modern Art, New York), two dogs look fixedly at something above, and some bones are lying on the ground; the attitude of the dogs gives an overtone of special significance. The form and subtle color of the work were enough to make the artist famous. Mexico's folklore has constantly interested Tamayo. From perhaps the most important series of this nature, is *The Red Mask* (1940) (private collection), in which a seated woman is playing a guitar. Lovers in houses or contemplating the sky appear frequently. *Nude in White* (1943) (Museum of Oslo, Norway) suggests feminine illusions and shyness. The entire painting is in light colors except for the head of the woman, which is red, as if all her blood were concentrated there; in the background is the figure of a man. *Women Reaching the Moon* (1946) (Cleveland, Ohio Museum), expresses the effort of achieving what is physically impossible but obtainable in the imagination and sentiments; the painting is delightful in idea, form of expression, color, and in its many refinements. In 1950, Tamayo painted the very large canvas: *Sleeping Musicians* (Museum of Modern Art, Mexico City), a masterful work which seems to express one of those moments and circumstances in which all creation is impossible. The moon is black; the reclining figures are black against a gray wall; a mandolin and a piece of paper lie scattered— everything is calm, inactive, and there are dark forebodings. All this is expressed in noble schematized forms and somber colors. In a more recent group of paintings (1956), Tamayo has taken a new tack. His color is more limited, although no less fine—rather, to the contrary his textures are rich and his subjects are drawn from his meditations on existence; a typical example is *The Telephone Man* (1956) (Artist's Collection). These recent paintings are first-class works of a positive, crea-

tive, and personal maturity. Tamayo holds one of the first places in twentieth-century painting. His work is sensitive, thoughtful, and imaginative. At the same time, it moves and delights through its form and colors, and has a greater profundity than is evidenced at first glance.

With Orozco, Rivera, Siqueiros, and Tamayo, Mexican painting achieved its highest level—a level reached only in rare periods in the history of art. A careful study of the work of these men is necessary for a proper assessment not only of painting but of all humanistic culture in our time. There are certainly other contemporary painters who deserve attention: muralists, such as Juan O'Gorman, represented in the Gertrudis Bocanegra Library in Pátzcuaro, Michoacán (1942); Fernando Leal, in the Anfiteatro Bolívar in Mexico City; Alfredo Zalce, in Morelia, Michoacán; José Chávez Morado, in the Alhóndiga de Granaditas in Guanajuato; and Jorge González Camarena, in Mexico City. Further, artists like Roberto Montenegro, Manuel Rodríguez Lozano, Carlos Orozco Romero, and Julio Castellanos have much enriched Mexican painting with their originality and richness of form. Among the younger particularly outstanding painters are Pedro Coronel (fig. 168), a great colorist and an artist of depth and force, and José Luis Cuevas (fig. 169), the most important expressionist nowadays. A sort of revival of surrealism combined with new ways of expression finds its way into the works of Pedro Friedeberg and José García Ocejo, this as a reaction against abstract art, which has excellent exponents like Lilia Carrillo, Cordelia Urueta, Antonio Peláez, Manuel Felguérez, and Juan García Ponce. The subject is a large one that cannot be treated here in this brief outline of Mexican art. I shall, however, bring this section to a close with one final superb example, *Tata Jesucristo* (1927) (Museum of Modern Art, Mexico City) by Francisco Goitia (1882–1960), one of the masterpieces of Mexican painting (fig. 170). The grief expressed by the two figures—who are shown before a candle and a few flowers, behind which must be a corpse—expresses a drama so authentic and profound that it stirs the viewer in the deepest reaches of his feelings. The figure on the right especially embodies all the character that synthesizes the most ancient Mexican traditions. It is in truth a prodigious work.

Mosaics. Mural painting took on a new expression in Mexico through the ancient technique of mosaic. Some of these mosaics have been executed in a highly original fashion, using, instead of the Roman or Byzantine type of tessera, small stones of different colors and qualities. Others have been made of Italian mosaic used to produce new effect. Mosaics have been especially successful on the exteriors of buildings. The principal work to this time is to be found on the walls designed by Juan O'Gorman for the Central Library at University City (1954); with originality and a sure sense of color and form, he has covered all four sides of the great cube that houses the stacks of the library. In this way he has lightened the effect of the architectural mass and at the same time has produced a distinctive architecture, breaking the monotony of the expanse of concrete, steel, and glass. The historical subjects are executed in a mosaic made up of colored stones, and the texture is thus agreeably opaque and velvety; the result is impressive. Rivera had already made other experiments with this technique in the pool of the Cárcamo de Dolores in the Federal District and elsewhere. Unfortunately, he was not able to finish the mosaics on the exterior walls of the stadium at University City. The central part that he completed, with the condor, the eagle, and other figures, employs forms in relief, the entire work covered with colored stones. Siqueiros achieved an interesting effect on the solid walls of the Tower of the Rectory at University City, using forms in high relief and planes and covering all with mosaic in the modern Italian manner, a technique derived from the Byzantines. In a similar technique, José Chávez Morado executed two murals in the Auditorium of Sciences, which are well conceived and carried out in the animated color which enriches so many of the works of art at University City. The concept of exterior decoration in mosaic has been expanded. The new buildings of the Secretary of Communications provide a noteworthy experience, suggesting a possible limit beyond which there is the danger of excess and multiplication. But in spite of the success of the renewed art of mosaic, it seems not to have achieved—possibly it will never achieve—the emotion that mural painting has provided; the direct brush strokes by the hand of the artist simply cannot be replaced.

Sculpture. Since we are not concerned here with a history or an inventory, but only with the larger directions, exemplified by a few works of Mexican art, we shall, in the same manner, only briefly discuss sculpture. Such masters as Ignacio Asúnsolo, Guillermo Ruiz, José Fernando Urbina, Fidias Elizondo, Carlos Bracho, Germán Cueto, Juan Olaguibel, Luis Ortiz Monasterio, Federico Canessi, and Guillermo Toussaint are notable for works worthy of every consideration. For example, the portrait of the composer Silvestre Revueltas (fig. 171) by Bracho is an exceptional work in its knowing treatment of form and portrayal of character. In Patzcuaro, Ruiz created the statue of Gertrudis Bocanegra, which is strong and moving. Other qualities and refinements characterize the works of Asúnsolo, evident in the statue of *The Worker* which stands on Avenida Juárez in Mexico City. Ortiz Monasterio has treated certain abstract forms with success—for example, his *Victory* (fig. 172); Cueto, working in an abstract direction, has created sculptures of great perfection with new materials. Other sculptors have risen in Mexico. Works of Francisco Zúñiga are to be found in the Bank of Mexico in Veracruz and in the Secretariat of Communications. There are also works by Rodrigo Arenas Betancourt in the latter building as well as in the Social Security Hospital No. 1 and at University City. Zúñiga has cultivated a style that has classical overtones, although very simplified, modern, and vigorous in its concept. Arenas Betancourt has created interesting and original forms, avoiding all suggestion of naturalism. Finally, Rómulo Rozo, whose works have great quality, has carved a monument in Mérida, Yucatan, of certain importance.

Mexican sculpture has maintained a prudent equilibrium between a naturalistic tradition and the extremes of the present day. In addition to the great sculptors, several young persons have expressed themselves with great sensibility and talent in small-scale works. Among these are Geles Cabrera, Rosa Castillo, de la Vega, Cruz, L. Ruiz, and many others who are securing and furthering the art of sculpture in Mexico. Pedro Coronel, the painter, has also created some sculptures of high artistic value. Feliciano Béjar, another painter, has surprised everyone with his interesting and beautiful "magiscopes."

Graphic Art. The critical-historical tradition of engraving and lithography, with its aspect of political-social extremism, a powerful means of expression in the nineteenth century, has taken on renewed energy in our own time. On one hand, we must remember the precedent set by the great draftsmen and lithographers considered earlier in this work; on the other, recall the work of Posada, whose presence is to be felt in all contemporary art, especially in the direction that engraving has taken in the last decades. But the field must not be too limited, because most of the artists who have cultivated engraving and lithography or both have been concerned not only with works of a critical-political type but also with lyrical works or illustrations of literary texts; in this, Francisco Díaz de León comes first. Only a few have expressed themselves in a single field. Without a doubt the most important and successful work has come from the Taller de Gráfica Popular, which many artists have joined or to which they have come to execute their works. Without deprecating the achievements of others, we might say that Leopoldo Méndez stands out in quality. His concept and technique are of the first order, and his work alone would be sufficient to warrant our saying that this art has been renewed and continues at the highest level. Perhaps his masterpiece is the wood engraving *Vision* (1945), excellent in the monumental form in which it is conceived and executed and in the penetration of its idea. Characteristically, Méndez made also a series of engravings in color to illustrate a book by Juan de la Cabada, entitled *Incidentes melódicos del mundo irracional (Melodious Incidents of the Irrational World)* (1944) that show an entirely different aspect of his creative personality (fig. 173). Here, fantasy, in part inspired by ancient indigenous motifs, provides excellent effects and prompts a technical virtuosity that makes the work another masterpiece for Méndez. Alfredo Zalce, whose production in engraving and lithography is also outstanding, illustrated the book, *El Sombrerón,* by Bernardo Ortiz de Montellano (1946). The catalogue of contemporary engravers and lithographers is extensive, and their production is worthy of continued study. The most violent expressions in these media owe much to the foremost artists, but there are also those of classical tradition. Federico Cantú has executed copper en-

gravings of great quality; Carlos Alvarado Lang, master that he was, worked in all media, as does another master, Francisco Díaz de León; José Arellano Fischer has published two albums of aquatints that are exceptional.

The painters themselves have at times executed works in engraving and lithography. Some of Orozco's lithographs are as important as his mural paintings. These are packed with all the force of this great draftsman, as are his series of copper engravings and aquatints from different periods in his career, constituting a rich addition to his works. Rivera executed some lithographs, such as his *Self-Portrait* (1930). Siqueiros also has made lithographs, some of which, such as *Zapata* and a *Self-Portrait,* are truly major works. Tamayo produced wood engravings in past years; some recent colored lithographs, like all his works, are distinctive creations of great quality. A lithograph by Julio Castellanos, *Cirugia Casera* (1932), is an excellent example of the refined art of this man. Also fine in quality are the lithographs of Raul Anguiano, a fact well supported by his album *Dichos Populares* (1939). Then too, the works of Montenegro, Orozco Romero, Charlot, Covarrubias, Dosamantes, Fernández Ledesma, Leal, Mérida, Castro Pacheco, Lola Cueto, and many others have great originality and many other fine qualities, as in the work of Alberto Beltrán. In the engraving and lithography of our own time is to be found the most violent criticism of the immediate past and present consciously expressed; but there are also works that express the most tender, the most dramatic, and most tragic aspects of Mexican life. In all instances, however, there is always artistic quality on the highest level. The Sociedad Mexicana de Grabadores has kept active, a number of artists working in varied techniques and expressions, from traditional to the most avant-garde.

Civil Architecture. After the inevitable attempts to escape from or to exploit tradition, contemporary civil architecture, which has dominated since 1926, has emerged in the past few years into a state of full maturity. At first a variety of innovations were attempted, such as *neo-indiginism, neo-colonialism,* and a rigid modernist formalism; but these were finally dominated by an architecture which had its roots in functionalism. This move-

ment held function to be the essential element, supposedly without any consideration for artistic or aesthetic character except for what might result from architectural solutions and elements themselves, such as construction, fenestration, and chimneys. At one point extremist "functional" works were produced, but architecture shortly turned into better-balanced directions.

It must be recognized that the beginnings of the most fruitful direction in the renewal of Mexican architecture are due principally to the architect José Villagrán García, whose works remain notable, especially his designs for hospitals.

For some years architectural production in Mexico has occupied an important place in the international scene. The efforts of architects to dignify their works have produced results, and they have succeeded in establishing new concepts which are no longer even questionable. Today no one would think of constructing a house or erecting a building in imitation of a historical style—Gothic, Renaissance, Romanesque, or Mayan. Nowhere can this be seen better than in Mexico City, whose streets and avenues take on a new and severe aspect, only partly enlivened by the use of varied materials and color. The cubes of steel and glass dominate to such an extent that tall glass buildings seem to be populating the city. The matter should be given some thought, because not everyone is convinced that this is an adequate solution for the climate and the light of Mexico. Nonetheless, from the aesthetic point of view, there is no doubt that many fine buildings have been created from concrete, iron, steel, glass, and other materials. A stroll through the principal avenues is enough to provoke astonishment at the number of new buildings that have been constructed and are still being constructed and also at the consistent abuse in the use of glass.

One aspect of civil architecture that is readily seen from the outside but does not at once reveal many of its fine points is domestic architecture—residences and apartment buildings in ever increasing number which are transforming the capital. Not only have these improved living conditions, but the architects have achieved some outstanding results. Also worthy of note are the new urban developments in which distinctive taste and new concepts have been introduced. For example, in the Gardens of the Pedregal, in the southern section of the capital, rock formed

from ancient strata of lava, vegetation, and contemporary architecture join to produce a unique effect. Credit must be given to the architect Luis Barragán for his creative part in this notable and original development. He has also been associated with the new Satelite City, where he and Matías Goeritz have built some interesting concrete towers in harmonious colors that produce an extraordinary effect and constitute a monument of genuine beauty. The plan of Satelite City is the work of the architect Mario Pani. Among the finest and most handsome buildings in Mexico City are: the Central Airport, by Augusto Alvarez; several hospitals, such as the Social Security Hospital No. 1, by Enrique Yáñez; commercial buildings such as the Bolsa de Valores, by Enrique de la Mora; buildings for offices, institutions, and departments of the government, such as the Social Security Building in the Paseo de la Reforma, by Carlos Obregón Santacilia; and the new building for the Secretary of Communications, designed by a group of architects under Carlos Lazo (1954). And then there are many fine private residences. But the masterpiece of all Mexican contemporary architecture remains University City. Many outstanding architects were involved in its design, and the result, in spite of some minor defects of detail that could be noted, is the grandest and most harmonious architectural complex to be erected in the country. In the first place, its setting is of great advantage—the *pedregal* presents a landscape which is open and beautiful. The volcanoes on one side and the rugged hills of the Ajusco on the other frame the distant horizon with forms of interest and beauty. Aside from its natural setting, University City is attractive in its proportions; the variety of its building forms avoids monotony, materials and colors are varied, and the complex is original in aspect and impressive in scale. Carlo Lazo's architectural coordination of the project made it possible to construct almost the entire campus in a very short time—from 1949 to 1954. Much is to be gained from a visit to University City, which offers many aesthetic satisfactions. Among the most handsome and interesting buildings are: the Medical School complex with its bold porticoes designed by Pedro Ramírez Vázquez, Roberto Alvarez Espinosa, and Ramón Torres; and the group of science buildings with its high tower, auditorium, and unusual class-

rooms designed by Raúl Cacho, Félix Sánchez, and Eugenio Peschard; and the schools of engineering and architecture. The humanities group, with its tower closing off the northern side of the great central quadrangle, makes the buildings housing the faculties of philosophy and literature, law, economics, and business seem disproportionately long. From the tower of the Rectory (fig. 174), a work by Mario Pani and Enrique del Moral, the view is majestic and overwhelming. Standing out in the complex because of its original form and its colored stone mosaic covering is the Central Library, designed by Juan O'Gorman, Martínez de Velasco, and Gustavo Saavedra (fig. 175). To the south is the sport area with its beautiful swimming pools and a most notable construction, the *frontón* courts (fig. 176), the work of Alberto Arai, who, in suggesting a form reminiscent of the ancient indigenous pyramids, produced a striking effect of unusual rhythm. For many reasons the most impressive work is the Olympic Stadium (fig. 177), on the western edge of the area; its size and unusual form produce a fine bold effect, and as a notable technical solution it surpasses similar constructions in other countries. It was designed by August Pérez Palacios, Raúl Salinas and Jorge Bravo.

University City constitutes the most important direction in Mexican architecture of the twentieth century and represents it on a high aesthetic level. No other country can match it in a building complex dedicated to the principal institution of higher learning. The art of architecture in our time is here expressed with positive monumentality and a severity of form that reveal a new classicism—a classicism enriched by color and modern technique.

Among other works, the Social Security Administration has constructed (1960) a splendid housing complex for workers called Unidad Independencia, which is south of Villa A. Obregón. Also of interest is the Medical Center, with its magnificent auditorium. Attention should be given to the new Museum of Anthropology (1964), in Chapultepec, the work of Pedro Ramírez Vazquez and a group of young architects under his direction (fig. 178). We might say it is the masterpiece— up to now—of modern Mexican architecture because of its noble forms, intelligently based upon the indigenous past, and

its original formulations, such as the large court with its suspended "umbrella" hovering above a cascading fountain. The new Museum of Modern Art, in Chapultepec, is the work of the same architect.

Ramírez Vázquez has also directed or coordinated all construction relating to the Olympic Games of 1968, among which is the Palace of Sports, the work of the notable architect Felix Candela.

One should not fail to visit the museum, based on indigenous forms, built by Diego Rivera to house his collection of prehispanic art. It is called *Anahuacalli.*

In the northern part of Mexico City important work began around 1964. First was the housing development of Nonoalco, planned and built by Mario Pani. Second was the *Plaza de las tres culturas*—indigenous, colonial, and modern—where one can see the remnants of prehispanic constructions, the colonial church of Santiago Tlatelolco, and the new building of the Secretary of Foreign Affairs. Ricardo de Robina worked on this project, which is surrounded by a number of high apartment buildings. The development of the old site of Tlatelolco was made possible by the prolongation, to the north, of the Paseo de la Reforma.

Ecclesiastical Architecture. There has been a notable effort to revitalize the design of ecclesiastical architecture in the past few decades. The number of new churches is surprising, and each shows some effort to attempt new forms. It must be recognized that this is the most difficult area of architectural innovation, because tradition and the liturgy determine many aspects of the plan. Further, one might wonder whether the severe aesthetic of modern architecture is capable of giving expression to the spirit that reigns over Catholicism in those aspects not limited by vows of poverty or simple necessity. The qualities which can be most readily produced by form alone are monumentality and majesty; others are much more difficult—above all, sumptuosity and spirituality—qualities achieved most successfully in the past by Baroque art. The new classicism of contemporary architecture has struggled in ecclesiastical art to achieve sumptuous forms and effects and has at times fallen into vulgarities

in the worst possible taste and into completely inadequate friv-
olities. One or two recent works mark a positive direction—
though only in *one* direction—and both are by the architect
Enrique de la Mora y Palomar. The first is the Parochial Church
of La Purísima in Monterrey, Nuevo León (1946), (fig. 179).
The parabolic arches, somewhat reminiscent of Gothic art but
very different, have been used in well-balanced proportion. The
plan is in the form of a Latin cross, but is novel in that it rein-
stitutes an ancient tradition by placing the choir behind the prin-
cipal altar—that is, at the rear of the apse. Its tower also is
unusual and quite successful, standing free of the building. The
exterior forms are dignified and beautiful, but the interior is
less satisfactory; even though it is grandiose in proportion, one
might have hoped for an ornamental treatment adequate to
create an atmosphere conducive to prayer and sufficient to pro-
vide the sumptuosity that should characterize the house of God.
The second work is the Chapel of the Padres del Espiritú Santo
in Avenida Universidad, Coyoacán, D. F. (1957) which is an
interesting solution, entirely different in type from the former.
Here the plan is rhomboidal, and the roof rises at a sharp angle,
slanting up from the two corners in such a way as to form two
great elongated triangular windows which join at the corner to
become a single window. Everything is freshly thought out. The
chairs for the novices of the community are placed along the
walls below the windows. The altar is almost in the center, and
allows the priest to officiate in front of the congregation, which
is gathered in the area formed by the base of the rhombus. The
part that is traditionally given over to the choir is raised in a
series of levels to afford additional space for the public. Finally,
although the entire chapel is severe in design, following the
dictates of the new classical aesthetic, it has been handsomely
enriched by the large stained-glass window, the work of Kitzia
Hoffman, and all the vestments of the priests and attendants as
well as the sacred vessels have been designed in harmony. Thus,
the whole aspect is surprising, and constitutes the most serious,
most dignified, and most homogeneous effort that has been
realized in giving unity to the forms and majesty to the propor-
tions while remaining within the character of a chapel—a prob-
lem quite different from that presented by a parochial church

or a cathedral. It is the best and most complete expression of contemporary ecclesiastical architecture and ornament. Although its aestheticism is as debatable as all others, it has succeeded in creating a certain perfection and beauty. This last can also be said of the church of Saint Ignatius, by Juan Sordo Madaleno. The church of La Medalla Milagrossa by Candela is also an example of outstanding modern religious architecture. Anyone interested in modern architecture, in fact, should look for the works of Felix Candela in Mexico City; they are generally original in form and extraordinary in technique.

Folk Art. Perhaps it will seem surprising to find a section on folk art in a chapter on contemporary art. To some readers, it will seem completely unrelated; to others, it will be a topic so important that it should be treated much more extensively in a section of its own. To the first group, it must be said that it was precisely the aesthetics of contemporary art, through its criticism and its new concepts and taste, that brought about a re-evaluation of folk art. The relationship is very close also because of the part that these objects coming from the people— a people with an almost unparalleled aesthetic and artistic sense —have played in modern art. To the second group, we can reply only that Mexican folk art assuredly merits a complete treatment, but there is space here to do little more than relate it to contemporary art and to point out some of its qualities.

We must distinguish between the authentic creations of folk artists and other objects, frequently in bad taste, which betray an effort to use modern forms or designs without understanding their character. Yet it is not a question of folk art's never changing; to insist that only older productions have any value would be tantamount to denying the creative capacity of the people, to trying to preserve both the past and the present in a kind of mummified museum. Folk art is that created by artists among the people whose names rarely become known; for the most part it applies to an anonymous production. But the anonymous quality of popular art stems as much from its traditionalism, for it continues to use techniques, forms, and ornamental designs whose true creators have been lost in the remote past. Folk art existed in the past; we have already called attention to various

of its aspects in considering other epochs. The folk art of our own time is, however, not exclusively the product of the indigenous race of people, although a large part of it is produced by them; the mestizos and the Creoles have also made their contributions. For this reason it is truly Mexican—fortunately, racial distinctions make no sense in our country.

It would be very difficult to make an inventory of the country's production in folk art. There are some privileged regions in the country, but each area has its own distinctive characteristics. Serapes and wool and cotton textiles are produced in the states of Sonora, Coahuila, Jalisco, México, and Puebla, but each is different from the others. The variety of forms that characterizes the ceramics is of a richness that defies classification. The states of Jalisco, Michoacán, México, Tlaxcala, Morelos, Guerrero, Puebla, and Oaxaca produce fine works of art. It is interesting to note that a large part of these are used in daily life. In fact, because of their artistic quality they are today more and more taking the place of similar imported objects. The same might be said of the glassware produced in Mexico, Guadalajara, and Puebla; the famous Avalo brothers have created works of first quality. Michoacán and Guerrero produce delicate, beautifully colored lacquer trays, boxes, masks, and other objects. Work in silver is varied, ranging from traditional models to such modern designs as those made in Taxco, Guerrero, of a beauty completely in accord with the most refined modern taste. There is also filigree work in silver and gold from the southern states; other pieces of originality are produced in Michoacán. Work in wax has been traditionally admired; the delicate technique, color, and fantasy in creating forms are often surprising. Although Luis Hidalgo is not a folk artist, he has distinguished himself in this tradition; his figures in polychrome wax are exceptional works of art. The same might be said of the wood carver Lázaro López Silva, who creates figurines of particular charm based on popular types drawn from literature and history.

Artistic intuition and spontaneity are characteristic of folk art, which at times has produced highly original works or effects. At times its helpful influence on contemporary art has brought about exceptional results—for example, in the tissue

paper painting of Jesús Reyes Ferreira. To be sure, this painter's artistic awareness places him well beyond any simple ingenuousness, but the spontaneity with which he expresses himself comes very close to folk art, which he has renewed with originality. This closeness is one of his merits, allowing him to create a technique and type of work both attractive and novel.

Although we cannot possibly consider the great variety of objects we might like to, at least we can note a few ceramic works that give an idea of the range of folk expression. A vase from Zumpango, Guerrero (fig. 180), may recall works in the archaic Greek geometric style but is freer in its drawing, in black or dark brown over a base of light brown clay. The decoration is organized in bands—*charros* on horseback form a delightful frieze of extraordinary elegance. For contrast, a vase from Tlaquepaque, Jalisco (fig. 181), is of a more elaborate technique but no less charming in its decoration, in which is depicted, in the midst of a tropical landscape with palms and pineapples, birds and flowers, the Cathedral of Guadalajara or, at least, a towered church inspired by it. The forthrightness of the entire composition and the spontaneity and delicacy of drawing, as well as the refined technique, make it an authentic work of art. Also from Tlaquepaque, another vase, different in ornamental style and form, is entirely covered with flowers and fantastic leaves drawn with the delicacy of filigree with light lines on a dark background; the effect is beautiful, delicate, and surprising. Finally, we must consider at least one example of the famous Talavera ware from Puebla: a covered jar, ornamented with panels painted with landscapes that recall Chinese or Japanese drawings (fig. 182). All the ornamentation is dark blue on a white background, and the resulting composition is of extraordinary beauty.

Toys and mats are among the other products of folk art; within each branch a whole range of forms, as well as a variety of admirable designs and expressions, exist. To conclude this brief look at folk art, let us examine a charro saddle, which is, like many other things, a symbol of Mexico (fig. 183). From Amozoc, Puebla, this saddle is made of tooled leather, and is complete with stirrups, buckles, and *chapetones*. The technique in which it is executed resembles the *Eibar* of Toledo, Spain,

except that here the metal is colored a deep blue and the designs are scratched in so that they glow like silver.

Folk art is not produced as a curiosity for museums, but plays an actual part in daily life; yet it is consistently admired for its artistic and aesthetic qualities. This is a vital art which slowly continues to renew itself with creations that merit being included in the history of art.

SUMMARY

The twentieth century has been generous to Mexico in the field of art. We have seen that in the decades following the Revolution a movement arose which revived mural painting and created great works which are a fundamental and brilliant chapter in the history of the century. The new classicism of Rivera, the baroque and tragic art of Orozco, the drama and force of Siqueiros, the very personal classicism of Tamayo—all are expressions which take their place in the highest aesthetic and artistic category in the international panorama of art in our time. Mural painting is something more—it is one of the great expressions of universal culture. Further, new tendencies in outdoor monumental painting and the revival of mosaic, with original contributions made by Mexican artists, are distinct innovations.

Efforts have been made to effect a revival of sculpture, and some works of notable quality have the solidity of the modern classical tradition. The innovations have been on a different level from those in painting—which is not to speak disparagingly of sculpture. Except for a few exceptions, however, sculpture has generally been slower to renew itself than has painting.

One of the most lively and varied Mexican artistic manifestations is contemporary graphic work, which displays on one hand an aspect that is predominantly critical and dramatic and, on the other, lyrical and folkloric. A large quantity of fine works have been produced in lithography; from these and the engravings, one gains not only an idea of the high technical quality achieved but a vivid awareness of what the artists feel, think, and imagine—their ideas and ideals.

In no lesser way, contemporary architecture has attained a high level and has frequently produced very original works. The complex of University City, and the new Museum of Anthropology, are worthy of every consideration, and have brought Mexico into the world panorama of the most advanced and original architecture. Ecclesiastical architecture also has undertaken to renew itself, and has attained some noteworthy successes that rival those produced in other countries.

Finally, folk art has entered definitely into contemporary consciousness and artistic taste, and its esteem is growing. Not only is the tradition being maintained, but new variations and new techniques and forms give evidence of the continued creative vitality of the Mexican people.

Something must be added concerning the criticism of contemporary art. Since the years before the Revolution, historians, critics, writers, poets, and the artists themselves expressed a consciousness that effected a rediscovery of the true values of Mexican art and life. The critic has been successful in handing on this consciousness to the public—to the Mexican people—and has restored to art and aesthetics the ancient indigenous past—the Hispano-Mexican past—and the past century, which is that of independent Mexico. Further, he has made relevant the values of the present day. This recovery of a Mexican consciousness, embracing all Mexican history, of the country's position in and relationship with the world—all this has given profundity and authenticity to Mexican contemporary art. This is not a matter of becoming chauvinistic or myopically nationalistic; on the contrary, it is simply coming to understand oneself and to place oneself in time. Contemporary Mexican art has been able to express its authentic being in various manifestations and artistic forms, and at the same time, to be universal, because evident within it is a humanism that transcends all provincial boundaries—its central theme is man, the past, present, and future of human existence. It is imbued with a high moral quality and spirituality, and, fortunately, these have found manifestation in great and elevated aesthetic forms.

Selected Bibliography

In English

Cetto, Max L. *Modern Architecture in Mexico*. New York: Praeger, 1961.

Charlot, Jean. *Mexican Mural Renaissance, 1920–1925*. New Haven: Yale University Press, 1963.

Faber, Colin. *Candela, the Shell Builder*. New York: Reinhold Publishing Corp., 1963.

Goldwater, Robert. *Rufino Tamayo*. New York: Quadrangle Press, 1947.

Helm, MacKinley. *Modern Mexican Painters*. New York and London: Harper Brothers, 1941.

————. *Man of Fire: Orozco*. The Institute of Contemporary Art, Boston, New York: Harcourt, Brace and Co., 1953.

Hopkins, John H. *Orozco: A Catalog of His Graphic Work*. Flagstaff, Ariz.: Northland Press, 1967.

Myers, Bernard S. *Mexican Painting in Our Time*. New York: Oxford University Press, 1956.

Myers, I. E. *Mexico's Modern Architecture*. New York: Architectural Book Publishing Co., 1952.

Orozco, José Clemente. *An Autobiography*. Austin, Tex.: University of Texas Press, 1962.

Portrait of Latin America as seen by Her Print Makers. Ann Lyon Haight, ed. New York: Hastings House Publishers, 1946.

Reed, Alma M. *The Mexican Muralists*. New York: Crown Publishers, 1960.

————. *Orozco*. New York: Oxford University Press, 1956.

Rivera, Diego. *My Art, My Life: An Autobiography*. New York: Citadel Press, 1960.

Schmeckebier, Laurence E. *Modern Mexican Art*. Minneapolis, Minn.: University of Minnesota Press, 1939.

Siqueiros, David Alfaro. *Siqueiros*. Mexico City: Ediciones Galería de Misrachi, 1965.

Toor, Frances. *A Treasury of Mexican Folkways*. New York: Crown Publishers, 1947.

Westheim, Paul. *Tamayo*. Mexico City: Ediciones Artes de México, 1957.

Wolfe, Bertram David. *The Fabulous Life of Diego Rivera*. New York: Stein and Day, 1963.

In Spanish

Artes de Mexico. 1953 and following years.

Atl, Dr. (pseud.). *Las Artes Populares en México*. Mexico City: Editorial Cultura, 1921.

Bonifaz Nuño, Rubén. *Ricardo Martínez*. Colección Arte 16. Mexico City: U.N.A.M., 1965.

Cardoza y Aragón, Luis. *Pintura Mexicana Contemporánea*. Mexico City: Imprenta Universitaria, 1953.

―――. *Orozco*. Mexico City: Instituto de Investigaciones Estéticas, U.N.A.M., 1959.

Fernández, Justino. *Litógrafos y Grabadores Mexicanos Contemporáneos*. Mexico City: Editorial Delfin, 1944.

―――. *Prometeo: Ensayo sobre pintura contemporánea*. Mexico City: Editorial Porrúa, S.A., 1945.

―――. *Orozco, Forma e Idea*. Mexico City: Editorial Porrúa, S.A., 1956.

―――. *Roberto Montenegro*. Colección Arte 10. Mexico City: U.N.A.M., 1962.

Flores Guerrero, Raul. *5 Pintores Mexicanos: Kahlo, Meza, O'Gorman, Castellanos, Reyes Ferreira*. Colección Arte 5. Mexico City: Direccíon General de Publicaciones, U.N.A.M., 1957.

Mexico en el Arte. Twelve numbers, 1948–1952. Mexico City: Instituto Nacional de Bellas Artes.

Nelken, Margarita. *Carlos Orozco Romero*. Colección Arte 7. Mexico City: Dirección General de Publicaciones, U.N.A.M., 1959.

―――. *Carlos Mérida*. Colección Arte 8. Mexico City: Dirección General de Publicaciones, U.N.A.M., 1961.

Neuvillate, Alfonso de. *Francisco Goitia*. Colección Arte 13. Mexico City: U.N.A.M., 1964.

―――. *Pintura Actual: México 1966*. Mexico City: Artes de México y del Mundo, S.A., 1966. (Spanish-English text.)

Orozco, José Clemente. *Autobiografía*. Mexico City: Ediciones Occidente, 1945.

————. *Obras de J. C. O. en la Colección Carillo Gil*. Mexico City, 1949. Catalog and notes by Justino Fernández with additional notes by Dr. Alvar Carillo Gil. Complement (2 vols.). Mexico City, 1953.

Paz, Octavio. *Tamayo*. Colección Arte 6. Mexico City: Dirección General de Publicaciones, U.N.A.M., 1958.

La Pintura Mural de la Revolución Mexicana: 1921–1960. Mexico City: Fondo Editorial de la Plástica Mexicana, 1960.

Ramos, Samuel. *Diego Rivera*. Colección Arte 4. Mexico City: Dirección General de Publicaciones, U.N.A.M., 1958.

Rivera, Diego. *Cincuenta años de su labor artística*. Mexico City: Instituto Nacional de Bellas Artes, S.E.P., 1951.

Siqueiros, David Alfaro. *No hay más ruta que la nuestra*. Mexico City, 1945.

————. *Monografía*. Mexico City: Instituto Nacional de Bellas Artes, S.E.P., 1951.

Textos de Orozco. Estudios y Fuentes del Arte en México, IV. Mexico City: Instituto de Investigaciones Estéticas, U.N.A.M., 1955. With an introduction and an appendix by Justino Fernández.

Tibol, Raquel. *Siqueiros, introductor de realidades*. Colección Arte, 8. Mexico City: Dirección General de Publicaciones, U.N.A.M., 1961.

Valdés, Carlos. *José Luis Cuevas*. Colección Arte 17. Mexico City: U.N.A.M., 1966.

ILLUSTRATIONS

1

ANCIENT INDIGENOUS ART

Fig. 1.—Figure of a Warrior, ceramic, from Jalisco.

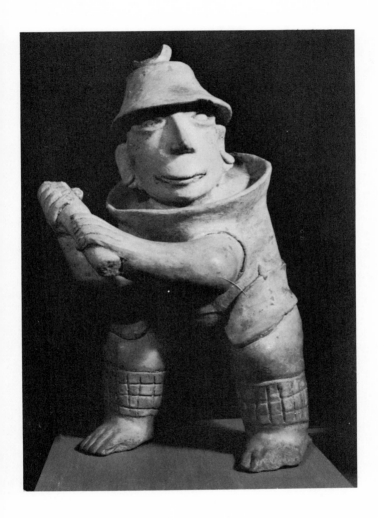

Fig. 2.—A Hunchback, ceramic, from Jalisco.

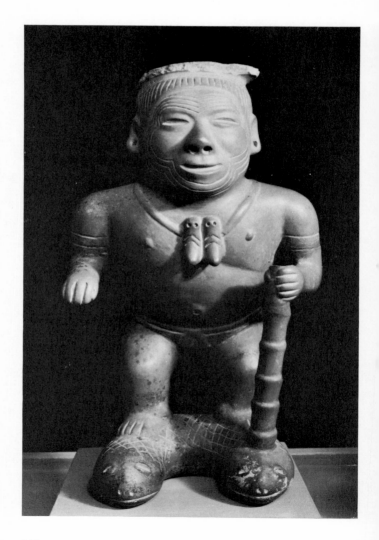

Fig. 3.—A Hunchback, side view.

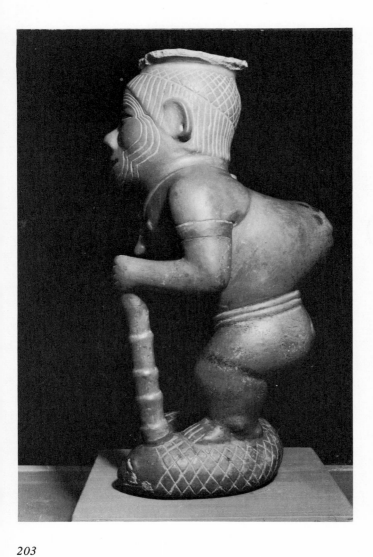

Fig. 4.—Dog, ceramic, from Colima.

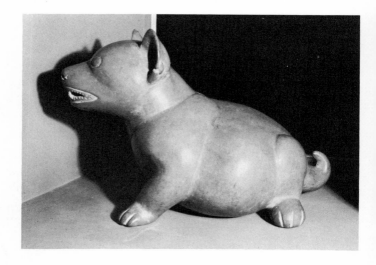

Fig. 5.—Figurine of a Woman, ceramic, from Tlaltilco, the Valley of Mexico.

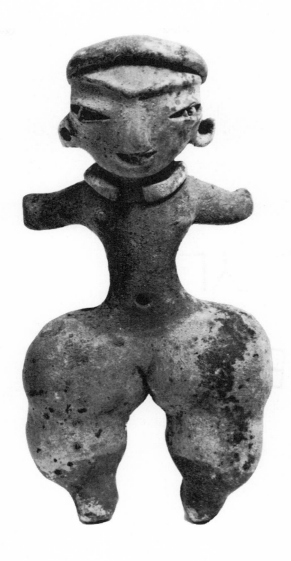

Fig. 6.—Head, ceramic, from Gualupita, Morelos.

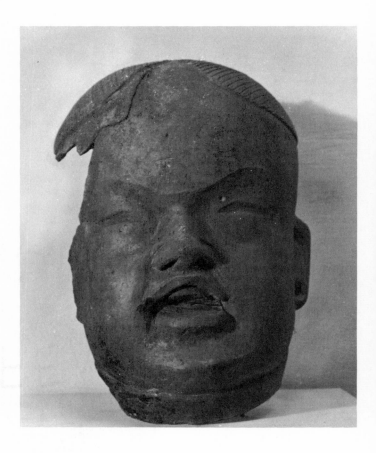

Fig. 7.—Huastec Sculpture, stone, from San Luis Potosí.

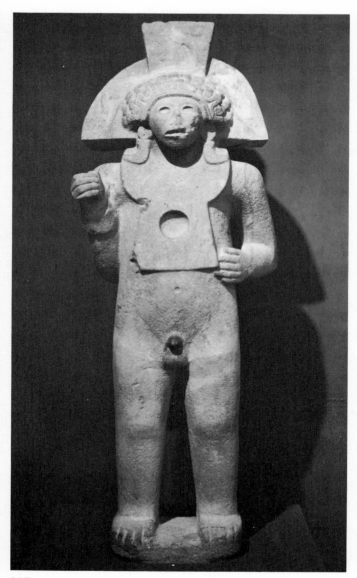

Fig. 8.—"Huastec Adolescent" (Quetzalcóatl), stone, from San Luis Potosí.

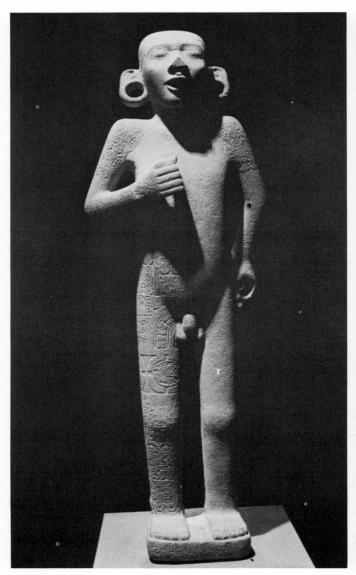

Fig. 9.—Colossal Head, Olmec Culture, from
La Venta, Tabasco (cast from the stone original).

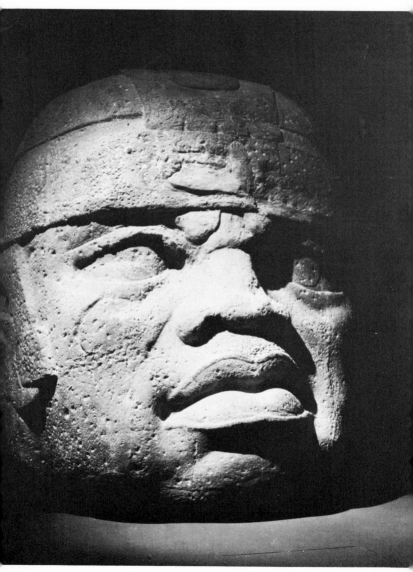

Fig. 10.—Seated Figure, black granite, Olmec Culture, from El Tejar, Veracruz.

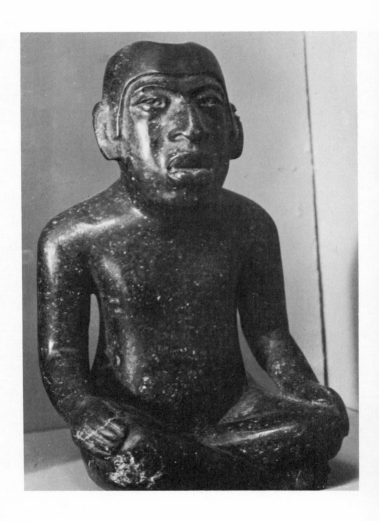

Fig. 11.—"The Wrestler," stone, Olmec Culture, from Veracruz (Corona Collection).

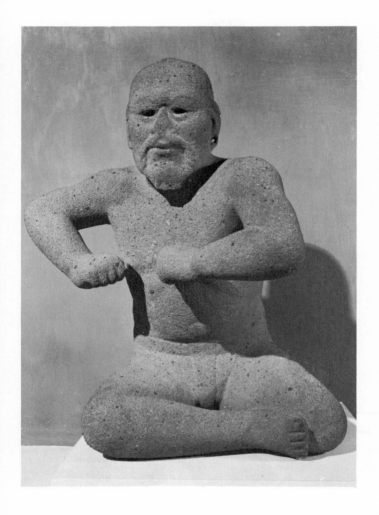

Fig. 12.—Child, showing traces of the Jaguar type, jade, Olmec Culture, from Veracruz.

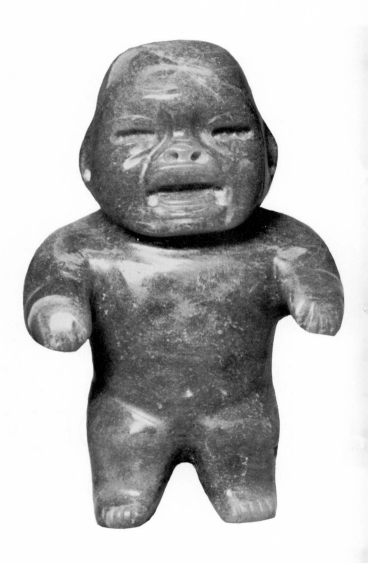

Fig. 13.—Axe-shaped Head, stone, Olmec Culture.

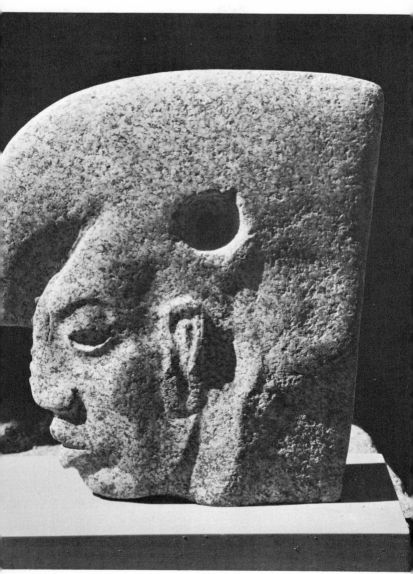

Fig. 14.—Axe-shaped Head of a Parrot, stone, Olmec Culture, from Xochicalco, Morelos.

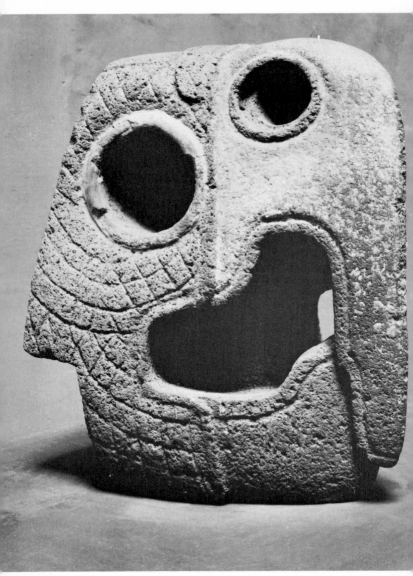

Fig. 15.—"Yoke" Sculpture, stone, Olmec Culture.

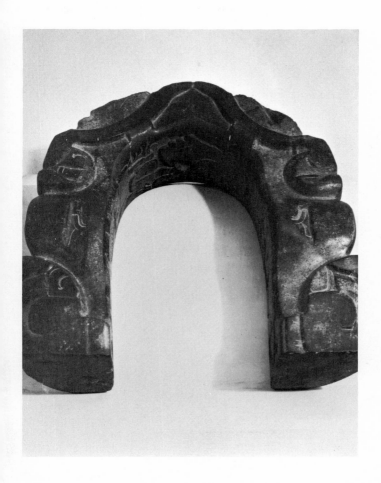

Fig. 16.—"Palm" Sculpture, stone, Olmec Culture.

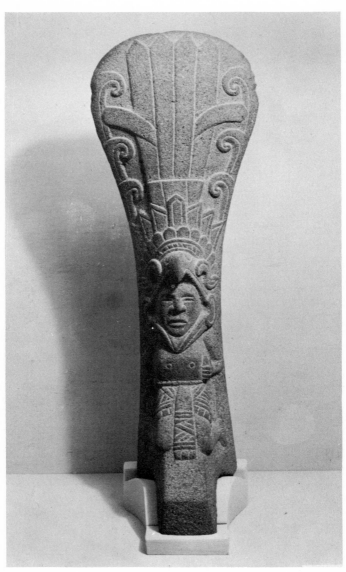

Fig. 17.—Head, stucco, from the lower chamber of the Temple of Inscriptions, Palenque, Chiapas.

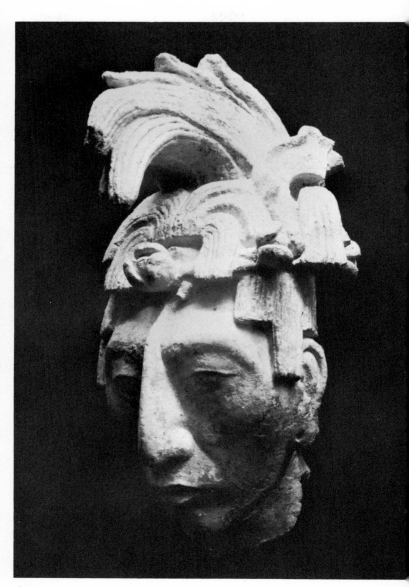

Fig. 18.—Mural Painting, fresco, Bonampak, Chiapas (copy by Agustín Villagra).

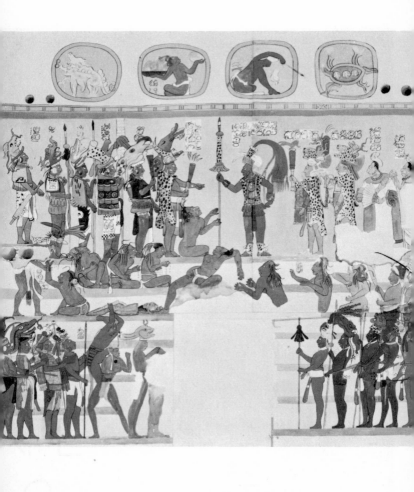

Fig. 19.—Commemorative Altar of a Ball
Game, stone, from Chinkultic, Chiapas.

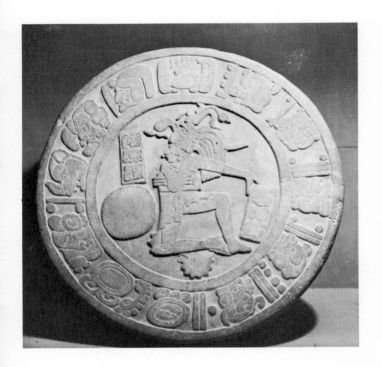

Fig. 20.—Seated Woman, ceramic, from the
Island of Jaina, Campeche.

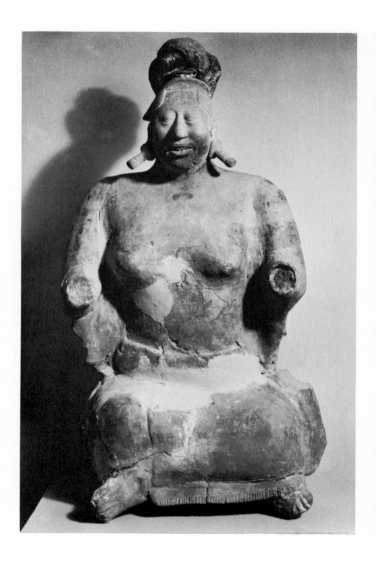

Fig. 21.—"The Queen," stone, from the Pyramid of the Magician, Uxmal, Yucatán.

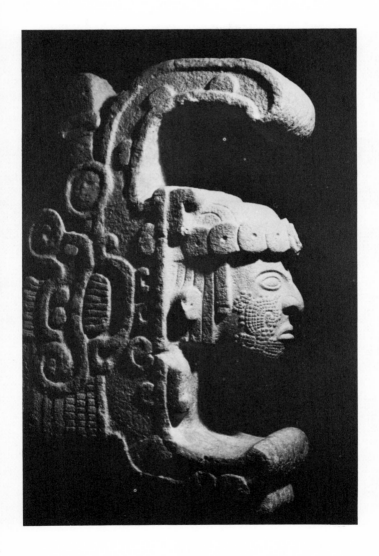

Fig. 22.—Pyramid of Quetzalcóatl, detail.

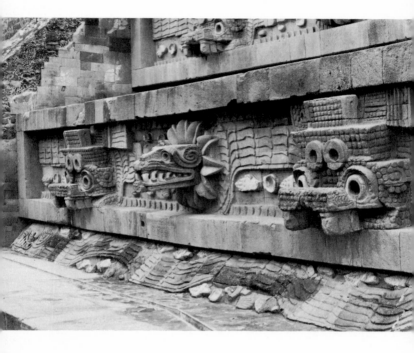

Fig. 23.—Mural Painting, fresco, from Tepan-titla, Teotihuacán (copy by Agustín Villagra).

Fig. 24.—General View of Teotihuacán, reconstruction and drawing by Feliciano Peña.

Fig. 25.—Teotihuacán, Mexico, Pyramid of the Sun.

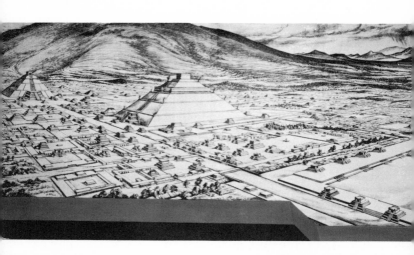

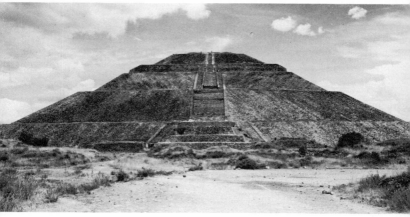

Fig. 26.—Chalchiutlicue, Goddess of Waters, stone, ten feet five inches high, from Teotihuacán, Mexico.

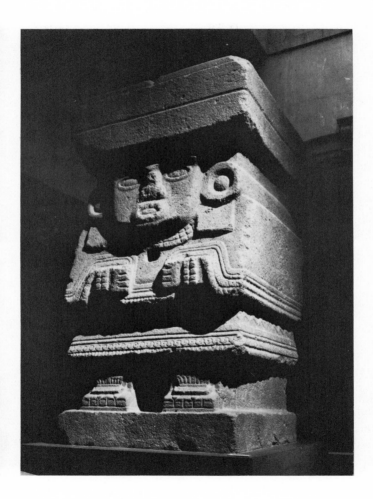

Fig. 27.—Mask, stone, from Teotihuacán, Mexico.

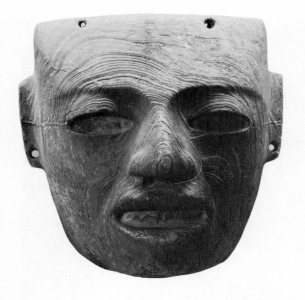

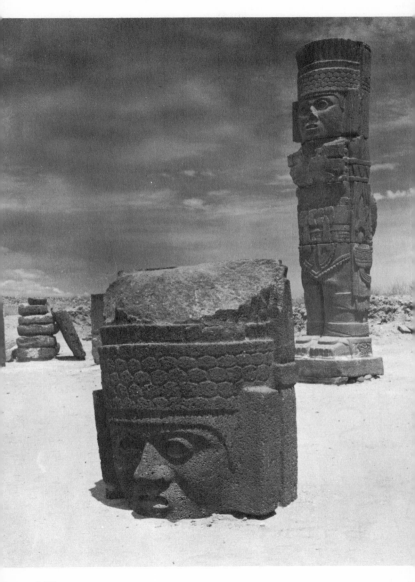

Fig. 28.—Tula, Hidalgo, Colossal Columns, called Atlantes, stone.

Fig. 29.—Chac Mool, stone, from Tula, Hidalgo.

Fig. 30.—Xochicalco, Morelos, Platform of a Temple in Form of a Pyramid.

Fig. 31.—Funerary Urn, ceramic, Zapotec
Culture, from Oaxaca.

Fig. 32.—Entrance of Tomb 104, Zapotec Culture, Monte Alban, Oaxaca.

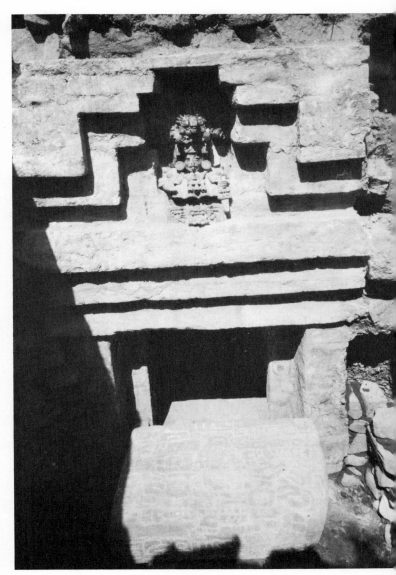

Fig. 33.—Funerary Urn, ceramic, Zapotec Culture, from Oaxaca.

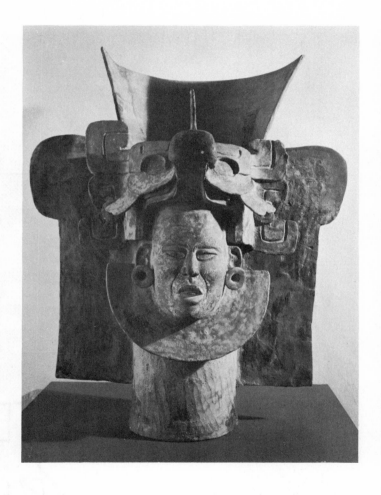

Fig. 34.—Seated Figure, ceramic, Zapotec Culture, from Cuilapan, Oaxaca, now in the Regional Museum of Anthropology and History, Oaxaca, Oaxaca.

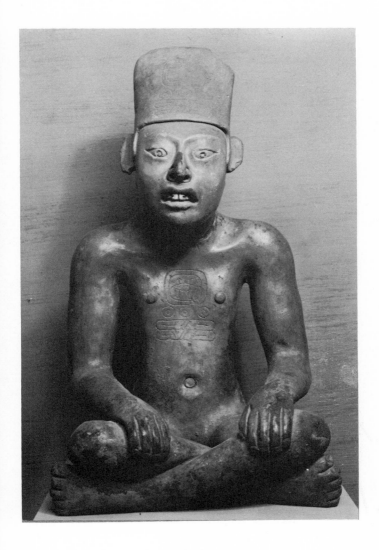

Fig. 35.—Mask in Form of a Bat, made up of fifteen pieces of jade, with eyes and teeth of shell, six and one eighth inches high, Zapotec Culture, from Monte Alban, Oaxaca.

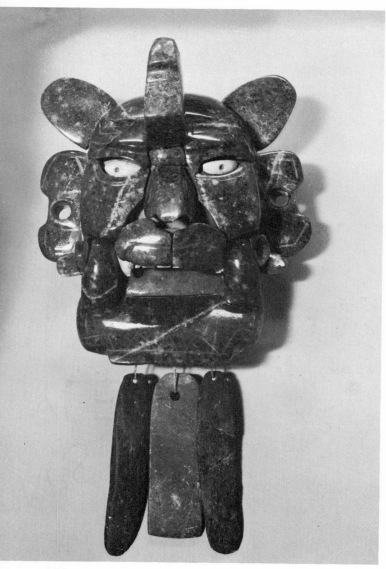

Fig. 36.—Pectoral Ornament (Mictlantecutli?) gold, Mixtec Culture, from Tomb 7, Monte Alban, Oaxaca, now in the Regional Museum of Anthropology and History, Oaxaca, Oaxaca.

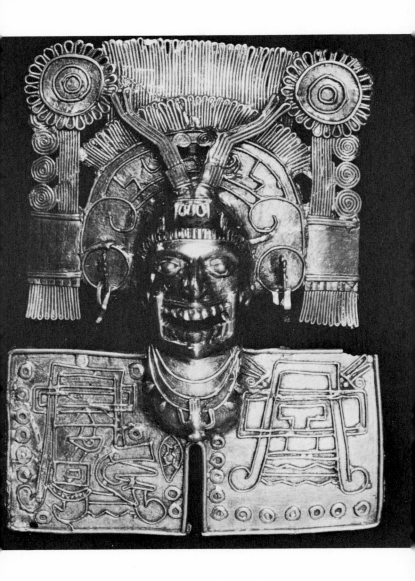

Fig. 37.—Mitla, Oaxaca, Principal Building, façade, Zapotec Culture.

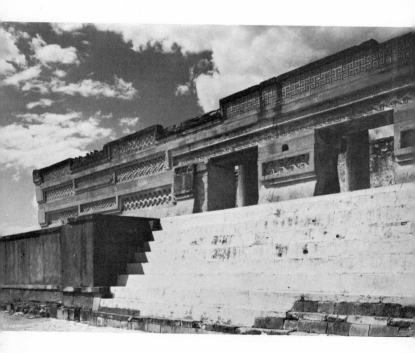

Fig. 38.—Mitla, Oaxaca, Interior of a Room, Principal Building.

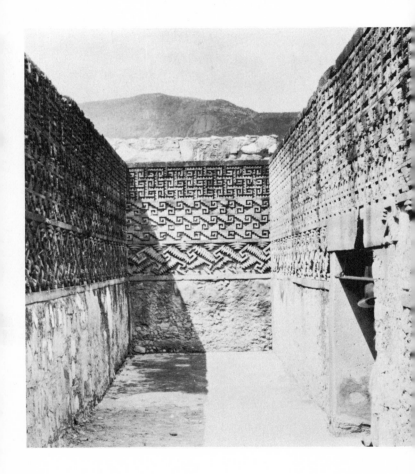

Fig. 39.—Coatlicue, Goddess of the Earth
(detail), stone, from Calixtlahuaca, Mexico.

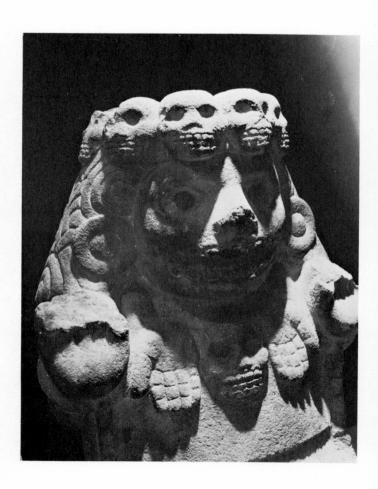

Fig. 40.—Coatlicue, Goddess of the Earth, stone inlaid with turquoise and shell, from the State of Puebla.

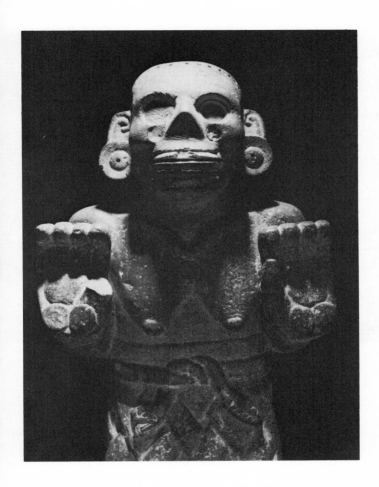

Fig. 41.—Stone of Tizoc (detail), from Tenoch-titlan, Mexico.

Fig. 42.—Cuauhxicalli in the Form of a Jaguar, stone, from Tenochtitlan, Mexico.

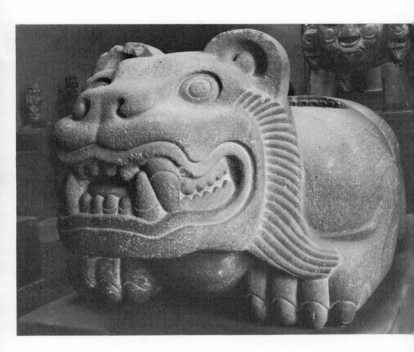

Fig. 43.—Head of a Dead Man, stone, from Veracruz.

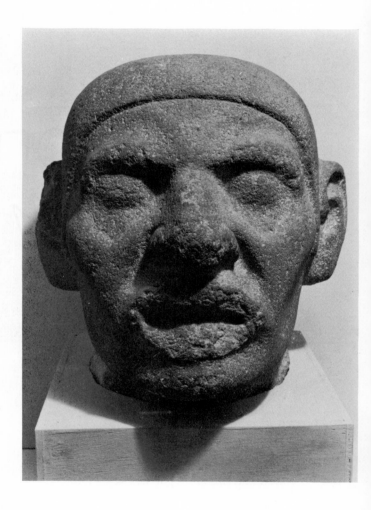

Fig. 44.—Head of an Eagle Man, stone, from
Texcoco, Mexico.

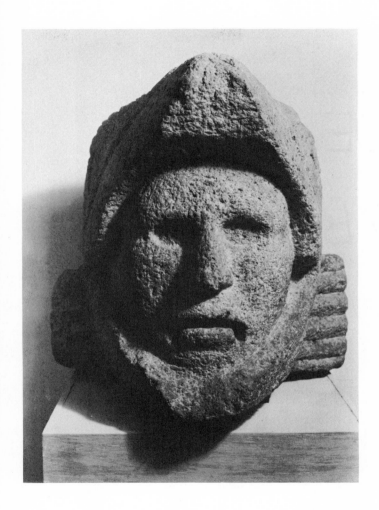

Fig. 45.—Xochipilli, God of Flowers, stone, from Tlalmanalco, Puebla.

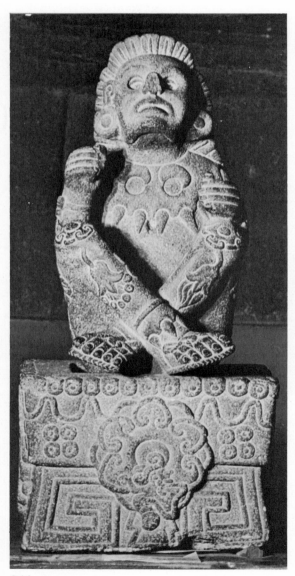

Fig. 46.—Coyolxauhqui, The Moon, stone, from
Tenochtitlan, Mexico.

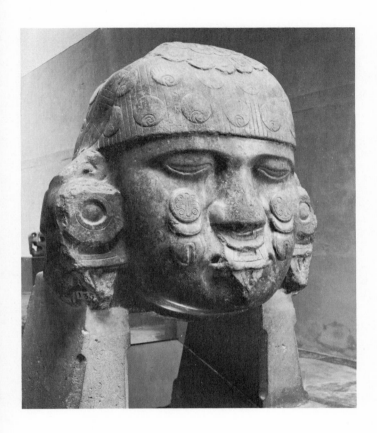

Fig. 47.—Stone of the Sun, the "Aztec Calendar," stone, eleven feet nine inches in diameter, from Tenochtitlan, Mexico.

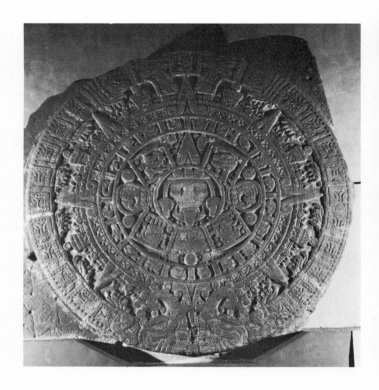

Fig. 48.—Coatlicue, Goddess of the Earth and of Life and Death, stone, slightly more than eight feet high, from Tenochtitlan, Mexico.

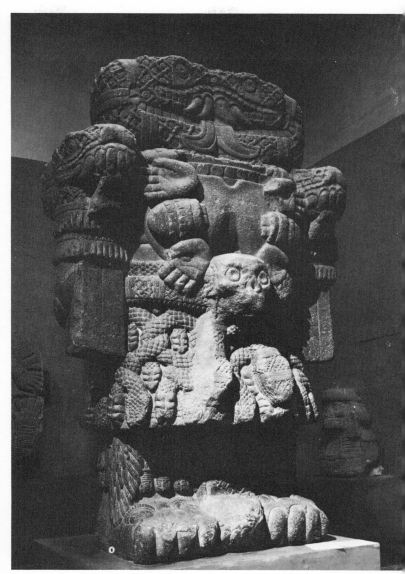

Fig. 49.—Mask, stone with a mosaic of turquoise and coral, and eyes of shell and obsidian, from Guerrero.

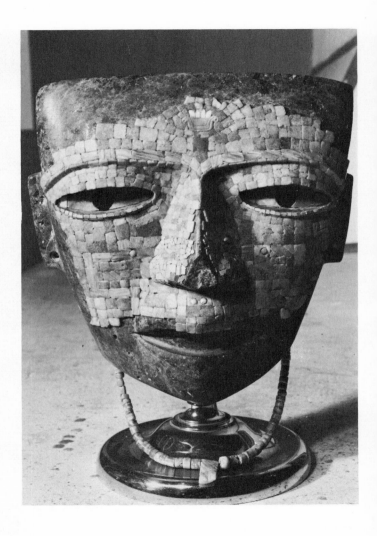

2

THE ART OF NEW SPAIN

Fig. 50.—Huejotzingo, Puebla. Franciscan
Monastery, sixteenth century: *Posa* Chapel.

Fig. 51.—Huejotzingo, Puebla. Franciscan Monastery: Principal Façade of the Church.

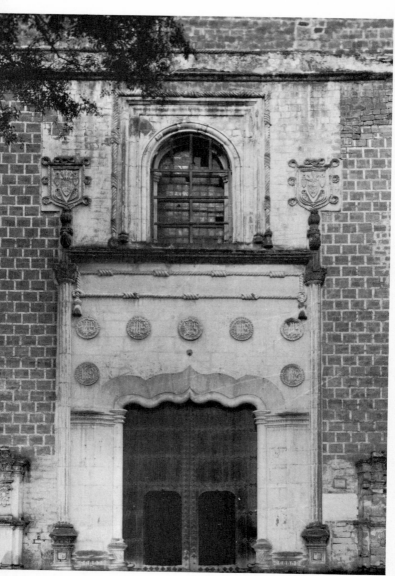

Fig. 52.—Huejotzingo, Puebla. Franciscan
Monastery: Door of Porciúncula.

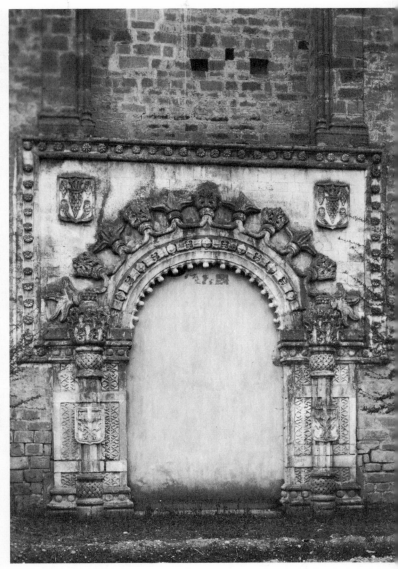

Fig. 53.—Huejotzingo, Puebla. Franciscan
Monastery: Entrance.

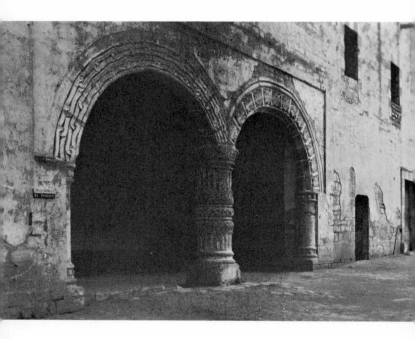

Fig. 54.—Huejotzingo, Puebla. Franciscan
Monastery: Fresco of the Twelve First
Franciscans.

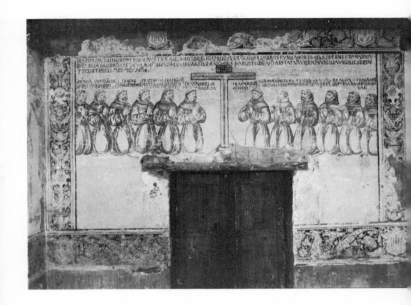

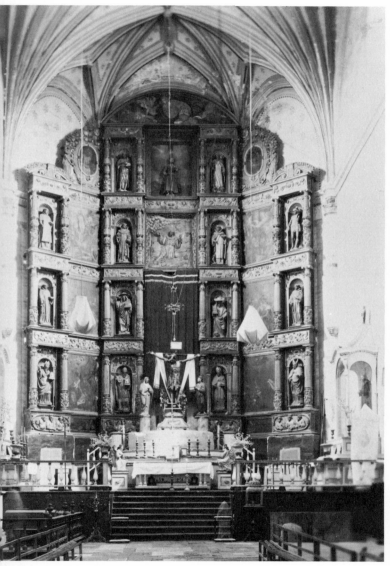

Fig. 56.—Oaxaca, Oaxaca. Dominican Monastery: Lower Cloister, sixteenth century.

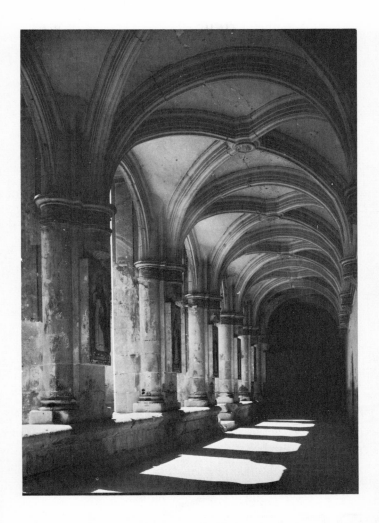

Fig. 57.—Oaxaca, Oaxaca. Dominican Monastery: Stairway.

Fig. 58.—Tepoztlán, Morelos. Dominican Monastery: sixteenth century, Façade of the Church.

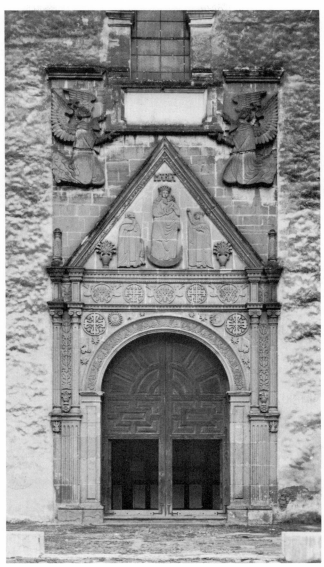

Fig. 59.—Acolman, Mexico. Augustinian Monastery: sixteenth century: Cross from the Atrium.

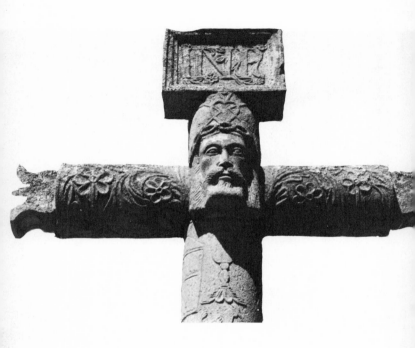

Fig. 60.—Acolman, Mexico. Augustinian Monastery: Façade of the Church and the Open Chapel.

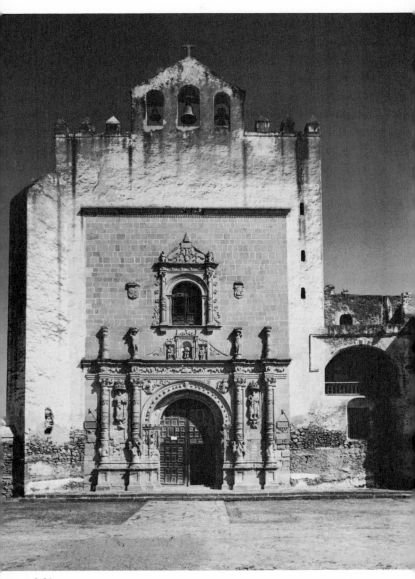

Fig. 61.—Acolman, Mexico. Augustinian
Monastery: Upper Cloister with Frescoes.

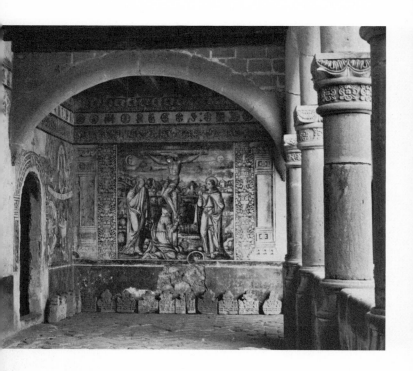

Fig. 62.—Acolman, Mexico. Augustinian Monastery: Interior of the Church.

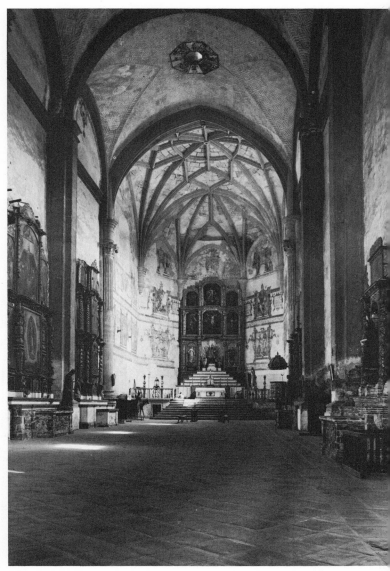

Fig. 63.—Yuririapúndaro, Michoacán. Augustinian Convent, sixteenth century: Lower Cloister.

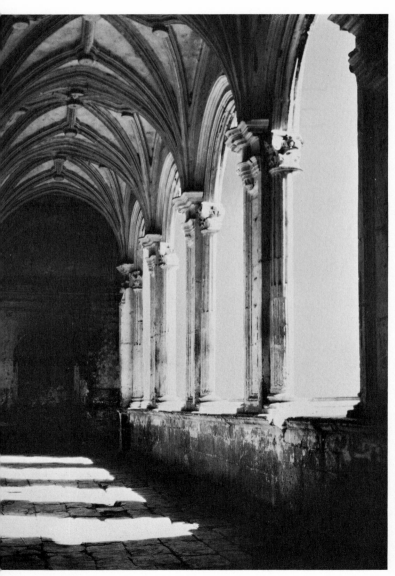

Fig. 64.—Cuitzeo, Michoacán. Augustinian
Monastery, sixteenth century: Façade of the
Church.

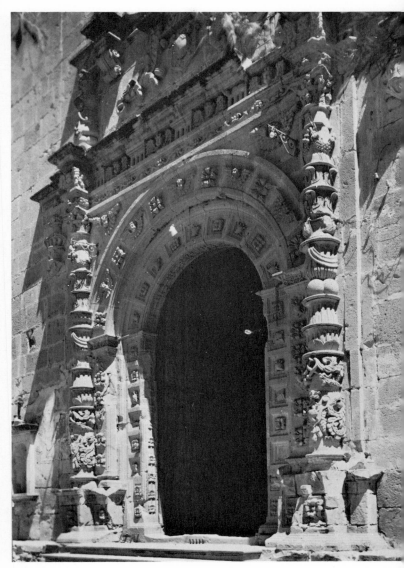

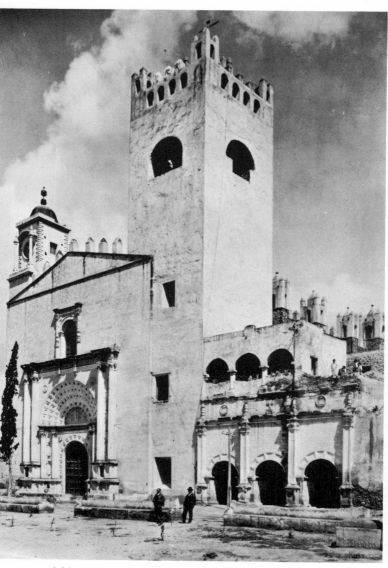

Fig. 65.—Actopan, Hidalgo. Augustinian Monastery, sixteenth century: Church and Entrance to the Monastery.

Fig. 66.—Actopan, Hidalgo. Augustinian
Monastery: Lower Cloister.

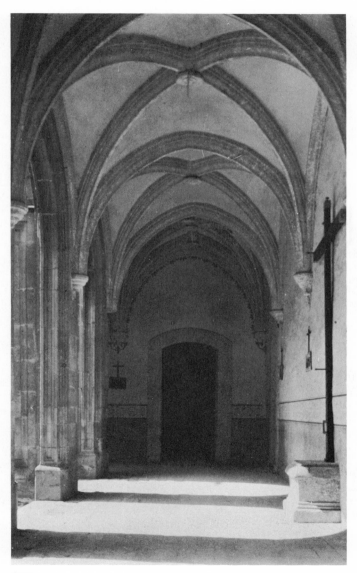

Fig. 67.—Actopan, Hidalgo. Augustinian
Monastery: Frescoes in the Stairway.

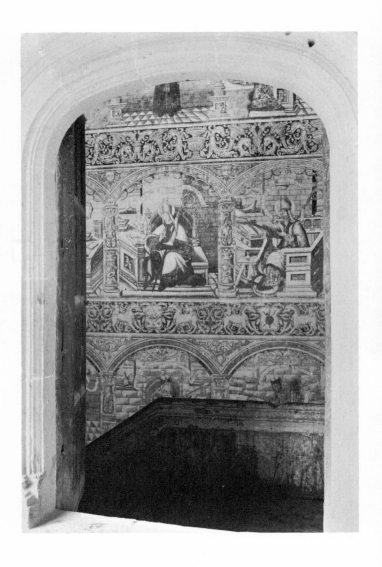

Fig. 68.—Tlalhuelilpan, Hidalgo. Augustinian Church, sixteenth century: Open Chapel.

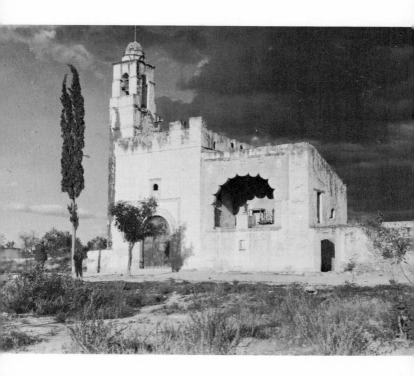

Fig. 69.—Tlalmanalco, Puebla. Open Chapel, sixteenth century.

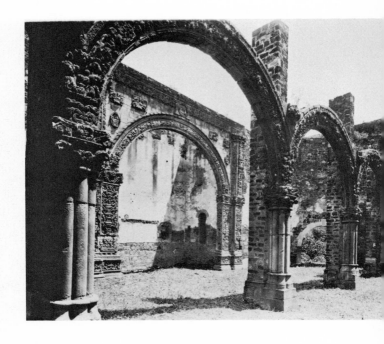

Fig. 70.—Cholula, Puebla. Royal Chapel, sixteenth century: Interior.

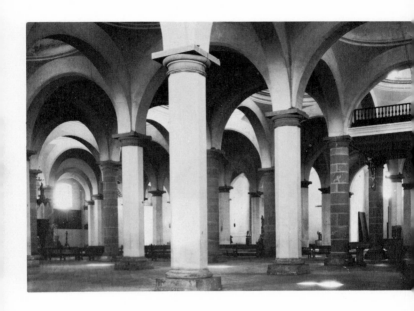

Fig. 71.—Chiapa de Corzo, Chiapas. The Well of Fra Rodrigo de Léon, 1562, built of brick used in the Moorish manner.

Fig. 72.—San Cristóbal las Casas, Chiapas.
House of Mazariegos, sixteenth century.

Fig. 73.—Mérida, Yucatán. House of Montejo, sixteenth century.

Fig. 74.—Acatzingo, Puebla. Holy-Water Font, sixteenth century.

Fig. 75.—Maní, Yucatán. Parochial Church of
San Miguel, sixteenth century, Polychrome
Retable.

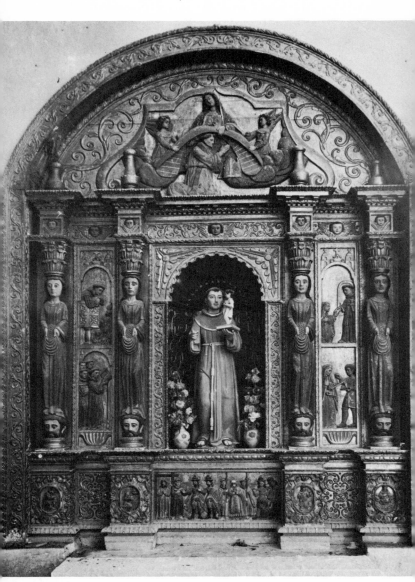

Fig. 76.—Statue of the Virgin, gessoed and polychromed wood, sixteenth century, from the high altar of the church in Xochimilco, Federal District.

Fig. 77.—Simón Pereyns, *Saint Christopher*, oil on wood panel, sixteenth century, Cathedral, Mexico City.

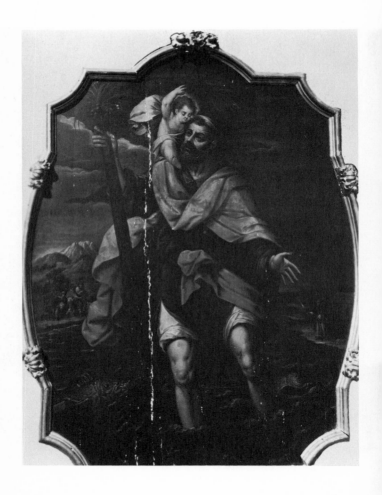

Fig. 78.—Puebla, Puebla. Cathedral, seven-
teenth century.

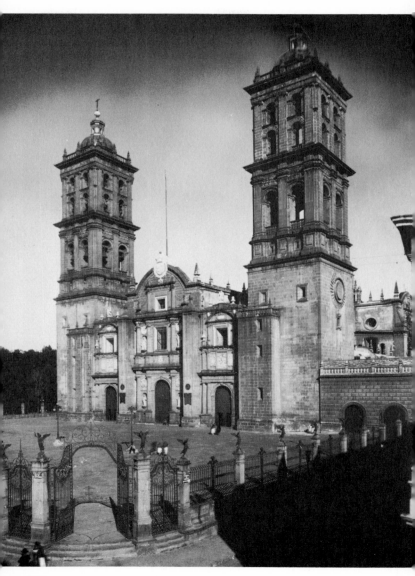

Fig. 79.—Puebla, Puebla. Cathedral: Interior.

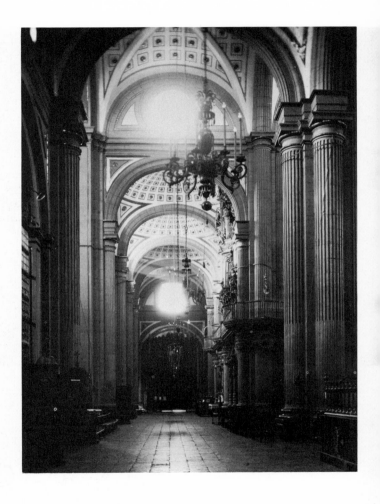

Fig. 80.—Mexico City, D.F. Cathedral and Sagrario.

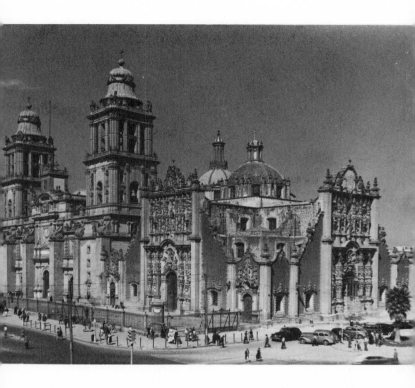

Fig. 81.—Mexico City, D.F. Cathedral: Interior from the Choir.

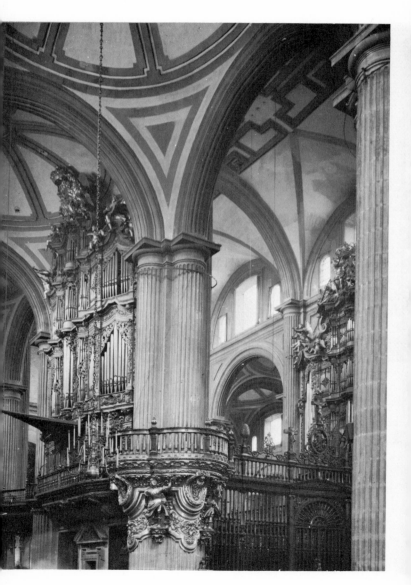

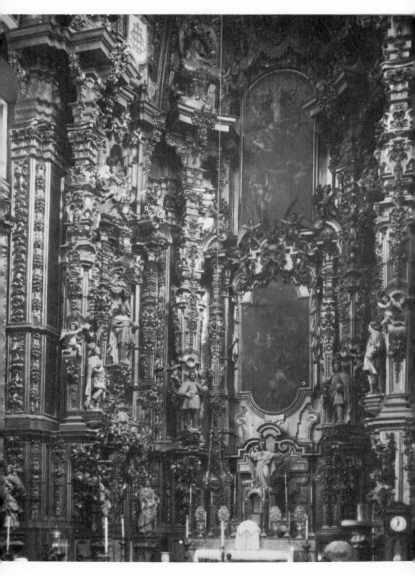

Fig. 82.—Mexico City, D.F. Cathedral: Altar of
the Kings, eighteenth century.

Fig. 83.—Zacatecas, Zacatecas. Cathedral,
eighteenth century.

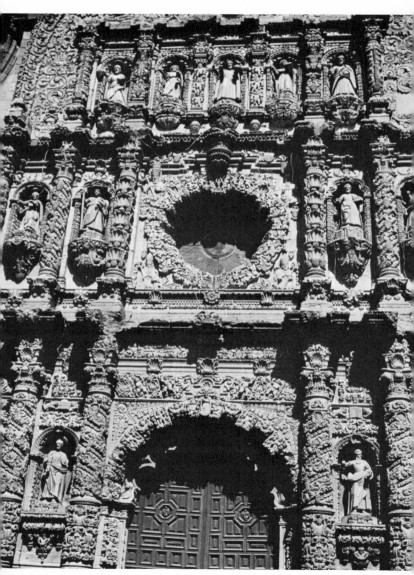

Fig. 84.—Guadalajara, Jalisco. Church of
Santa Mónica, eighteenth century: One of the
Portals.

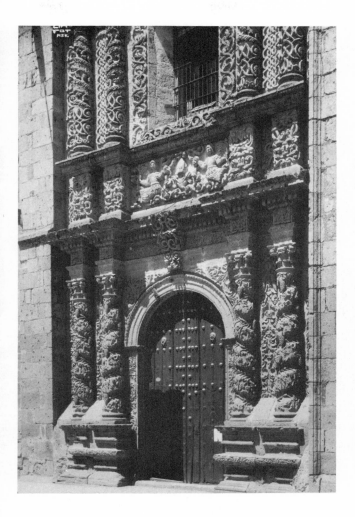

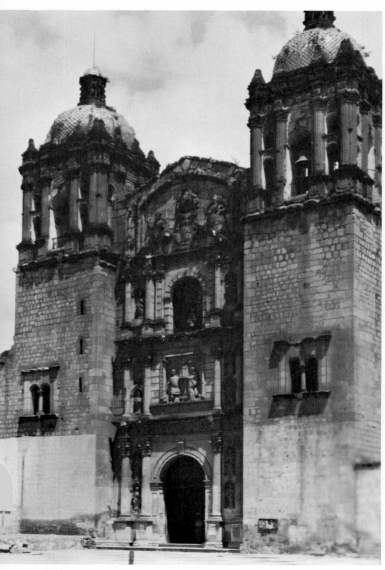

Fig. 86.—Oaxaca, Oaxaca. Church of Santo Domingo: Polychrome Relief in the Choir, seventeenth century.

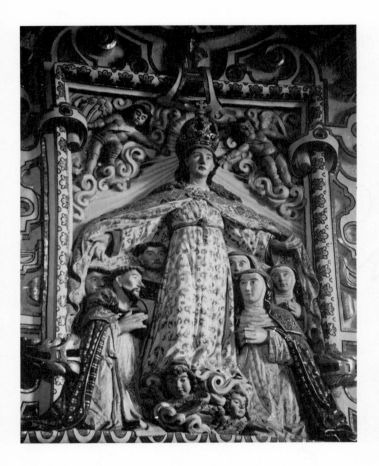

Fig. 87.—Puebla, Puebla. Church of Santo Domingo: Chapel of the Rosary, Interior of Cupola, seventeenth century.

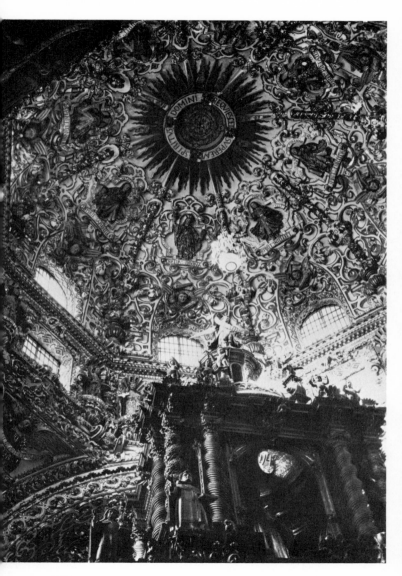

Fig. 88.—Puebla, Puebla. Church of Santo Domingo: Retable of the Main Altar, seventeenth century.

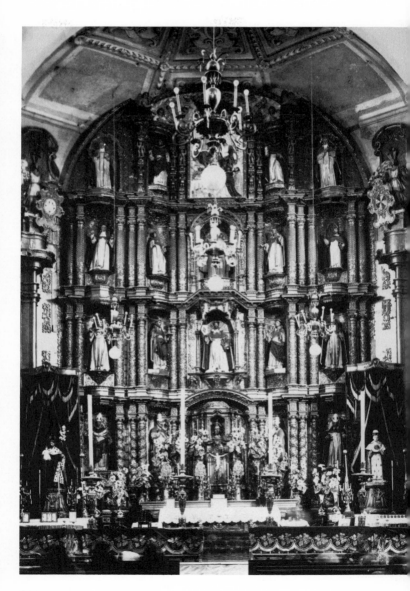

Fig. 89.—Tepotzotlán, Mexico. Façade of the
Church, eighteenth century.

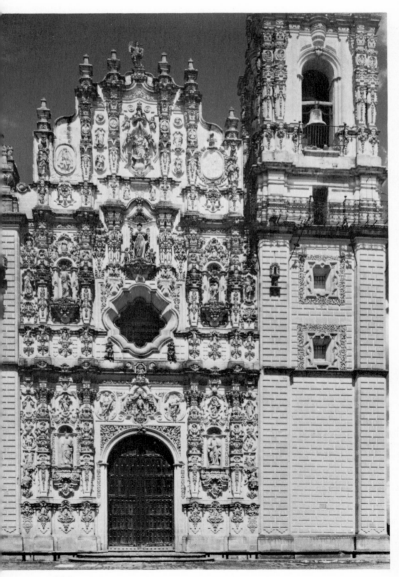

Fig. 90.—Tepotzotlán, Mexico. Retable of San
José.

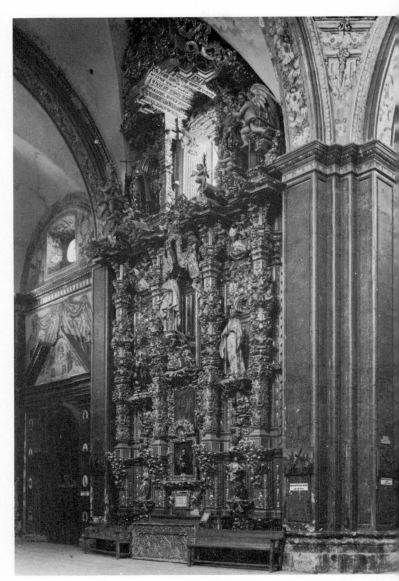

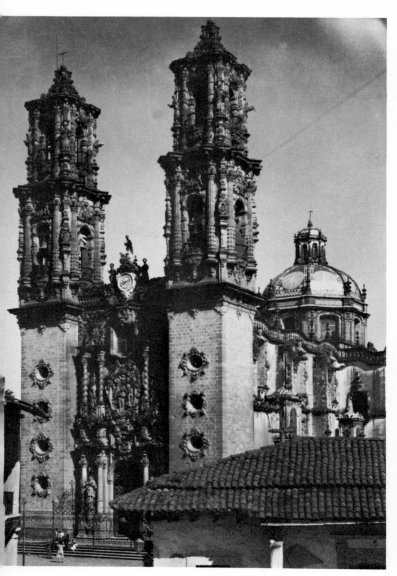

Fig. 91.—Taxco, Guerrero. Parochial Church of Santa Prisca and San Sebastián, eighteenth century.

Fig. 92.—Taxco, Guerrero. Parochial Church of
Santa Prisca and San Sebastián: Main Altar.

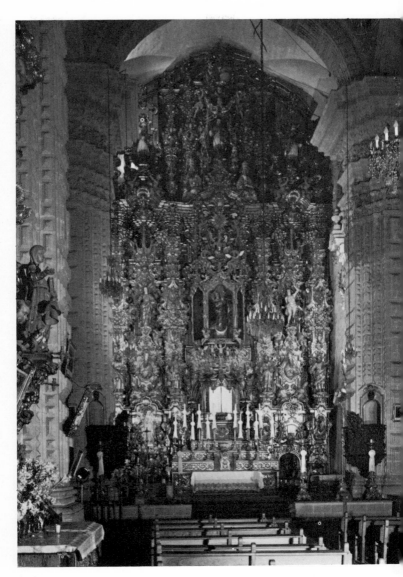

Fig. 93.—Ocotlán, Tlaxcala. View of the Sanctuary, eighteenth century.

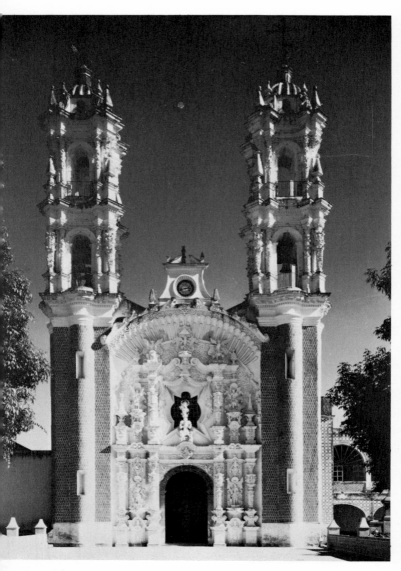

Fig. 94.—Ocotlán, Tlaxcala. The *Camarín* of the Virgin, eighteenth century.

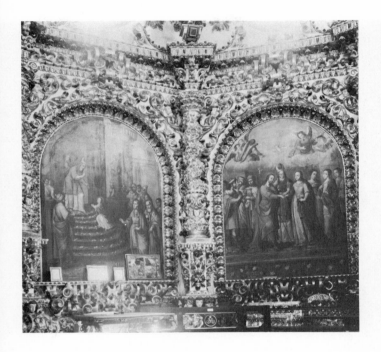

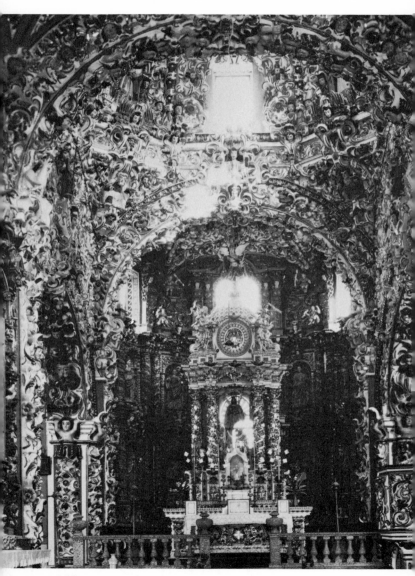

Fig. 96.—Acatepec, Puebla. Church of San
Francisco: Façade, eighteenth century.

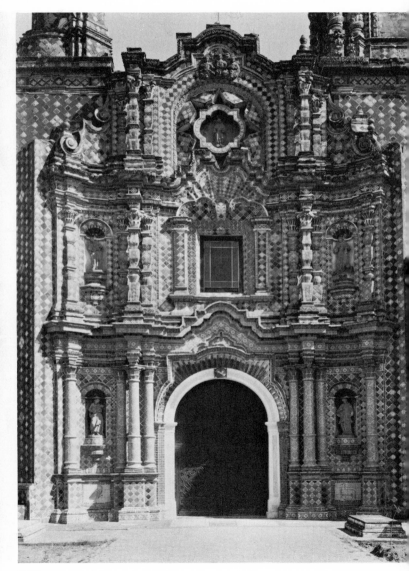

Fig. 97.—Acatepec, Puebla. Church of San Francisco: Detail of the Interior Ornament.

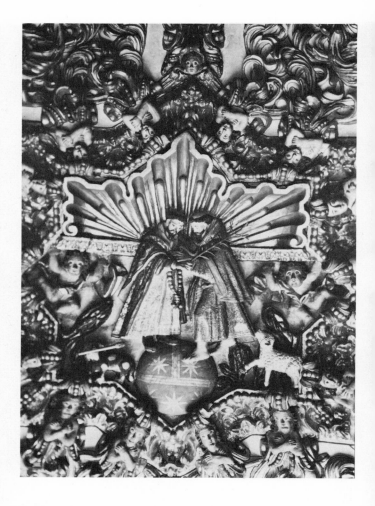

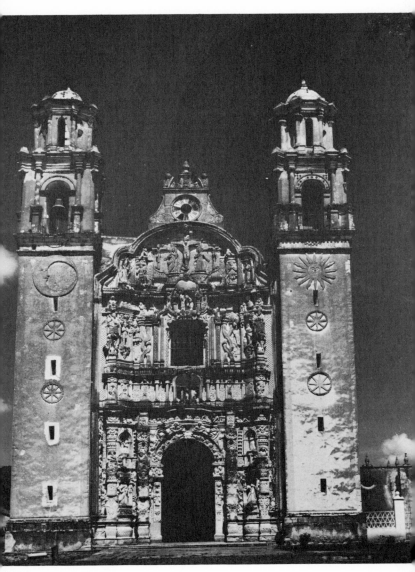

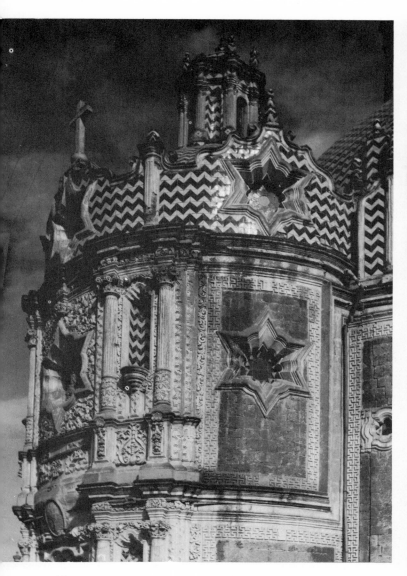

Fig. 100.—Mexico City, D.F. Hotel Iturbide, eighteenth century (from a nineteenth century lithograph).

Fig. 101.—Mexico City, D.F. Hotel Iturbide: Courtyard.

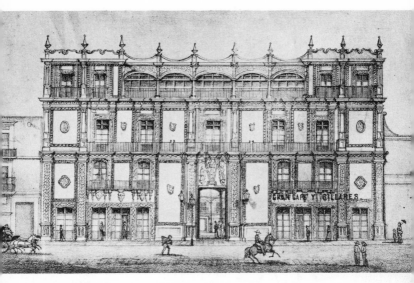

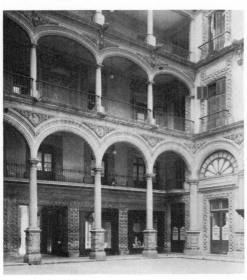

Fig. 102.—Mexico City, D.F. House of Tiles, eighteenth century.

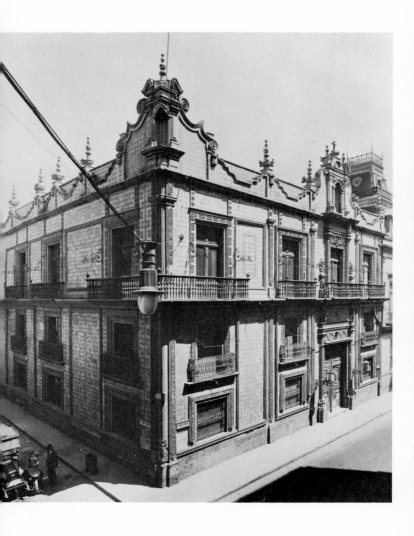

Fig. 103.—Puebla, Puebla. House of Alfeñique, eighteenth century.

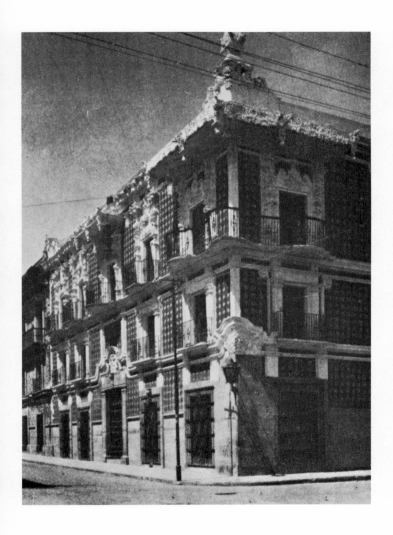

Fig. 104.—Mexico City, D.F. College of the Viscaínas, eighteenth century.

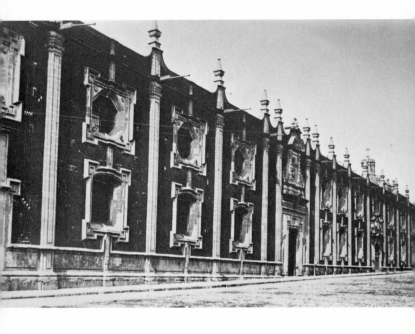

Fig. 105.—Taxco, Guerrero. Casa Humboldt, eighteenth century.

Fig. 106.—Mexico City, D.F. Church of San Agustín (National Library): Relief over the Central Door, seventeenth century.

Fig. 107.—Choirstall from the former Church of San Agustín, in the Hall *El Generalito*, National Preparatory School of San Ildefonso, Mexico City, D.F.

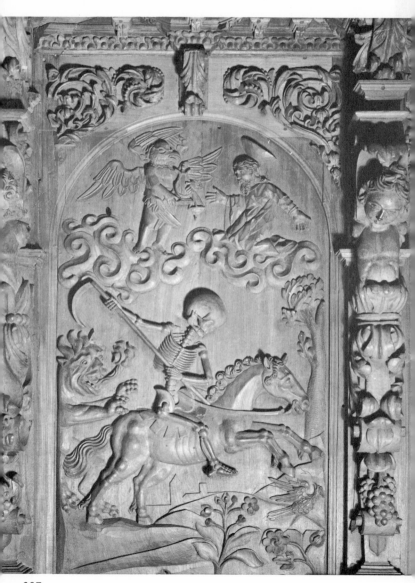

Fig. 108.—*San Diego de Alcalá*, polychromed
wood, seventeenth century, Viceregal Museum,
Tepotzotlán.

Fig. 109.—*San José*, gessoed and polychromed wood, eighteenth century, Viceregal Museum, Tepotzotlán.

Fig. 110.—Alonzo López de Herrera, *The Assumption of the Virgin*, seventeenth century, Pinacoteca of San Diego, Mexico City.

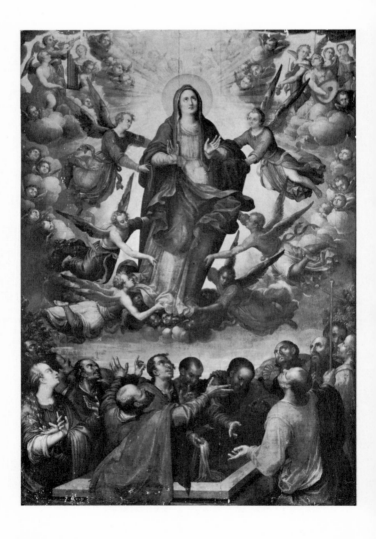

Fig. 111.—Baltasar Echave Orio, *Martyrdom of San Ponciano*, seventeenth century, Pinacoteca of San Diego, Mexico City.

Fig. 112.—Baltasar Echave Orio, *Adoration of the Kings*, seventeenth century, Pinacoteca of San Diego, Mexico City.

Fig. 113.—Baltasar Echave Orio, *Agony in the Garden*, seventeenth century, Pinacoteca of San Diego, Mexico City.

Fig. 114.—Baltasar Echave Ibía, *The Im-maculata*, 1622, Pinacoteca of San Diego, Mexico City.

Fig. 115.—Luis Juárez, *Saint Ildefonso receiving the Chasuble*, seventeenth century, Pinacoteca of San Diego, Mexico City.

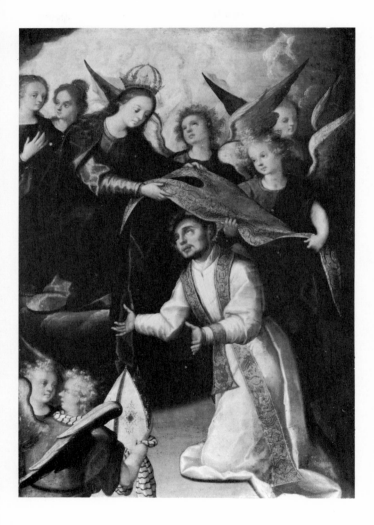

Fig. 116.—Sebastián López de Arteaga, *Christ on the Cross*, seventeenth century, Pinacoteca of San Diego, Mexico City.

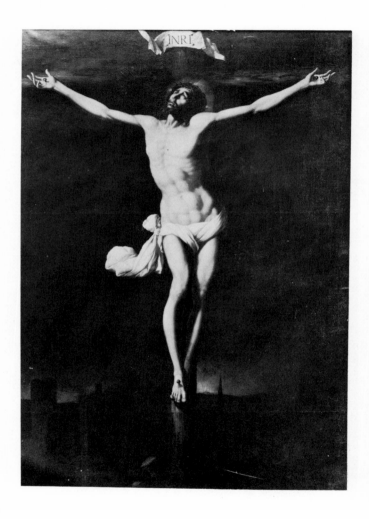

Fig. 117.—Sebastián López de Arteaga, *Incredulity of Saint Thomas*, Pinacoteca of San Diego, Mexico City.

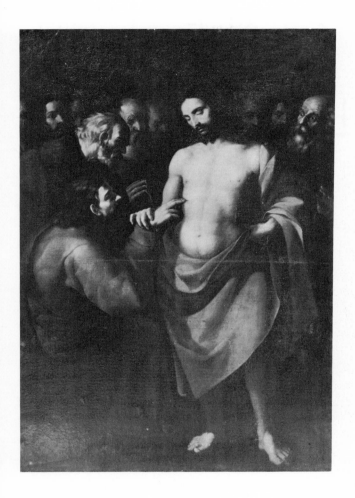

Fig. 118.—Pedro Ramírez, *The Delivery of Saint Peter*, seventeenth century, Viceregal Museum, Tepotzotlán, Mexico.

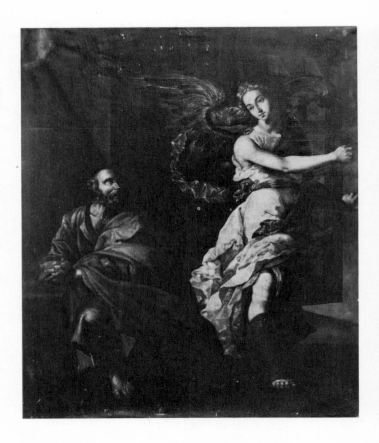

Fig. 119.—José Juárez, *The Adoration of the Kings*, seventeenth century, Pinacoteca of San Diego, Mexico City.

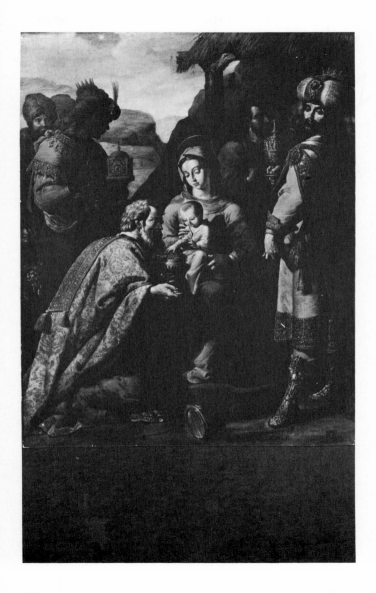

Fig. 120.—Juan Rodríguez Juárez, *The Duke de Linares*, eighteenth century, Pinacoteca of San Diego, Mexico City.

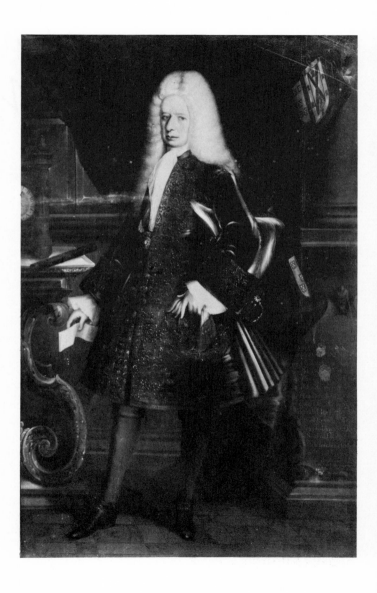

Fig. 121.—Miguel Cabrera, *The Vigin of the Apocalypse*, eighteenth century, Pinacoteca of San Diego, Mexico City.

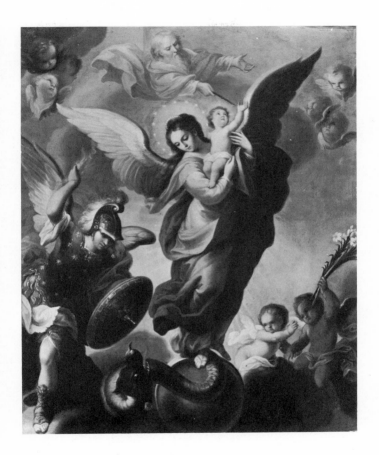

Fig. 122.—Miguel Cabrera, *Sor Juana Inés de la Cruz,* eighteenth century, Museum of History, Chapultepec, Mexico City.

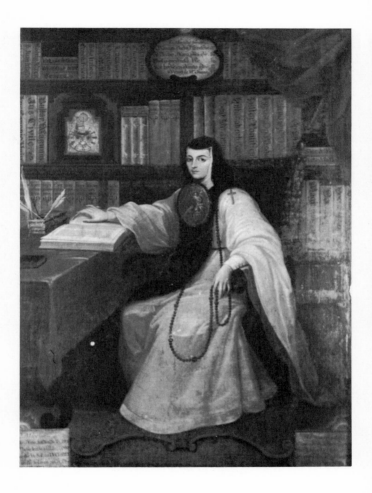

Fig. 123.—Anonymous, *The Plaza Mayor*
(detail), eighteenth century, Alcázar Collection,
now in the Hotel Ritz, Mexico City.

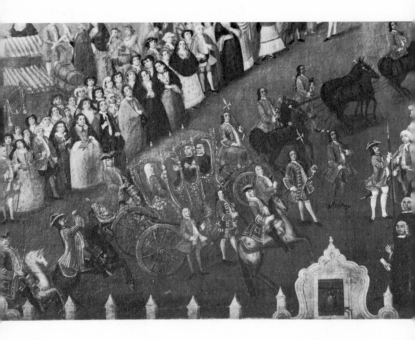

Fig. 124.—Celaya, Guanajuato. Church of the Carmen, 1802–1807, Francisco Eduardo de Tresguerras, architect.

Fig. 125.—Mexico City. Palace of Mines, 1797–1813, Manuel Tolsá, architect.

Fig. 126.—Mexico City. Palace of Mines:
Courtyard Arcade.

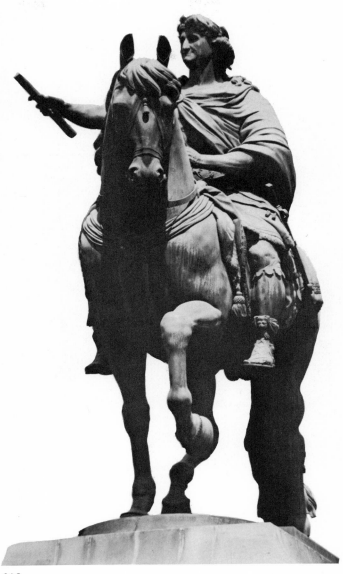

Fig. 130.—Rafael Ximeno y Planes, *Manuel Tolsá*, Pinacoteca of San Diego, Mexico City.

Fig. 131.—José María Vázquez, *Doña María Luisa Gonzaga Foncerrada*, 1806, Pinacoteca of San Diego, Mexico City.

Fig. 132.—José Luis Rodríguez Alconedo, *Self-Portrait*, pastel, Academy of Fine Arts, Puebla, Puebla.

Fig. 133.—José Joaquín Fabregat, *The Plaza Mayor in 1796*, engraving, private collection.

3

MODERN ART

Fig. 134.—Pelegrín Clavé, *Portrait of Señorita Echeverría*, 1847, oil on canvas, Palace of Fine Arts, Mexico City.

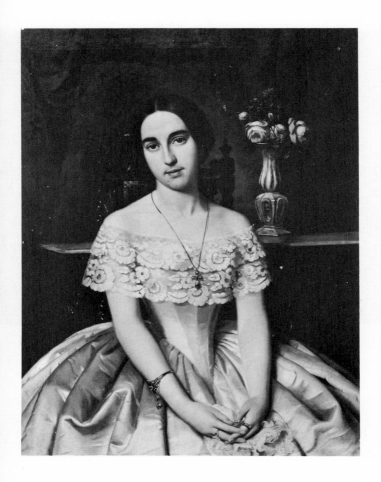

Fig. 135.—José Obregón, *The Discovery of Pulque*, exhibited 1869, oil on canvas, Palace of Fine Arts, Mexico City.

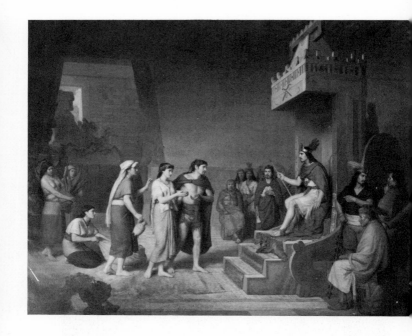

Fig. 136.—Juan Cordero, *Portrait of the Sculptors Pérez and Valero*, 1847, oil on canvas, Palace of Fine Arts, Mexico City.

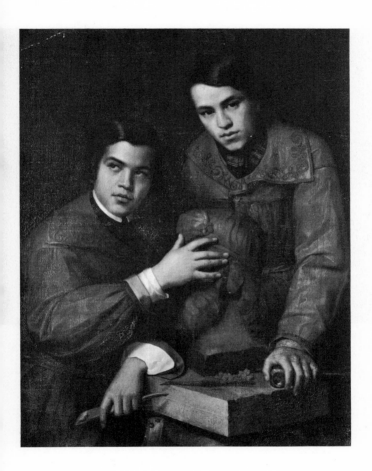

Fig. 137.—Felipe Gutiérrez, *Saint Jerome*, exhibited 1878, oil on canvas, Palace of Fine Arts, Mexico City.

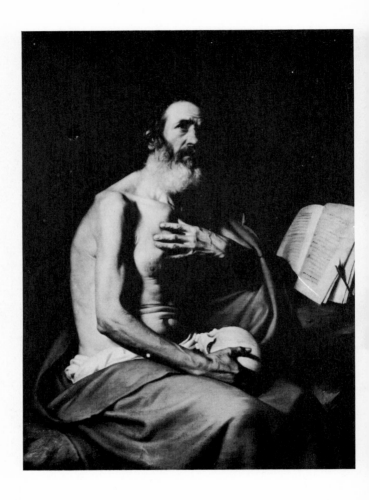

Fig. 138.—Félix Parra, *Galileo*, exhibited 1874, oil on canvas, Palace of Fine Arts, Mexico City.

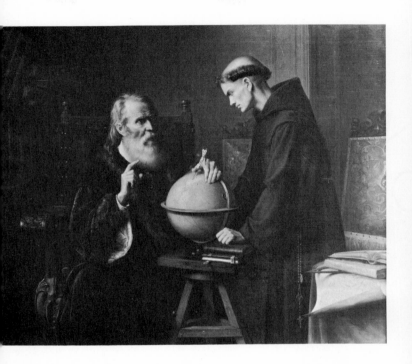

Fig. 139.—Leandro Izaguirre, *The Torture of Cuauhtémoc,* 1892, oil on canvas, Palace of Fine Arts, Mexico City.

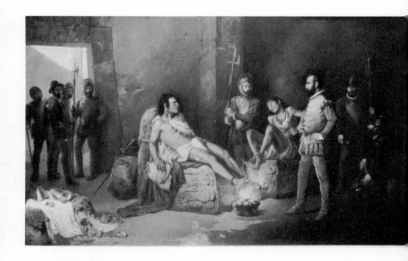

Fig. 141.—José María Velasco, *An Excursion on the Outskirts of Mexico City*, 1866, oil on canvas, Museum of Modern Art, Mexico City.

Fig. 142.—José María Velasco, *El Citlaltépetl*, 1897, oil on canvas, Museum of Modern Art, Mexico City.

Fig. 143.—José María Estrada, Portrait of a Woman, 1844, oil, Palace of Fine Arts, Mexico City.

Fig. 144.—Miguel Noreña, *Statue of Cuauhté-moc,* 1887, bronze, Monument to Cuauhtémoc, Mexico City.

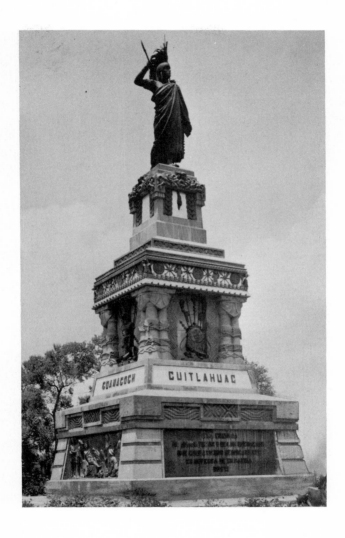

Fig. 145.—Gabriel Guerra, *Torture of Cuauhté-moc*, 1887, bronze relief, Monument to Cuauhtémoc, Mexico City.

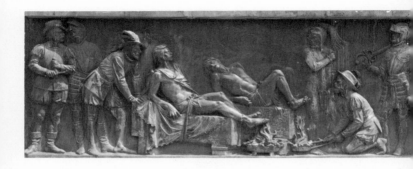

Fig. 146.—Mexico City. Dome of the Church of
Santa Teresa, 1855, Lorenzo de la Hidalga,
architect.

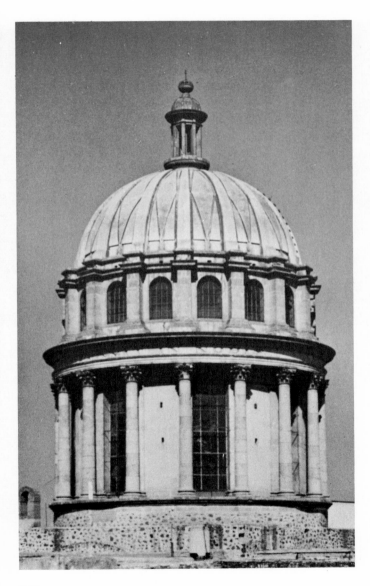

Fig. 147.—Mexico City, D.F. Palace of Fine
Arts, 1904–1934, Adamo Boari, architect.

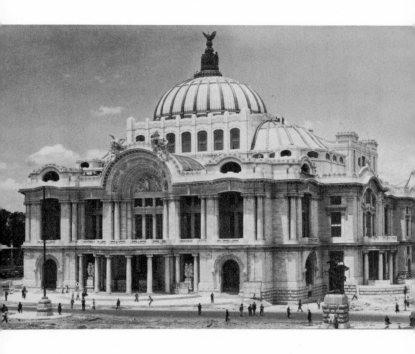

Fig. 148.—Saturnino Herrán, *The Rebozo*, 1916, oil, Palace of Fine Arts, Mexico City.

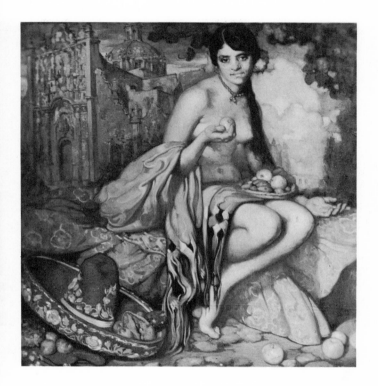

Fig. 149.—Saturnino Herrán, *The Offering*, 1913, oil, Palace of Fine Arts, Mexico City.

Fig. 150.—Saturnino Herrán, *Our Gods* (detail), 1917, charcoal, Palace of Fine Arts, Mexico City.

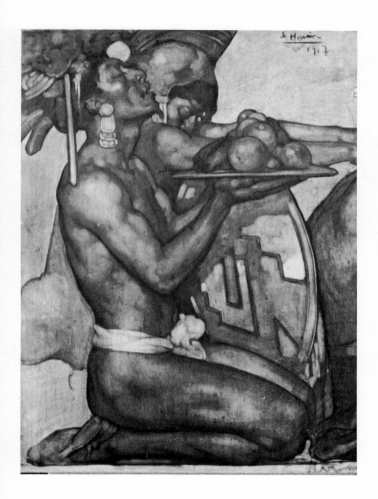

Fig. 151.—Joaquín Clausell, *Clouds over the Harvest*, 1920 (?), oil, private collection.

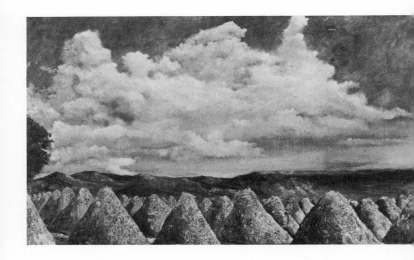

Fig. 152.—Dr. Atl (Gerardo Murillo), *The Valley of Mexico*, 1940, oil, Palace of Fine Arts, Mexico City.

Fig. 153.—José Guadalupe Posada, *Big Spur against the Knife*, zinc cut.

Fig. 154.—José Guadalupe Posada, *Calavera Zapatista*, zinc cut.

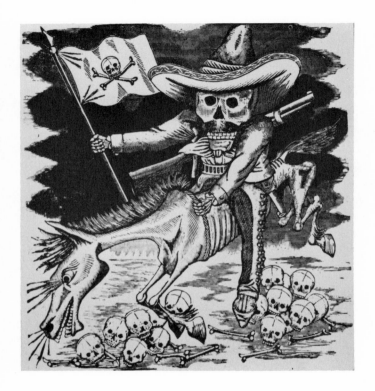

4

CONTEMPORARY ART

Fig. 155.—Diego Rivera, *Man with a Cigarette*, 1913, oil, private collection.

Fig. 156.—Diego Rivera, *The Sleeping Earth*, detail of fresco, Salón de Actos, National Agriculture School, Chapingo, Mexico.

Fig. 157.—Diego Rivera, *Our Time*, 1934, detail of fresco, Palace of Fine Arts, Mexico City.

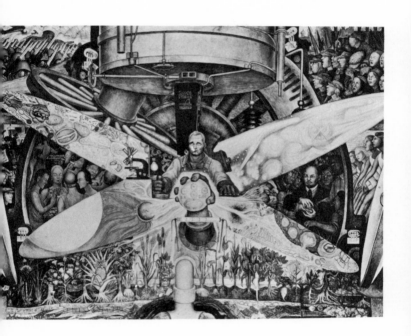

Fig. 158.—José Clemente Orozco, *The Trench*, 1923, fresco, National Preparatory School, Mexico City.

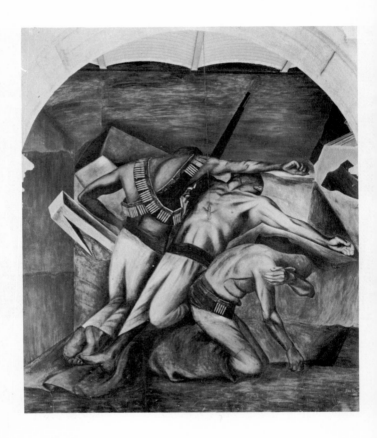

Fig. 159.—José Clemente Orozco, *Prometheus*, detail of fresco, 1930, Pomona College, Claremont, California.

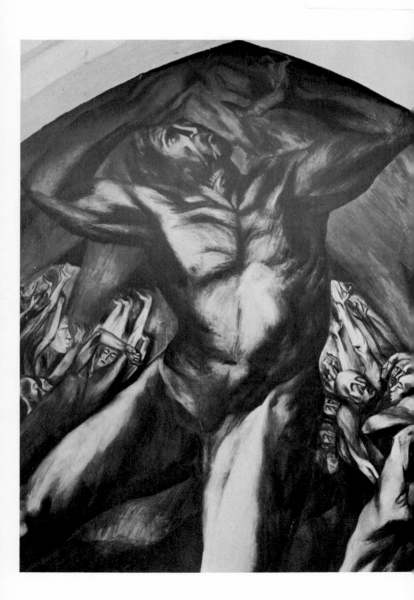

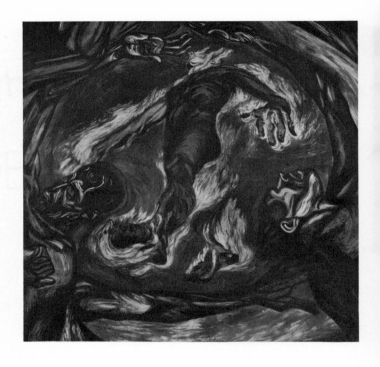

Fig. 161.—David Alfaro Siqueiros, *New Democracy*, central part of a mural, 1942, pyroxylin, Palace of Fine Arts, Mexico City.

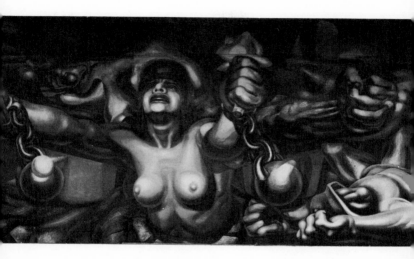

Fig. 162.—David Alfaro Siqueiros, *The Aesthetician in Drama,* 1944, pyroxylin, private collection.

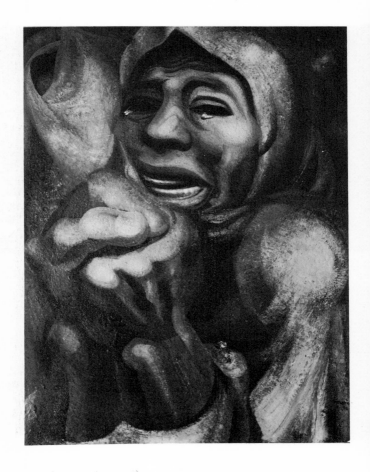

Fig. 163.—David Alfaro Siqueiros, *Our Present Image*, 1947, pyroxylin, Palace of Fine Arts, Mexico City.

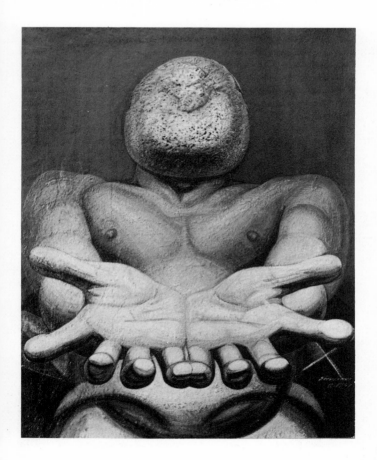

Fig. 164.—Rufino Tamayo, *Music*, detail of
fresco, 1933, Former Conservatory of Music,
now Secretaria de Bienes Nacionales, Mexico
City.

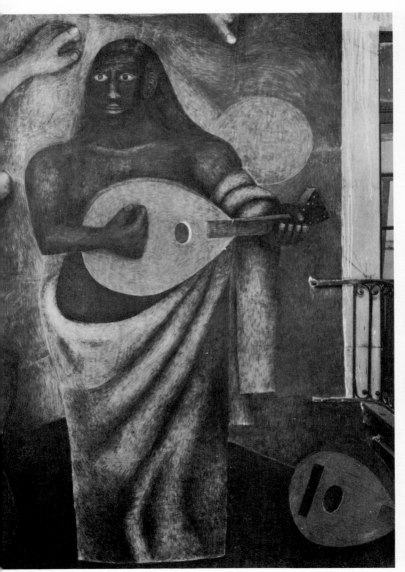

Fig. 165.—Rufino Tamayo, *The Birth of Our Nationality,* vinylite on canvas, 1952, Palace of Fine Arts, Mexico City.
Fig. 166.—Rufino Tamayo, *Mexico Today,* vinylite on canvas, 1952, Palace of Fine Arts, Mexico City.

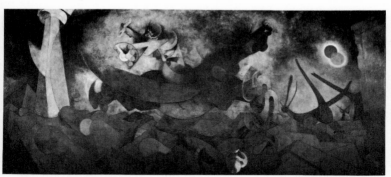

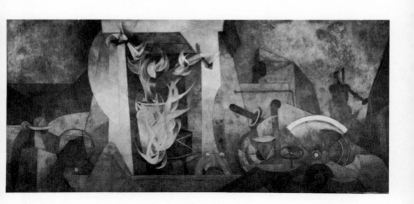

Fig. 167.—Rufino Tamayo, *Niña Bonita,* 1937, oil, private collection.

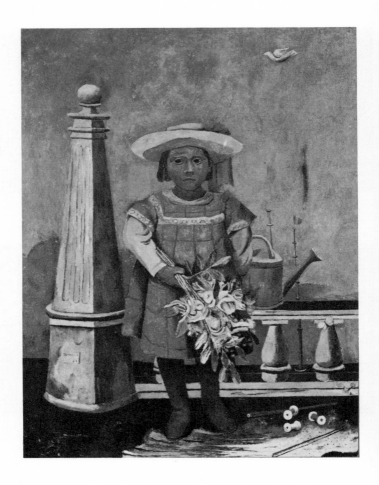

Fig. 168.—Pedro Coronel, *Reposo*, oil on
canvas, 1965, Collection Banco Nacional de
México, Paris.

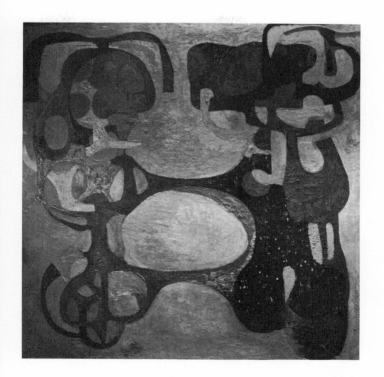

Fig. 169.—José Luis Cuevas, *Vigil*, 1959, ink and wash, Dr. Eugene A. Solow and Family, Chicago.

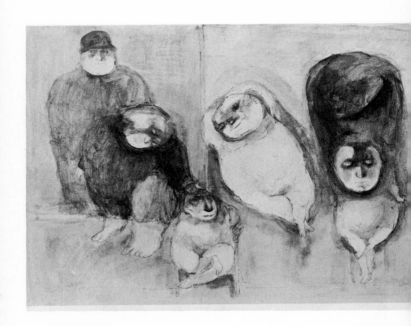

Fig. 170.—Francisco Goitia, *Tata Jesucristo*, 1927, oil, Palace of Fine Arts, Mexico City.

Fig. 171.—Carlos Bracho, *Silvestre Revueltas*, marble, Palace of Fine Arts, Mexico City.

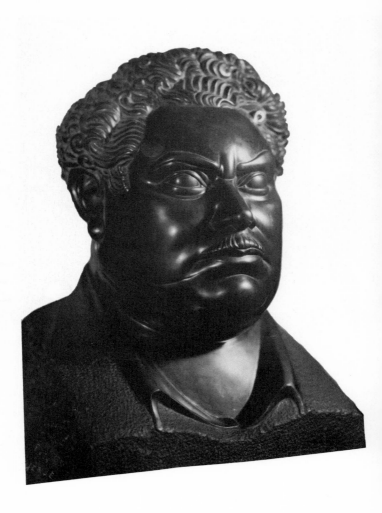

Fig. 172.—Luis Ortiz Monasterio, *Victory*,
marble, private collection.

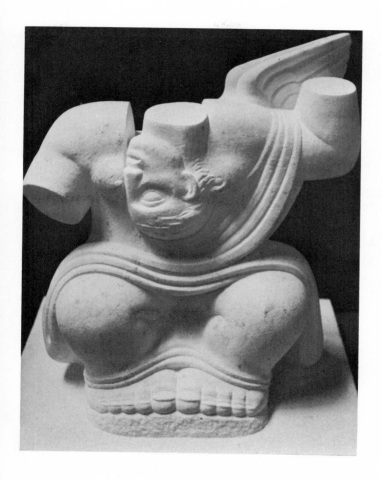

Fig. 173.—Leopoldo Méndez, *Don Zopilote Drunk*, 1944, Wood engraving, from *Incidentes Melódicos del Mundo Irracional* of Juan de la Cabada.

Fig. 174.—Mexico City. University City: Tower of the Rectory, 1954, Mario Pani and Enrique Del Moral, architects. The relief with mosaic is by Siqueiros.

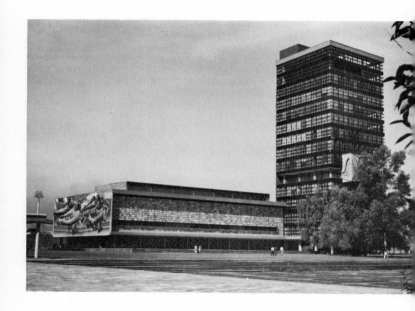

Fig. 175.—Mexico City. University City:
Central Library, 1952, Juan O'Gorman,
designer.

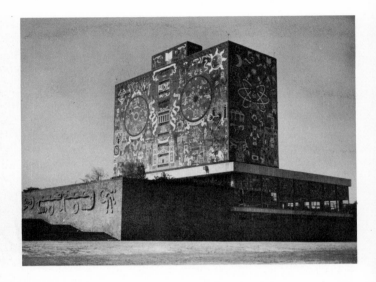

Fig. 176.—Mexico City. University City:
Frontón Courts, 1954, Alberto Arai, architect.

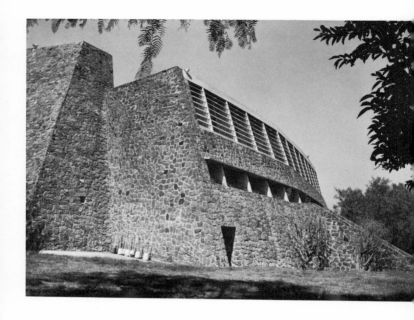

Fig. 177.—Mexico, D.F. University City: Olympic Stadium, 1954, Augusto Pérez Palacios, architect.

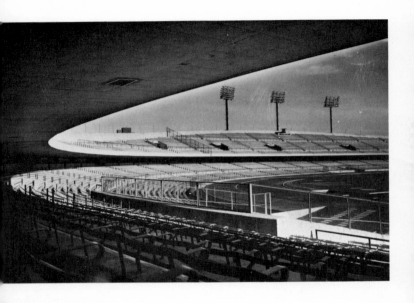

Fig. 178.—Pedro Ramírez Vázquez, *National Museum of Anthropology*, central court, Chapultepec, Mexico City.

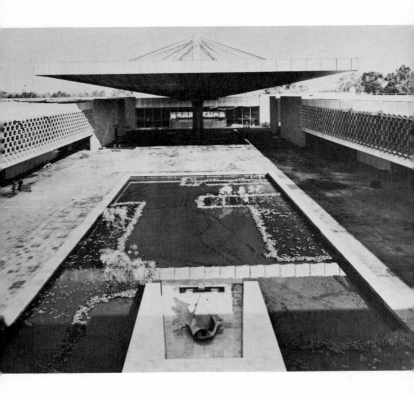

Fig. 179.—Monterrey, Nuevo Leon. Parochial
Church of La Purísima, 1946, Enrique de la
Mora, architect.

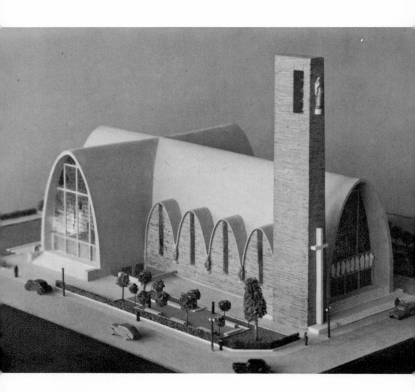

Fig. 180.—Ceramic Pot from Zumpango, Guerrero.

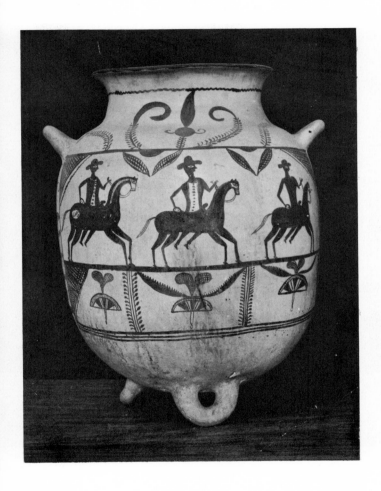

Fig. 181.—Ceramic Pot from Tlaquepaque, Jalisco.

Fig. 182.—Talavera Ware, Puebla, Puebla.

Fig. 183.—Saddle, embossed leather from Mexico City and metal work from Amozoc, Puebla.

A BRIEF CHRONOLOGY OF MODERN MEXICO

1440–87 Aztec expansion under Moctezuma I. The pre-conquest population of Mexico has been estimated at more than twenty million.

1519 Hernando Cortés lands near Vera Cruz and begins the conquest, arriving at Tenochtitlan (the site of Mexico City) late in the year.

1520 June 30, the so-called *noche triste*, Cortés' retreat from Tenochtitlan with heavy losses.

1521 Tenochtitlan taken and largely destroyed; Cuauhtémoc captured and tortured.

1521–42 Central Mexico conquered and occupied. Franciscans arrive, 1523; Dominicans, 1526; Augustinians, 1533. Extensive eclesiastical complexes are begun.

1537 First printing press in New Spain.

1551 The University of Mexico is established by charter; first classes meet in 1553.

1571 Office of the Inquisition in Mexico City.

1649 The Cathedral of Puebla dedicated.

1650 By this date the Indian population had been reduced to about one million but begins now to increase.

1667 The Cathedral of Mexico City dedicated.

1764 Royal tobacco factory established in Mexico.

1767 Jesuits expelled.

1768 School of Medicine founded in Mexico City.

1783 San Carlos Academy of Fine Arts of New Spain established by Carlos III, inaugurated 1785.

1788 Botanical gardens laid out for study near Mexico City.

1791 School of Mines established. Casts from antique sculptures sent to the San Carlos Academy, and Rafael Jimenes and Manuel Tolsá arrive to serve as masters. Tolsá builds the Palace of Mines, 1797–1813.

1810 September 16, the movement for independence is publicly launched by Father Hidalgo, who utters his famous cry for independence *(el Grito de Dolores)* in the town of Dolores, Guanajuato. September 16 is celebrated as Independence Day. Hidalgo and other leaders are

captured and executed in 1811, but the independence movement continues.

1821 Mexico wins its independence, although the treaty is not at once recognized by Spain. A provisional government is set up under Iturbide, who becomes Emperor Agustín I.

1822 Independent Mexico is recognized by the United States.

1823 Iturbide abdicates and a provisional government is formed.

1824 A constitution is adopted forming a federal republican government. Guadalupe Victoria becomes the first president of Mexico.

1829 Spanish invade Tampico but surrender to General Santa Anna, who will become a major figure in Mexican politics. Slavery is abolished.

1836 Texas declares its independence from Mexico. Santa Anna captures the Alamo in San Antonio but is defeated at San Jacinto and forced to recognize the independence of Texas.

1845 Over Mexican objections, Texas becomes a state in the United States.

1846–48 War between Mexico and the United States. American troops storm Chapultepec Castle in Mexico City, then a military academy, and the defending cadets commit suicide rather than surrender. They are celebrated as "The Boy Heroes" (Los Niños Héroes), September 13.

1847 The San Carlos Academy, closed for some years, reopens under the Italian-trained Spanish painter, Pelegrin Clavé.

1853 A government under Santa Anna sells the Mesilla Valley to the United States (the Gadsden Purchase).

1856–57 A new constitution is drafted and anticlerical laws passed.

1858–61 War of Reform between conservative (clerical) and liberal forces, the latter under Benito Juárez (1806–72). The conservatives are defeated, but the new government under Juárez is threatened with intervention by England, France, and Spain.

1862–67 French intervention in Mexico.

1862 May 5, French defeated at Puebla. The day is celebrated as a holiday.

1864 Archduke Maximilian of Austria arrives as Emperor, Mexico City having fallen to the French the preceding

year. He is accompanied by his wife Carlota. Chapul-tepec Castle is rebuilt to serve as the official residence.

1867 French forces are withdrawn from Mexico, and Maxi-milian is captured and shot. Juárez restores the govern-ment although the economic situation is critical.

1876–1911 Porfirio Díaz, elected to the presidency in 1876, remains through successive terms as virtual dictator until 1911. The period is often referred to as the *Porfiriato*. Mexico is opened to foreign investment, and industry and rail transportation are expanded. Society is dominated by Europeans and European ideals. The engraver Posada is active toward the end of the period.

1903 The Catalan painter Antonio Fabrés reorganizes the school of the San Carlos Academy. Greater emphasis is placed on painting from nature.

1904 The Palace of Fine Arts is begun in Mexico City.

1910–20 Period of Revolution. Díaz is overthrown in 1911. Some outstanding figures of the period are Francisco Madero, Emiliano Zapata, Venustiano Carranza, Francisco (Pancho) Villa, and Alvaro Obregón.

1917 New constitution is adopted, strongly national and anti-clerical in tone.

1922 Diego Rivera, having returned from Europe in 1921, paints a mural in the Amfiteatro Bolívar, the first in what will become the Mexican mural movement. The Union of Revolutionary Painters, Sculptors, and Engravers is organized. Murals begun in the National Preparatory School: Rivera, Orozco, Siqueiros, Charlot, and others.

1927 Presidential term extended to six years.

1934 Lázaro Cárdenas elected president.

1940 Manuel Avila Camacho elected president.

1942 Mexico joins the Allies in declaring war against the Axis.

1946 Miguel Alemán elected president.

1949–54 University City is constructed.

1952 Ruiz Cortines elected president.

1958 Adolfo López Mateos elected president. Many monu-ments restored and museums opened during his presi-dency.

1964 Gustavo Díaz Ordaz elected president.

INDEX